D1237893

STILLE STÄDTE

CITIES OF SILENCE

teNeues

VERSTÖRENDE SCHÖNHEIT

DISTURBING BEAUTY

Als die Welt den Atem anhielt

Simon & Garfunkel haben 1964 in ihrem Song *The Sound of Silence* keine weltumspannende Seuche vorhergesagt. Und noch vor ein paar Monaten hätte die Vorstellung einer Pandemie im Ausmaß von Corona wohl die Fantasie der meisten von uns überfordert. Dennoch wurde der Titel aus Paul Simons Feder in der Krise von 2020 real: Der »Klang der Stille« breitete sich aus. Stille erreichte unsere Städte und ihre beliebtesten Hotspots, die in Reiseführern gerne als »pulsierend« oder »lebendig« beschrieben werden.

Im Frühjahr 2020 kam das öffentliche Leben und mit ihm das Pulsieren an vielen Orten zum Erliegen. Während die Menschen einen Großteil ihrer Zeit in häuslicher Quarantäne verbrachten, die Geschäfte geschlossen hatten und mehr oder minder drastische Ausgangssperren herrschten, legte sich eine unbekannte Ruhe über große und kleinere Metropolen. Die Welt hielt fast buchstäblich den Atem an. Das London Eye stand still,

> WENN PERMANENTE BESCHALLUNG DIE NORMALITÄT IN UNSEREN STÄDTEN IST, DANN IRRITIERT UNS DAS EINTRETEN VON RUHE.

When the World Held its Breath

Simon & Garfunkel did not predict a pandemic in their 1964 song The Sound of Silence. *Just a few months ago, the notion of a pandemic on the scale of COVID-19 would have been unfathomable to most people. Still, the title penned by Paul Simon became a reality in the crisis of 2020: the "sound of silence" spread. Silence reached our cities and their most popular hotspots, places travel guides enjoy calling "vibrant" or "lively."*

In the spring of 2020, public life and its associated vibrancy came to a screeching halt in many places. While people spent most of their time quarantined inside their homes, businesses were closed and lockdowns of varying strictness ruled the day, a heretofore unknown stillness descended on cities large and small. The world almost literally held its breath. The London Eye stood still under a perfect blue sky. Venetian gondolas slept under tarps. The Fontana di Trevi in Rome, Sanssouci Castle in Potsdam, the Brooklyn Bridge—all deserted. In broad daylight.

On the one hand, this resulted in a nearly apocalyptic scene. On the other, this bizarre

vor strahlend blauem Himmel. Venezianische Gondeln schliefen unter Planen. Die Fontana di Trevi in Rom, Schloss Sanssouci in Potsdam, die Brooklyn Bridge in New York – alle waren menschenleer. Mitten am Tag.

Das sorgte zum einen für ein geradezu apokalyptisches Bild. Zum anderen schuf diese bizarre Situation einen Widerspruch: Der Begriff Ruhestörung geht davon aus, dass Ruhe der Normalzustand ist, der durch Lärm gestört wird. Im Frühjahr 2020 haben wir die Umkehrung dieses Sachverhalts, und damit eigentlich ein Paradoxon, erlebt. Wir wurden in unserem Lärm gestört. Wenn überfüllte Plätze und permanente Beschallung – mit Motorengeräuschen, Hupen, Martinshörnern, Baulärm – die Normalität in unseren Städten sind, dann irritiert uns das Eintreten von Ruhe. Beim New York Police Department oder der Polizei Berlin sind vermutlich keine Anzeigen wegen Lärmstörung eingegangen. Aber neben vielen anderen Begleiterscheinungen von Corona stellte uns auch die neue Stille vor – für manche Menschen unlösbare – Herausforderungen.

Gipfelblick als Hoffnungsschimmer

Dabei ist Stille in diesem Fall mehr als die Abstinenz von Geräuschen. In manchen Großstädten ist sie nicht einmal das. Während die in Man-

situation created a contradiction: the concept of "disturbing the peace" assumes that peace is the normal condition, and noise disturbs it. Spring 2020 delivered the exact opposite, which is actually paradoxical. Our noise was disturbed. When packed public spaces and unrelenting noise—from engines, horns, ambulances, and construction sites—are the norm in cities, then the advent of silence disturbs us. The New York or Berlin police departments probably didn't get any complaints about

> WHEN UNRELENT-ING NOISE IS THE NORM IN CITIES, THEN THE ADVENT OF SILENCE DISTURBS US.

disturbing the noise. But along with many other side effects of COVID-19, the new silence posed challenges that overwhelmed many people.

Visible Peaks Offer a Glimmer of Hope
In this case, silence is more than the absence of sounds. In many large cities, it isn't even that. While Josephine Meckseper, an artist living in Manhattan, notes in a Der Spiegel interview that the typical city sounds "suddenly fell silent," the Süddeutsche Zeitung

hattan lebende Künstlerin Josephine Meckseper im *Spiegel*-Interview anmerkt, die für die Stadt typische Geräuschkulisse »verstummte schlagartig«, heißt es in der *SZ* (unter der Überschrift »Die neue Stille«): »Der Sound von New York City hat sich nicht so stark verändert, wie man aus der Ferne glauben könnte.« Insofern ist »Stille« hier eher als Symptom und auch als Metapher zu verstehen. So wie es Fernando Pessoa im *Buch der Unruhe* beschreibt: »Große Stille liegt über dem Geräuschpegel der Stadt.« Nicht nur unser Leben ändert sich gerade in einem Maß und mit Folgen, die wir noch nicht absehen können. Unsere Städte fühlen sich anders an, sie sehen anders aus, sie riechen anders und hören sich anders an. In diesem Buch lassen wir uns in einer einmaligen Momentaufnahme auf die Ästhetik der Katastrophe ein – zeigen eine unbekannte Leere und damit einhergehend eine verstörende Schönheit. Fotografie vermittelt hier die Wirkung von Stille, auch wenn sie die auditive Wahrnehmung nicht abzubilden vermag.

Ob Stille oder neue Geräuschkulisse, die Ausnahmesituation des Frühjahrs 2020 hat uns mit voller Wucht vor Augen und Ohren geführt, dass wir in einer lauten, überhitzten, turbobeschleunigten Welt leben, in der Still-Stand

(under the headline "The New Silence") writes, "The sound of New York City hasn't changed as much as an outside observer might think." Here, "silence" should be understood as both a symptom and a metaphor. As Fernando Pessoa describes it in his Book of Disquiet, *"An immense calm hangs over the noisy city." It's not just our lives that are changing so radically, with consequences we cannot yet see. Our cities feel different, they look different; they smell different and sound different. In this book, we immerse ourselves in a unique snapshot of the aesthetics of the catastrophe—showing an unknown emptiness accompanied by a disturbing beauty. Here, photography conveys the effect of silence, even if it lacks audio.*

Whether it's silence or a new constellation of sounds, the exceptional circumstances of Spring 2020 have made it abundantly clear to our eyes and ears that we live in a loud, overheated, turbocharged world where downtime has no place. The shutdown has forced the world to take its foot off the gas pedal. This is a quasi-euphemism, because COVID-19 is not

nicht vorgesehen ist. Der Shutdown hat die Welt dazu gezwungen, den Fuß vom Gaspedal zu nehmen. Das ist gleichsam eine Art Euphemismus, denn Corona ist keine entschleunigende Detox-Kur, sondern eine Krankheit, die sehr viele Menschenleben kostet.

Dennoch birgt dieses Szenario – wie bei vielen Krisen in der Historie – auch Chancen. Unmittelbar positive Folgen ergeben sich in puncto Luftverschmutzung für die Umwelt. So ermöglichte die verminderte Reise- und Industrietätigkeit in Nordindien einen ungeahnten Ausblick: Dank verringerter Emissionen waren für Bewohner der Provinz Punjab erstmals seit langem wieder die Gipfel des Himalaya zu sehen. Diese Meldung erscheint wie die Allegorie auf eine mögliche Umkehr.

Einzigartige Impressionen

Ein freier Blick ist es auch, was sich Fotografen wünschen. Man kennt das Phänomen von sich selbst: Wenn man im Museum versucht, mit 25 weiteren Interessierten einen Blick auf ein berühmtes Gemälde zu erhaschen. Oder wenn man an einem so schönen wie touristisch erschlossenen Ort ankommt und dort eine Busladung nach der nächsten ausgespuckt wird und sich der Gedanke aufdrängt: Diesen Ort hätte ich gerne mal für mich allein.

a detox retreat, but an illness that is costing a great many human lives.

Still, like many crisis points in our history, this scenario also provides opportunities. Immediate positive changes to our environment have been observed regarding air pollution. Reduced travel and industrial activity in northern India opened up an unexpected view: thanks to lower emissions, the residents of Punjab province were able to see the peaks of the Himalayas for the first time in many years. This story seems like an allegory for a possible reversal of climate change.

Unique Impressions

Photographers also love an unobstructed view. You know how it is: you're in a museum with 25 other people trying to get a glimpse of a famous painting. Or you get to a beautiful but very touristy spot, where buses constantly disgorge hordes of people, and suddenly you think, "I wish I could have this place to myself."

Photographers fortunate enough to move freely around interesting places during the COVID-19 emergency had previously

> # FÜR FOTOGRAFEN ERÖFFNETEN SICH WÄHREND CORONA ZUVOR UNVORSTELL-BARE MÖGLICHKEITEN FÜR EINZIGARTIGE IMPRESSIONEN.

Für Fotografen, die das Glück hatten, sich während Corona an interessanten Orten frei bewegen zu können, eröffneten sich zuvor unvorstellbare Möglichkeiten für einzigartige Impressionen. Es wurde sozusagen in doppeltem Sinne der Traum des Fotografen von Exklusivität wahr. Er/sie konnte wahrhaft einmalige Bilder machen: So, wie auf den Fotos in diesem Buch, hat man die abgebildeten Städte noch nicht gesehen und so wird man sie wohl auch nicht wieder sehen. Außerdem gestattet das Fehlen menschlichen Beiwerks einen neuen Blick auf Plätze und Bauwerke.

Die in diesem Band versammelten Fotografien, sowohl von Profis als auch von Laien, offenbaren echten Mut zur Lücke, zum Freiraum. Sie dokumentieren ästhetische Strukturen, die man sonst kaum wahrnehmen kann: die Symmetrie von Plätzen und Boulevards, die Schönheit eines unbelebten Sandstrands, die Harmonie von Fassaden, unverstellt von Werbebotschaften. Diese Bestandsaufnahme lässt manche hoffen,

unimaginable opportunities to gather unique impressions. The photographer's dream of exclusivity came true in two senses of the word. He/she was able to take truly unique pictures: the cities as shown in this book have never looked this way before, and they might not look like this again. Furthermore, the absence of human trappings permits a new perspective on public squares and buildings.

The photographs assembled in this volume, from both professional and amateur photographers, reveal a true courage to look at the gaps, the empty spaces. They document aesthetic structures one might never see otherwise: the symmetry of public squares and boulevards, the beauty of an empty sandy beach, the harmony of façades unmarred by advertising. This appraisal makes many people hope that "normalcy" and its inherent disquiet will not be so quick to return.

As layered as the topic is, this book allows the reader to approach the material in many different ways. As a "slow" medium, this book has an enormous advantage over the daily news cycle: you can determine the

die »Normalität« mit ihrer latenten Unruhe möge nicht zu schnell wieder Einzug halten.

So vielschichtig das Thema ist, so bietet dieses Buch diverse Möglichkeiten des Zugangs. Das Buch hat dabei als langsames Medium einen großen Vorteil gegenüber allem Tagesaktuellen: Man kann sich im selbstbestimmten Rhythmus einer meditativen Beobachtung hingeben, bei der Unbehagen auf Ästhetik trifft. Kopfkino mit dem Sound der Stille als Filmmusik. Ob unsere Städte während der Pandemie tatsächlich still waren oder nur anders laut, beim Betrachten der meist leergefegten Straßen stellt sich unweigerlich ein Gefühl der Ruhe ein. Diese Kompilation von Bildern aus der Krise ist eine Erinnerung an eine besondere Phase in der Geschichte der Menschheit, verbunden mit der Hoffnung, dass bei aller Schönheit der Aufnahmen aus dem bedrückenden *Ist* bald ein befreiendes *War* wird. Der Band dient als Inspiration, vermeintlich Festgefahrenes infrage zu stellen. Vielleicht sorgt das Innehalten im Frühjahr/Sommer 2020 für positive Impulse: für Inseln der lärmstörenden Ruhe im urbanen Raum. Für mehr Respekt im Umgang mit uns, unserer Umwelt, unseren Städten. Für Demut und für den Mut zur Lücke.

pace at which you sink into meditative observance, where discomfort meets aesthetics. It's like seeing a movie in your head with the sound of silence as the soundtrack. Whether our cities were actually silent during the pandemic or just loud in a different way, looking at the mostly deserted streets is undeniably calming. This compilation of pictures from the crisis is a reminder of a special phase of human history, tied to the hope that, regardless of the beauty of the images, the current depressing Is *will soon become a freeing* Was. *This volume inspires us to question things we have always taken for granted. Perhaps this introspection in Spring/Summer 2020 will spark positive changes: islands of noise-disrupting quiet in urban spaces. Greater respect when dealing with ourselves, our environment, our cities. Humility, and the courage to face the gaps.*

PHOTOGRAPHERS HAD PREVIOUSLY UNIMAGINABLE OPPORTUNITIES TO GATHER UNIQUE IMPRESSIONS.

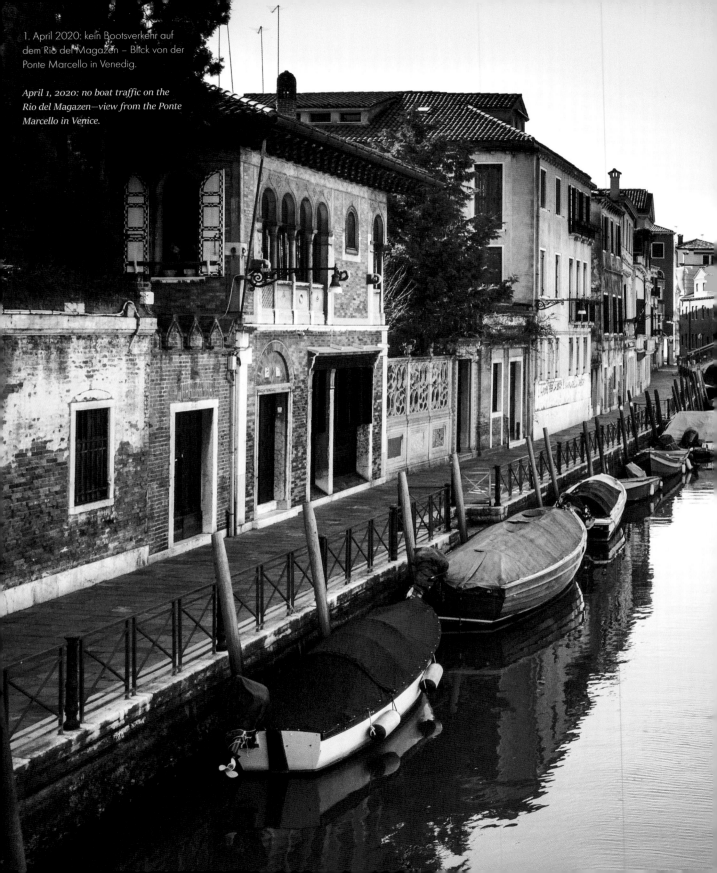

1. April 2020: kein Bootsverkehr auf
dem Rio del Magazen – Blick von der
Ponte Marcello in Venedig.

*April 1, 2020: no boat traffic on the
Rio del Magazen—view from the Ponte
Marcello in Venice.*

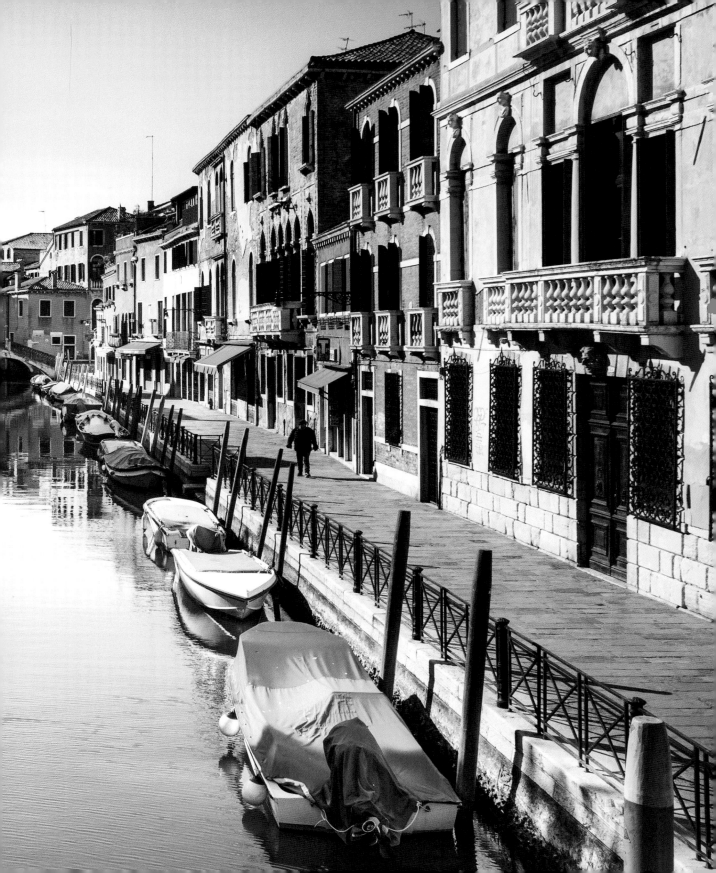

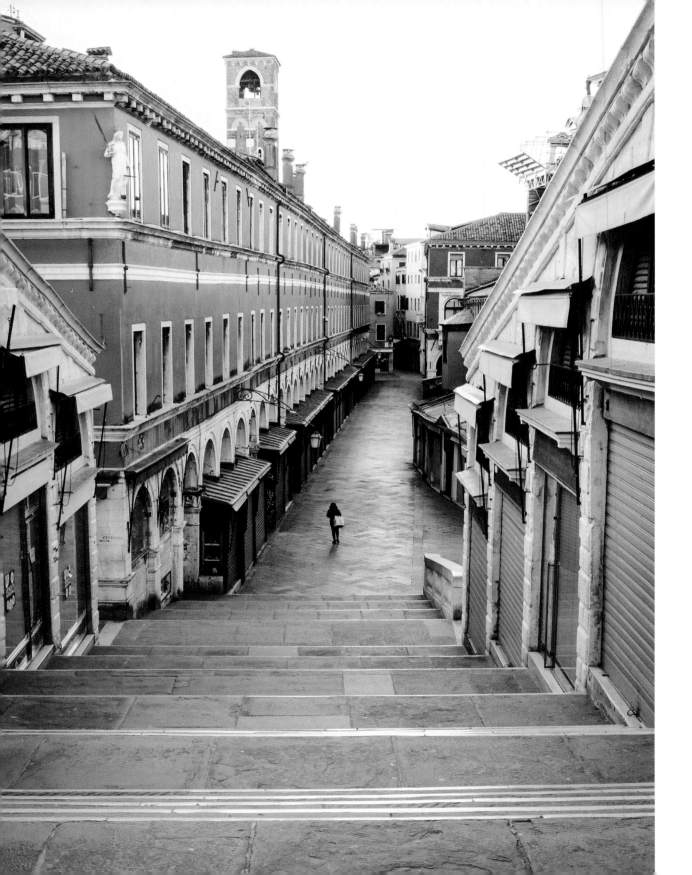

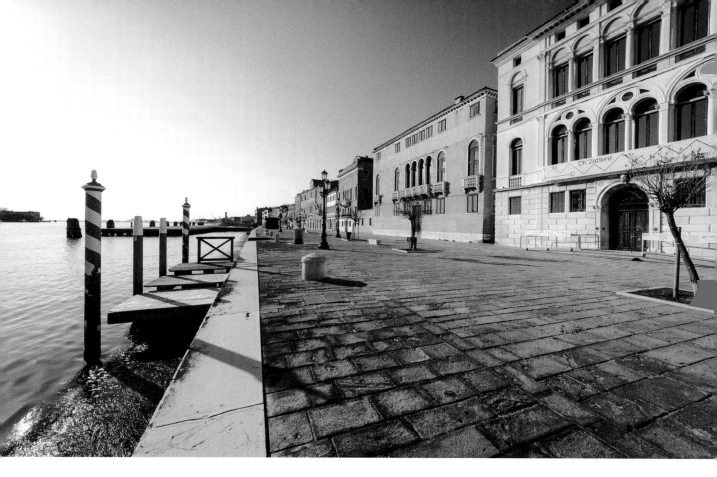

Flaniermeile für Besucher aus aller
Welt: Venedigs Uferpromenade
Fondamenta delle Zattere.

A boulevard for visitors from all over
the world: Venice's seaside promenade,
Fondamenta delle Zattere.

Wo sich sonst die Massen drängen: Stufen zu
Venedigs Rialtobrücke am 1. April 2020.

Where it's usually packed with people: the steps
to Venice's Rialto Bridge on April 1, 2020.

13

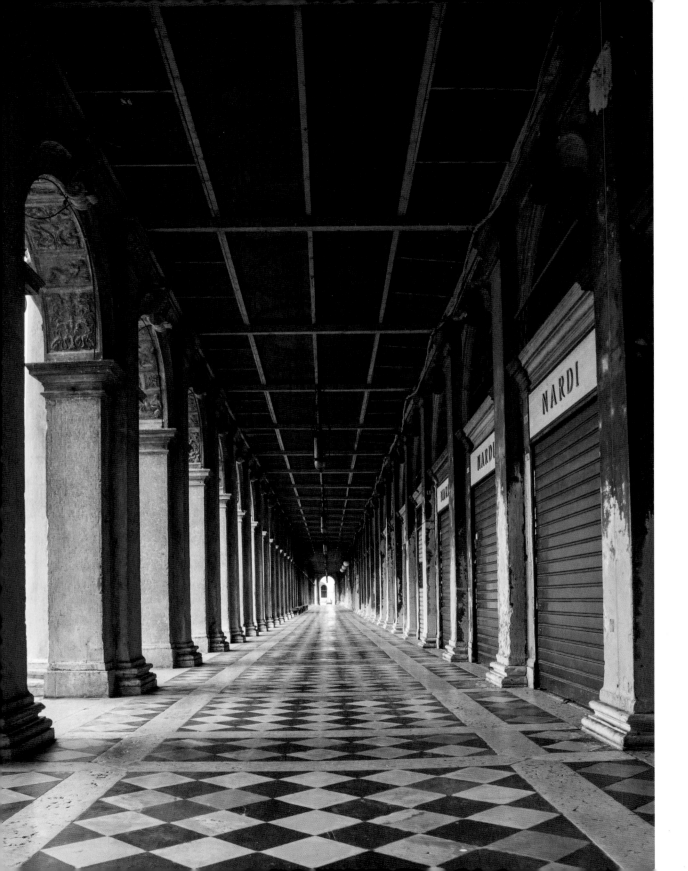

17. April 2020: Beim Luxus-Juwelier Nardi unter den Arkaden des Markusplatz' schmücken sich gerne die Reichen und Schönen.

April 17, 2020: The rich and famous love to get their bling on at luxury jeweler Nardi in the shopping arcade at St. Mark's Square.

23. März 2020: »Servizio sospeso« – auch der Traghetto Santa Sofia muss die Gondel-fahrten über den Canal Grande einstellen.

March 23, 2020: "Servizio sospeso"—even the Traghetto Santa Sofia has to suspend gondola service across the Grand Canal.

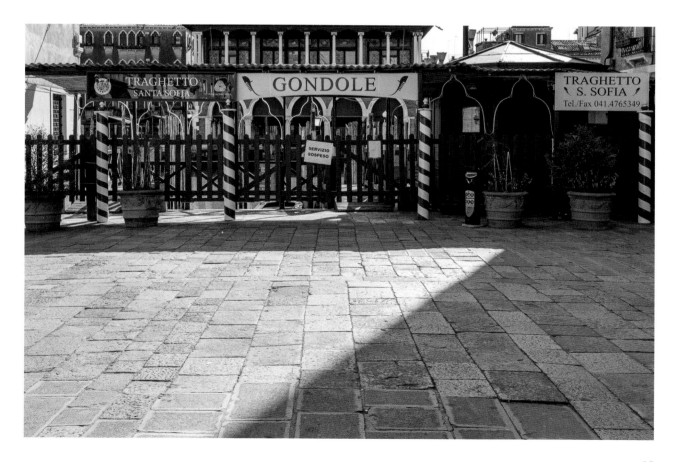

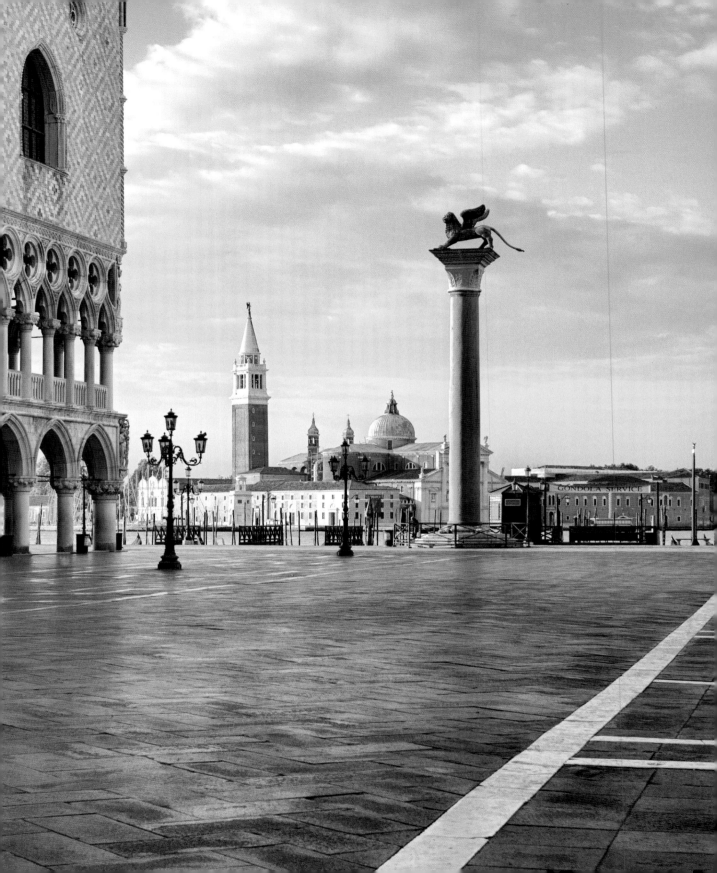

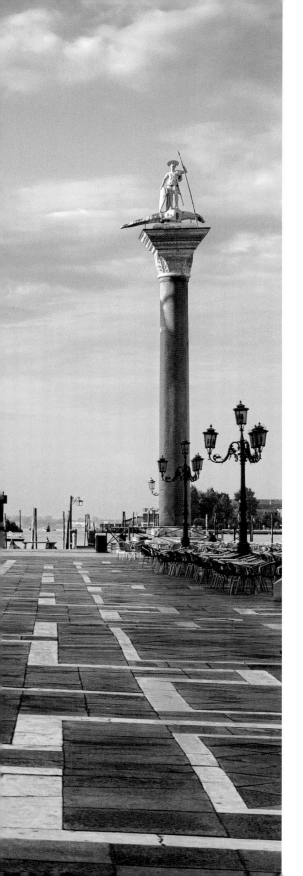

Auf einmal Raum für Details: Der Markusplatz ist mit Trachyt, einem vulkanischen Gestein, und hellem, istrischem Kalkstein bepflastert.

Suddenly, there's space for the details: the stones of St. Mark's Square are made of trachyte, an igneous rock, and light Istrian limestone.

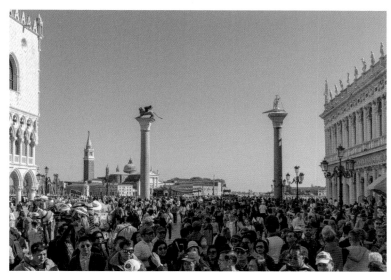

April 2019: Menschenmassen verstellen den Blick auf den Markusplatz.

April 2019: Throngs of people block the view of St. Mark's Square.

Venedigs kristallklare Kanäle:

Erstmals seit Jahrzehnten können die Venezianer bis auf den Grund ihrer Kanäle blicken. Ursache ist allerdings nicht die verbesserte Wasserqualität – weil weniger Boote unterwegs sind, werden auch weniger trübende Sedimente aufgewirbelt.

Venice's crystal-clear canals:

For the first time in decades, Venetians can see the bottom of their canals. It's not because of improved water quality—less boat traffic means less cloudy sediment being churned up.

Grauer Ball mit roten Dornen: Das weltbekannte Bild des **COVID-19-Virus** entwerfen Grafiker des US-Gesundheitsministeriums. In Wirklichkeit ist das Virus farblos.

*Gray ball with red thorns: graphic artists at the US CDC create the world-famous picture of the **COVID-19 virus**. The virus is actually colorless.*

Flieger am Boden: Durch die Reisebeschränkungen bricht weltweit der **Flugverkehr** ein. In Deutschland kontrollierte die Flugsicherung nur noch rund 15% des sonst üblichen Aufkommens.

*Grounded airplanes: travel restrictions bring global **air travel** to a standstill. In Germany, air traffic control handles only about 15% of normal flight volume.*

Platz für **Delfine**: Nachdem der Schiffsverkehr zum Erliegen kommt, sichten die Sarden im Hafen von Cagliari erstmals seit Jahren wieder Delfine. Die Säugetiere, die sensibel auf Unterwasserlärm reagieren, wagen sich bis an die Kaimauern vor.

*Room for **dolphins**: after ships quit sailing, Sardinians spot dolphins in the harbor of Cagliari for the first time in years. These mammals, which are very sensitive to underwater noise, come all the way up to the stone pier.*

2 500 000 000 Euro: So teuer zu stehen kommt die Verlegung der **Olympischen Spiele 2020** in Japan um ein Jahr.

*2,500,000,000 euros: That's how much it will cost to delay the **2020 Olympic Games** in Japan by one year.*

Glühende Drähte: Die **Telefonseelsorge** verzeichnet im März teilweise bis zu 50% mehr Anrufe als üblich. Zum einen wachsen die wirtschaftlichen Existenzängste, zum anderen führen die Beschränkungen zu schleichender Vereinsamung der Menschen.

*Burning up the wires: Some **crisis helplines** in Germany are inundated with up to 50% more calls than usual in March. Economic anxieties are growing on the one hand, while restrictions on movement and gatherings on the other are gradually isolating people.*

Akkord auf zwei Rädern: Die großen **Radsportevents** Tour de France, Giro d'Italia und Vuelta a España müssen verschoben werden. Was normalerweise über die gesamte Saison verteilt wird, soll nun in 72 Tagen, sich teilweise überschneidend, abgestrampelt werden – 9 930 km zwischen 29. August und 8. November.

*Piecework on two wheels: The great **cycling events** Tour de France, Giro d'Italia and Vuelta a España have to be postponed. Races that would normally be distributed across an entire season will now be crammed into 72 days, with some event overlap. Competitors will pedal 9,930 km between August 29 and November 8.*

Rezessions-Virus: Für 2020 rechnet der Euroraum mit einem Anstieg der **Arbeitslosenzahlen** von 7,5% im vergangenen Jahr auf 9,6%. Besonders hart trifft die Entwicklung Griechenland: Dort sinkt die Wirtschaftsleistung um 9,75%. Polen steht mit einem Minus von 4,25% am besten da.

*Recession virus: for 2020, the Euro zone is forecasting a rise in **unemployment** from 7.5% last year to 9.6%. Greece will be particularly hard hit: their economy will contract by 9.75%. Poland, at -4.25%, is the best Euro zone performer.*

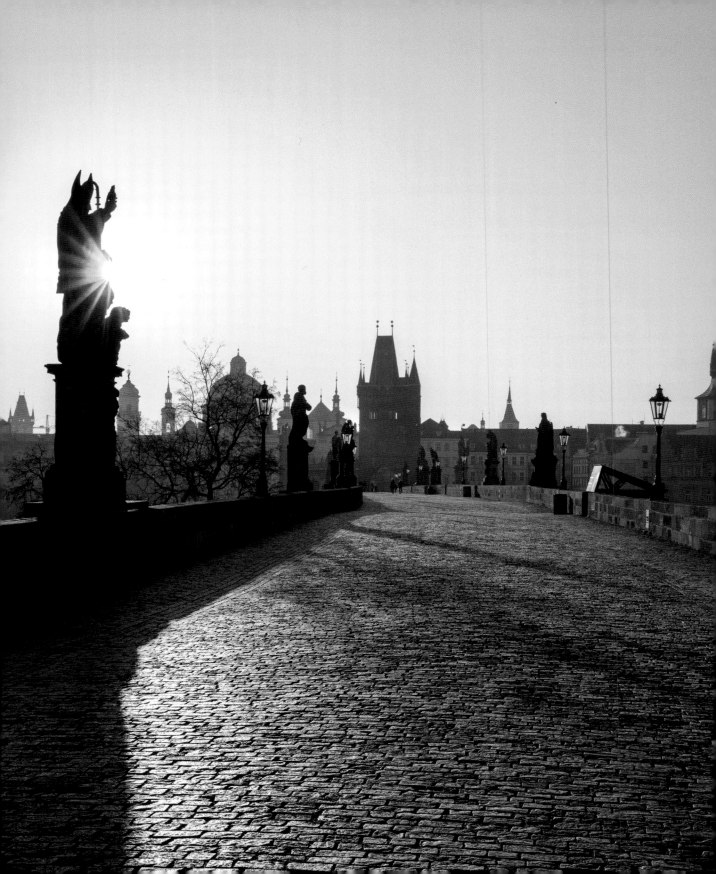

Die Karlsbrücke in Prag, nationales
Kulturdenkmal der Tschechen.

The Charles Bridge in Prague,
a Czech national cultural monument.

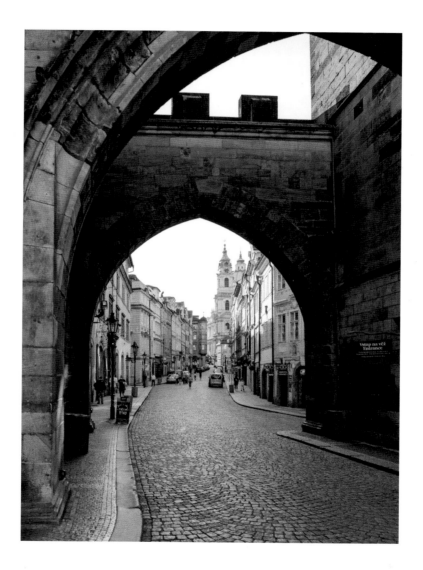

20. April 2020: Der Kleinseitner Brückenturm bildet
auf westlicher Seite den Eingang zur Karlsbrücke.

April 20, 2020: The Malá Strana Bridge Tower is
the entrance to the Charles Bridge from the west.

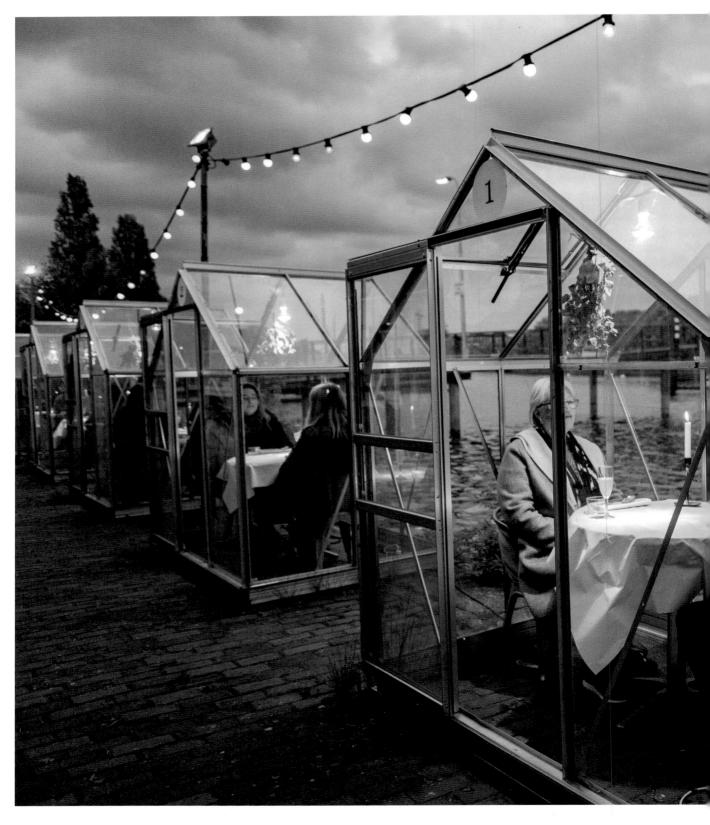

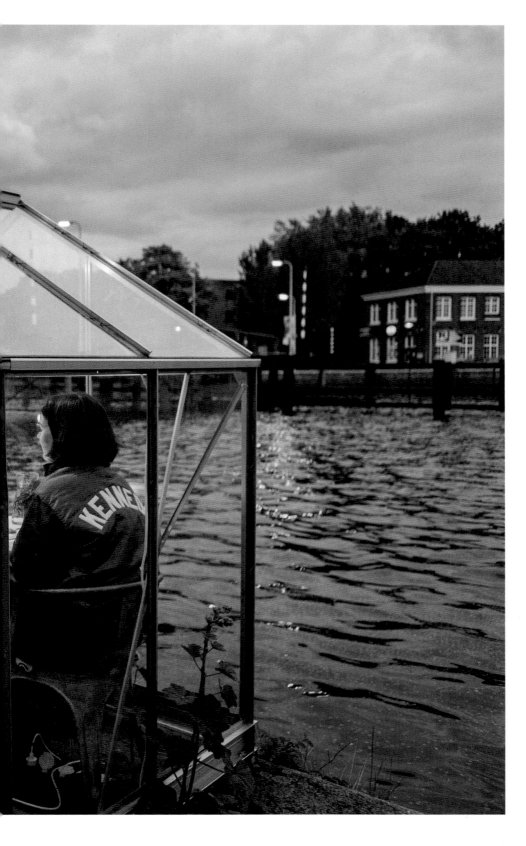

12. Mai 2020, Amsterdam: Das Restaurant des Art Centers Mediamatic macht aus Social Distancing ein Kunstprojekt mit Gewächshäusern.

May 12, 2020, Amsterdam: The Mediamatic Art Center restaurant turns social distancing into an art project with greenhouses.

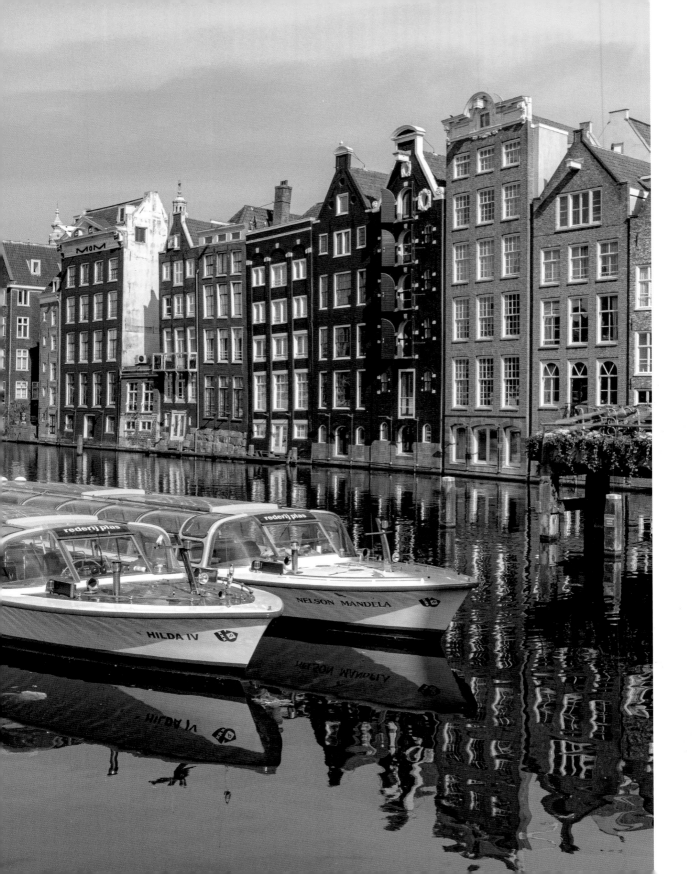

23. April 2020: Rundfahrboote vor
den tanzenden Häusern am Damrak
in Amsterdam.

*April 23, 2020: Tour boats in front
of the Dancing Houses of the Damrak
in Amsterdam.*

17. April 2020: Im Amsterdamer Stadtteil
Weesperzijde, direkt an der Amstel, mahnt ein
Schild mit den Worten »Bleibt drinnen«.

*April 17, 2020: In the Weesperzijde neighbor-
hood of Amsterdam, directly on the Amstel,
a sign entreats passersby to "stay inside."*

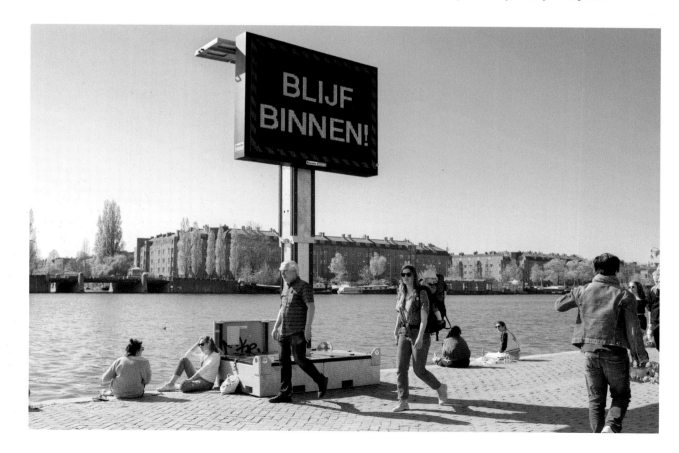

18. März 2020, Flughafen, Frankfurt am Main: Im Zuge der Reisebeschränkungen füllt sich das Rollfeld mit überflüssigen Maschinen. Der Luftraum bleibt dementsprechend fast leer. Die *Frankfurter Rundschau* titelt: »Unheimliche Stille am Frankfurter Flughafen«.

March 18, 2020, Frankfurt Airport: Travel restrictions cause the runways to fill with surplus aircraft. Airspaces remain nearly empty as a result. The Frankfurter Rundschau *headline: "Eerie silence at Frankfurt Airport."*

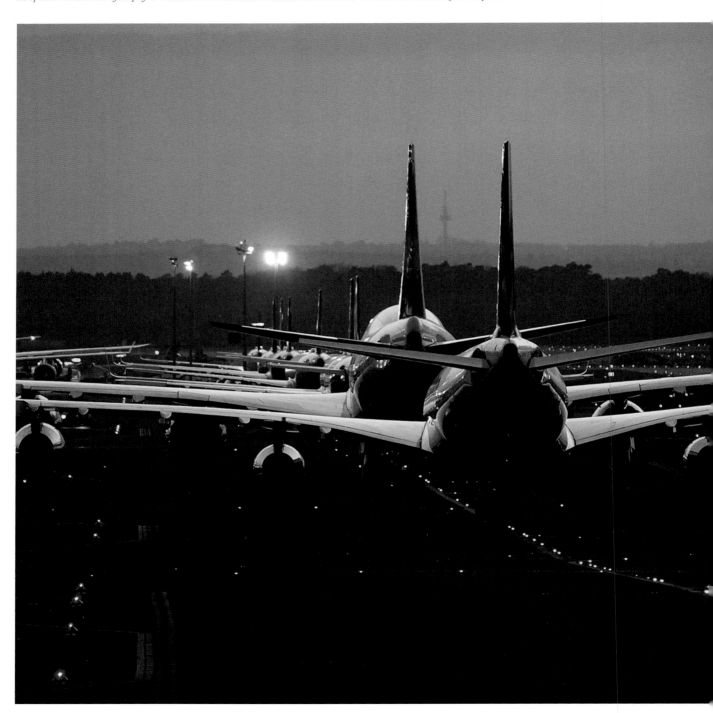

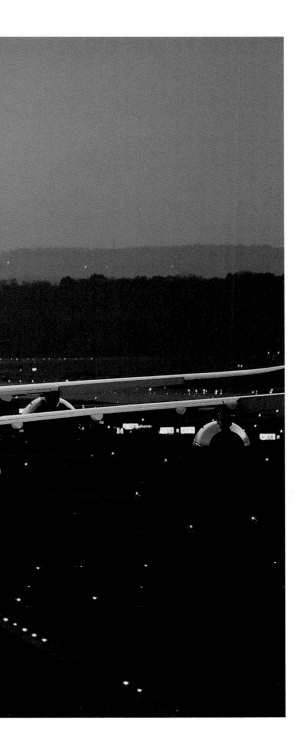

20. April 2020: Den Pink-Path-Radweg,
Abschnitt des Nelson Street Cycleway in
Auckland, nutzen die Neuseeländer auch
während der Beschränkungen.

April 20, 2020: Even during lockdown,
New Zealanders continue to use the Pink Path,
part of the Nelson Street Cycleway in Auckland.

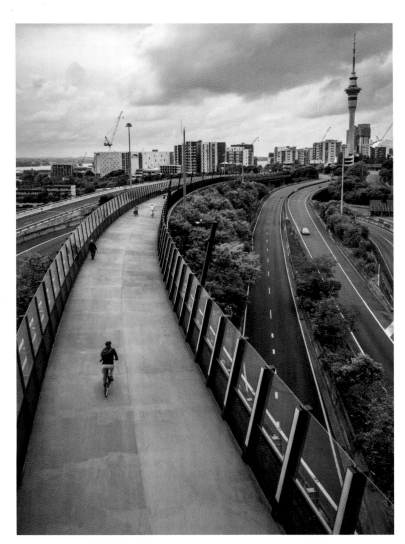

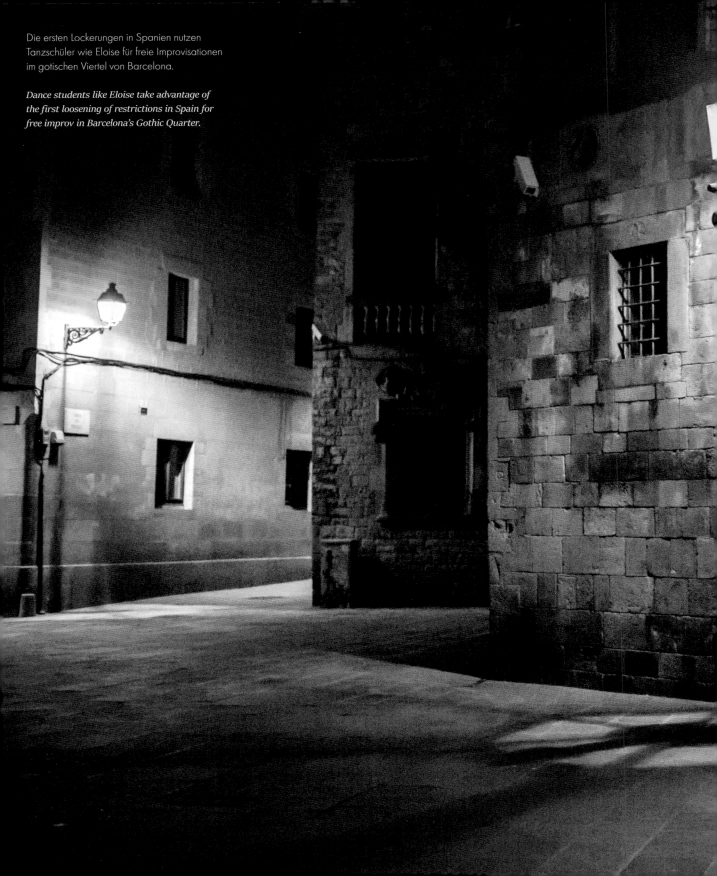

Die ersten Lockerungen in Spanien nutzen
Tanzschüler wie Eloise für freie Improvisationen
im gotischen Viertel von Barcelona.

*Dance students like Eloise take advantage of
the first loosening of restrictions in Spain for
free improv in Barcelona's Gothic Quarter.*

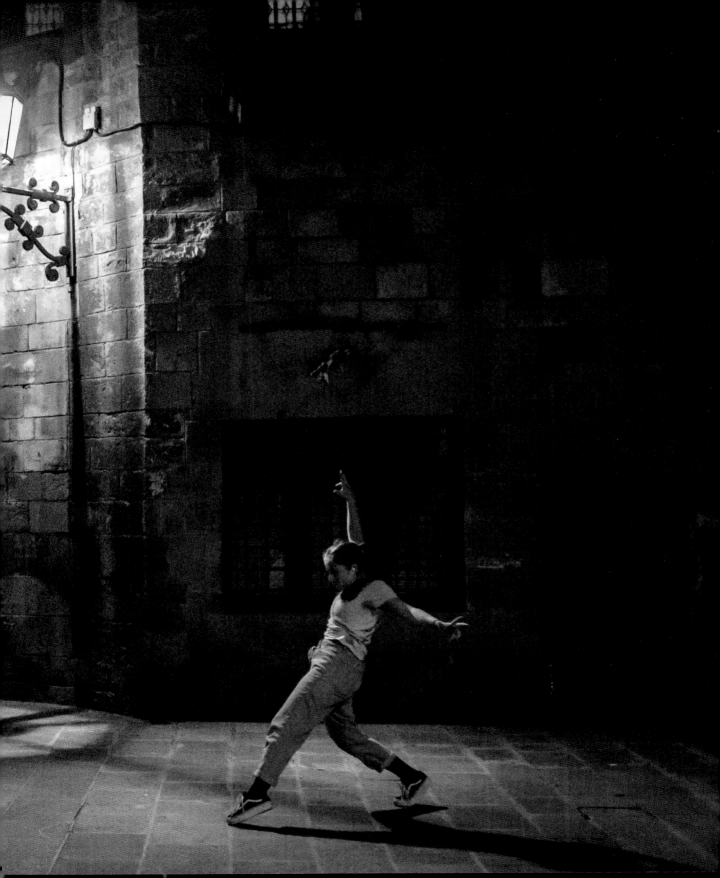

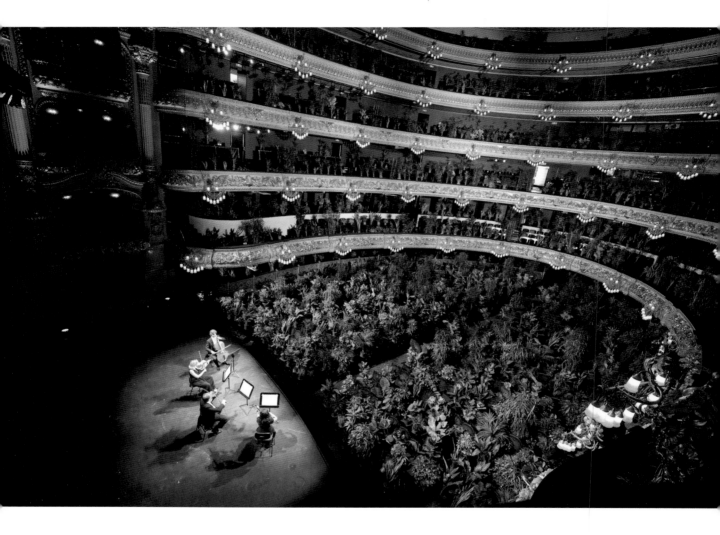

»Im Gran Teatre del Liceu erklingt wieder Musik – allerdings erstmal nur für ein stummes Publikum.« So beschreibt *Der Spiegel* das erste Konzert im Opernhaus von Barcelona nach dem Ende des Notstands, bei dem vier Musiker Giacomo Puccinis »Crisantemi« vor 2 292 Pflanzen spielen. Spiritus rector: der Konzeptkünstler Eugenio Ampudia, der dadurch für einen respektvolleren Umgang mit der Natur wirbt.

"Music once again fills the Gran Teatre del Liceu—but for the time being, the audience is mute." This is how Der Spiegel *magazine describes the first concert in the Barcelona opera house following the end of the state of emergency, where four musicians play Giacomo Puccini's "Crisantemi" to 2,292 plants. The guiding spirit: concept artist Eugenio Ampudia, who uses the moment to advocate for more respectful stewardship of nature.*

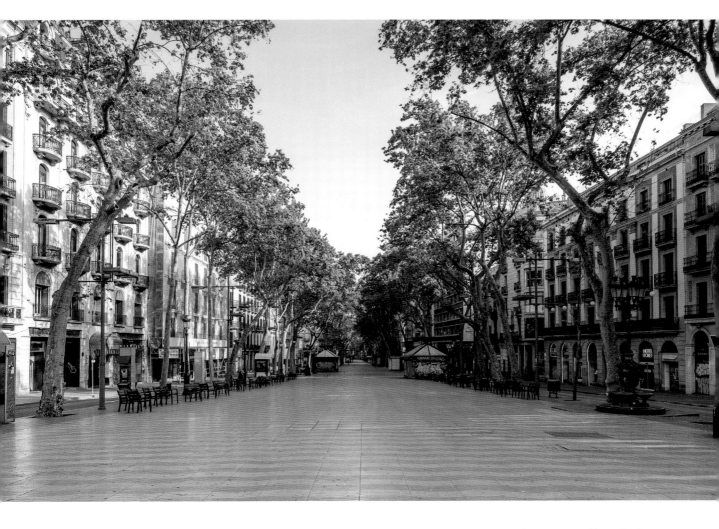

9. April 2020: Les Rambles verbindet
auf rund 1,2 Kilometern Länge die
Plaça de Catalunya mit Barcelonas
Altem Hafen.

*April 9, 2020: Over its 1.2 kilometers,
Las Ramblas connects the Plaça de
Catalunya with Barcelona's Port Vell.*

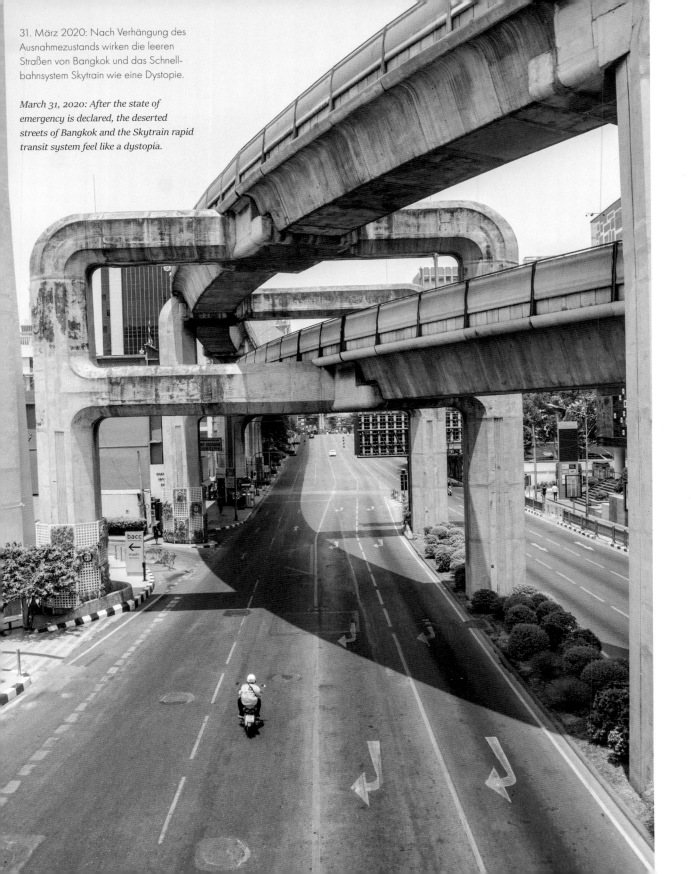

31. März 2020: Nach Verhängung des Ausnahmezustands wirken die leeren Straßen von Bangkok und das Schnellbahnsystem Skytrain wie eine Dystopie.

March 31, 2020: After the state of emergency is declared, the deserted streets of Bangkok and the Skytrain rapid transit system feel like a dystopia.

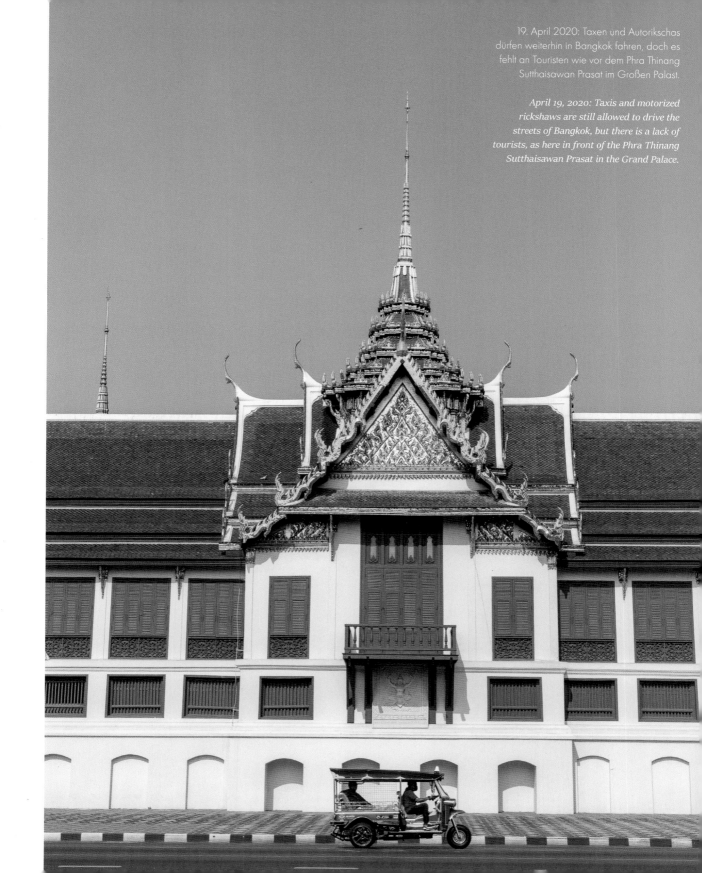

19. April 2020: Taxen und Autorikschas dürfen weiterhin in Bangkok fahren, doch es fehlt an Touristen wie vor dem Phra Thinang Sutthaisawan Prasat im Großen Palast.

April 19, 2020: Taxis and motorized rickshaws are still allowed to drive the streets of Bangkok, but there is a lack of tourists, as here in front of the Phra Thinang Sutthaisawan Prasat in the Grand Palace.

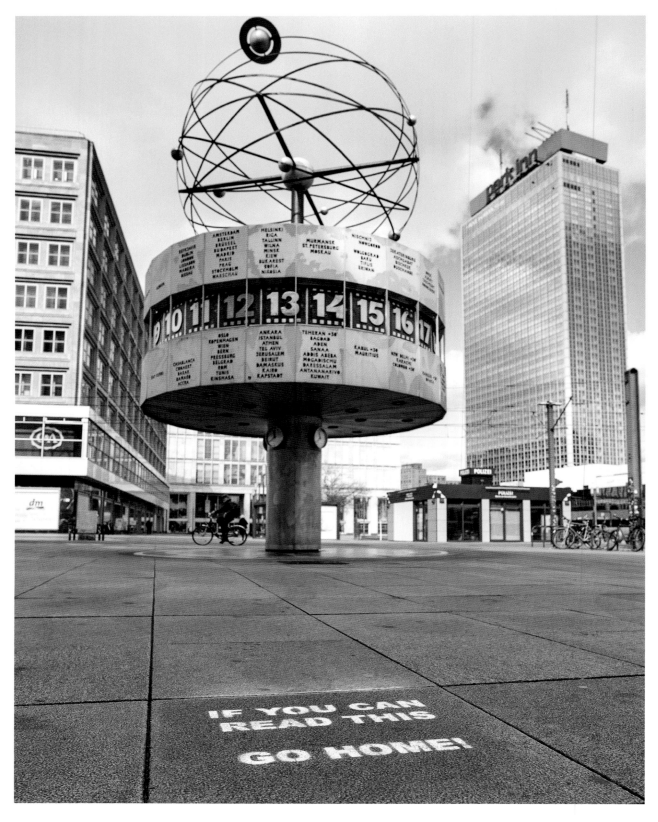

21. März 2020: Weltzeituhr auf dem Alexanderplatz im Berliner Ortsteil Mitte, mit projizierter Botschaft: »Wenn Sie dies lesen können, gehen Sie nach Hause!«

March 21, 2020: World Clock at downtown Berlin's Alexanderplatz, with a projected message: "If you can read this, go home!"

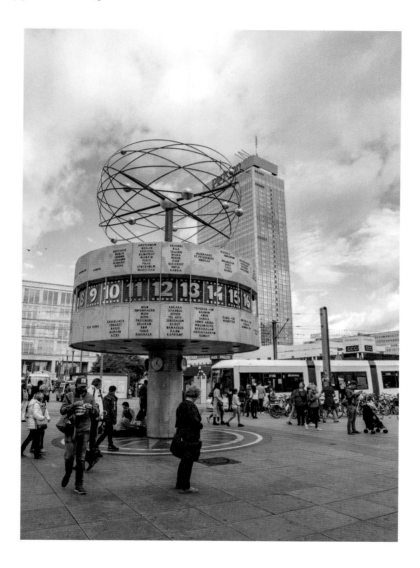

Seit 1969 Treffpunkt für Berliner und Besucher: die zehn Meter hohe Weltzeituhr auf dem Berliner Alexanderplatz.

A meeting point for Berliners and visitors since 1969: the thirty-foot tall world clock at the Alexanderplatz in Berlin.

24. März 2020: Polizisten sorgen am
Brandenburger Tor für die Einhaltung
der Corona-Regeln.

*March 24, 2020: Police ensure corona-
virus rules are being adhered to at the
Brandenburg Gate.*

3. Juli 2017: Ein Besuch des Brandenburger Tors in Berlin
gehört zum Pflichtprogramm jedes Touristen.

*July 3, 2017: A visit to the Brandenburg Gate in Berlin
is a must for every tourist.*

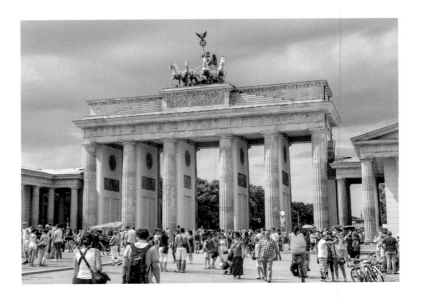

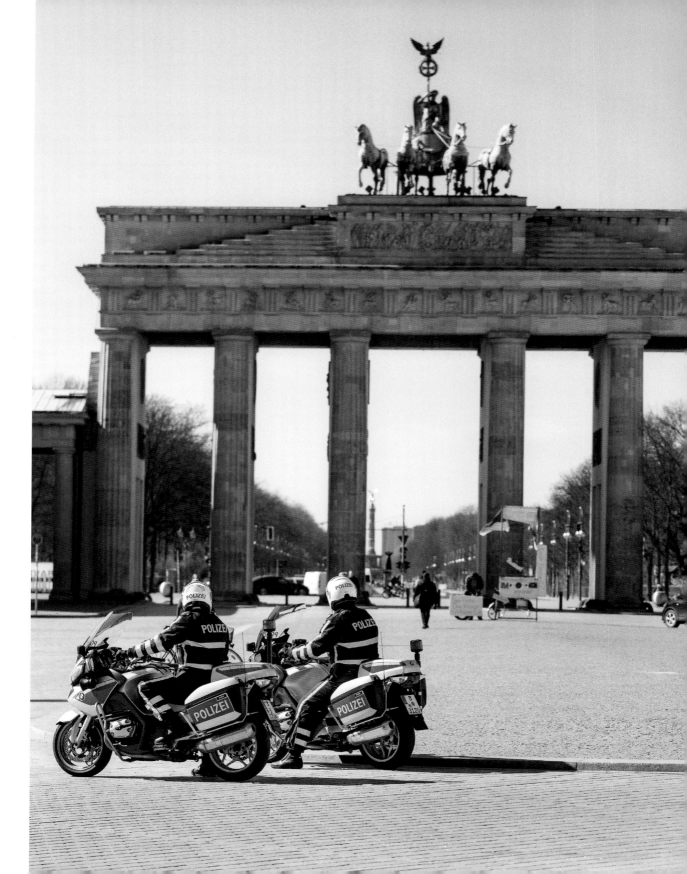

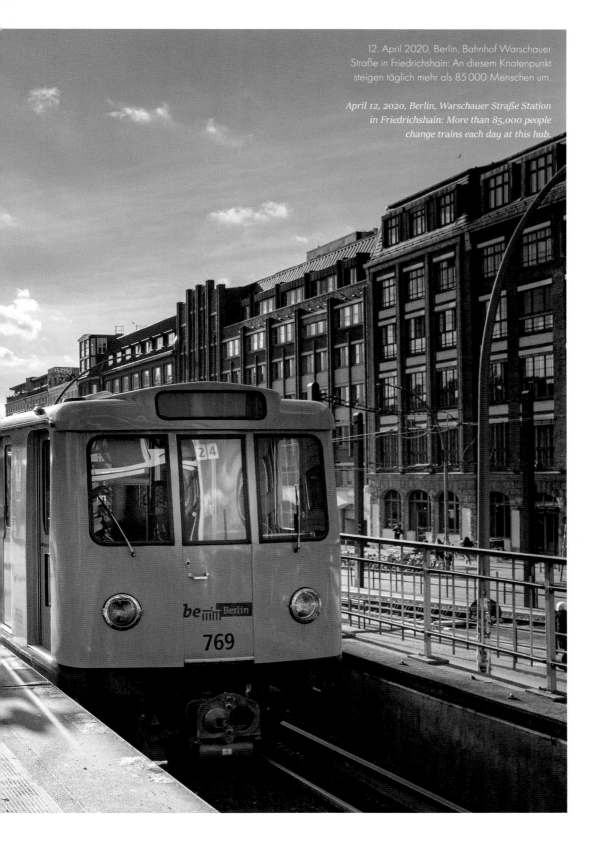

12. April 2020, Berlin, Bahnhof Warschauer
Straße in Friedrichshain: An diesem Knotenpunkt
steigen täglich mehr als 85 000 Menschen um.

*April 12, 2020, Berlin, Warschauer Straße Station
in Friedrichshain: More than 85,000 people
change trains each day at this hub.*

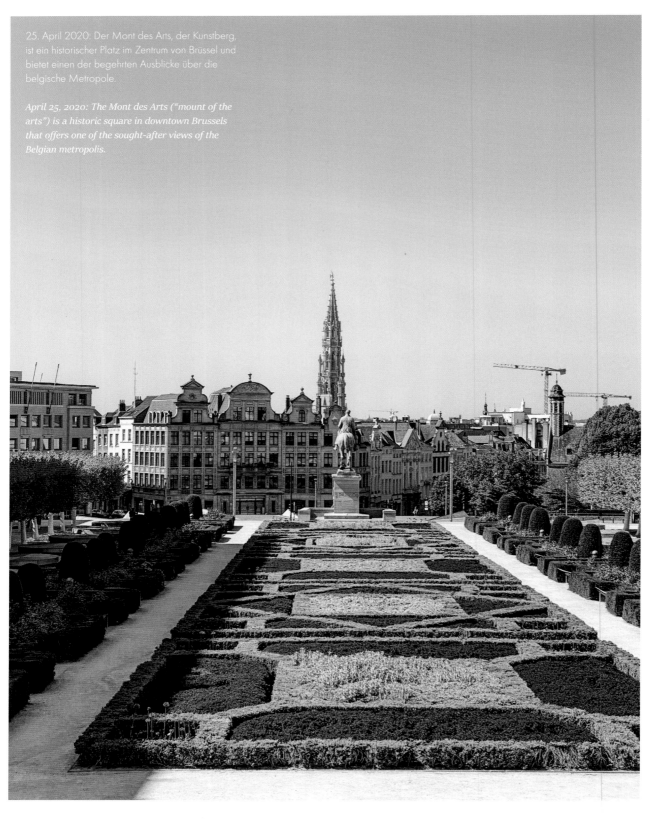

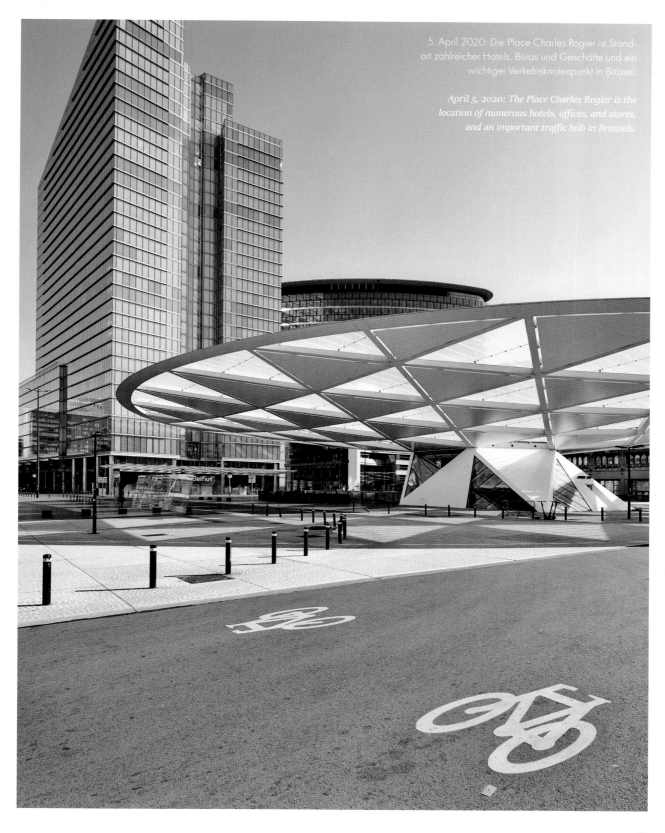

41

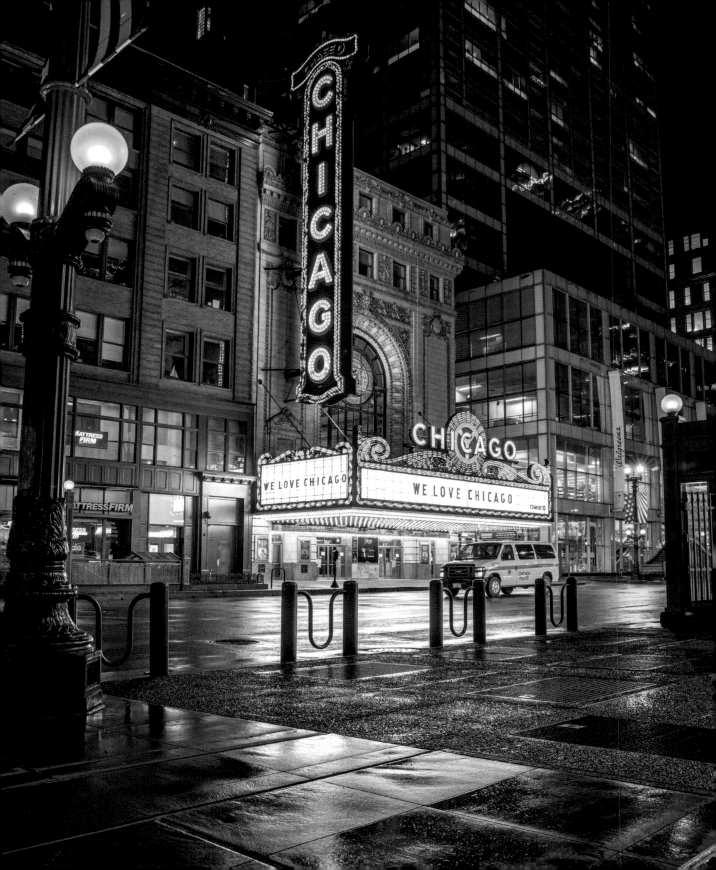

22. April 2020: Das Chicago Theatre,
1921 erbaut und eines der Wahrzeichen der
Stadt, sendet während der coronabedingten
Schließung aufmunternde Botschaften.

April 22, 2020: The Chicago Theatre, a city
landmark dating back to 1921, posts encourag-
ing messages during the coronavirus closure.

18. April 2020: The Lytle House Art
Initiative schafft in Chicago Kunst im
öffentlichen Raum. Das Wandbild im
Stadtteil Edgewater »installiert« Hoffnung.

April 18, 2020: The Lytle House Art
Initiative creates public-space art in
Chicago. The wall art in the Edgewater
neighborhood is "installing" hope.

25. März 2020: der Majdan mit dem Unabhängigkeits-
denkmal, das Zentrum Kiews nahe des Hotels Ukrajina.

*March 25, 2020: the Maidan with the independence
monument in downtown Kiev near the Ukraine Hotel.*

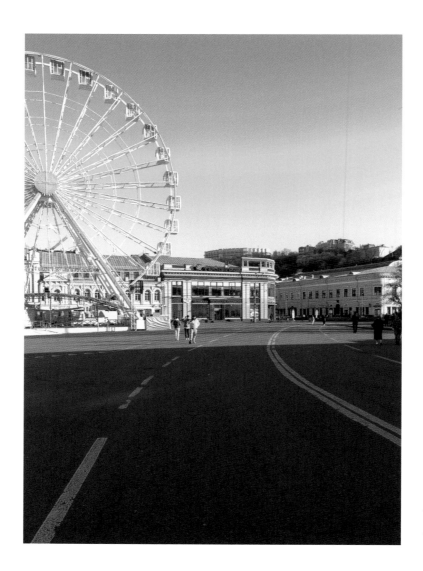

5. April 2020: Das beliebte Riesenrad auf
dem Kontraktowa-Platz in der ukrainischen
Hauptstadt Kiew.

*April 5, 2020: The beloved Ferris wheel
in Kontraktova Square in the Ukrainian
capital of Kiev.*

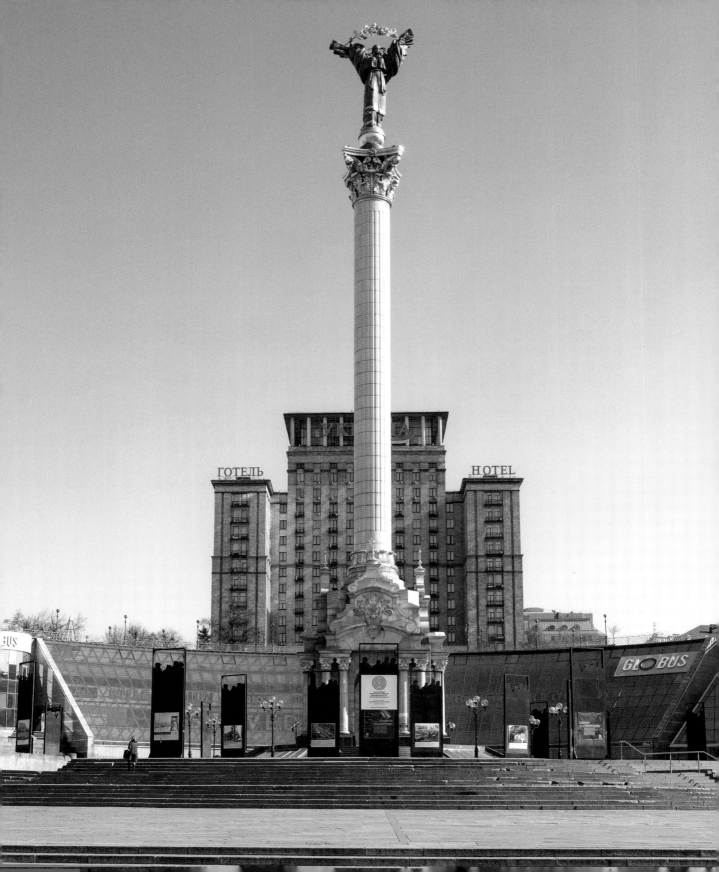

Allein der Respekt vor den Opfern des Corona-virus und der gewiss noch sehr viel zahlreicheren Betroffenen der bevorstehenden Wirtschaftskrise sollte uns verbieten, einfach auf dem schnellsten Weg zur Tagesordnung zurückkehren zu wollen. Um wie viel mehr aber müsste ökonomischer, politischer und gesellschaftlicher Sachverstand gebieten, die Gewohnheiten von gestern als untaugliches Businessmodell für die Zukunft zu betrachten.

Aus dem Essay *Normalität war gestern. Die Zukunft nach der Corona-Krise verdient Besseres* von Roman Bucheli (erschienen in der *Neuen Zürcher Zeitung*, 12. Mai 2020)
Roman Bucheli ist stellvertretender Feuilletonleiter der *NZZ*
2020 erhielt er als »Anerkennung seines literaturkritischen Schaffens« den Premio Masciadri.

From the essay Normalität war gestern. Die Zukunft nach der Corona-Krise verdient Besseres *[Normality was yesterday. The future after the corona crisis deserves better] by Roman* Bucheli (published in the Neue Zürcher Zeitung, *May 12, 2020) Roman Bucheli is the feuilleton section's Assistant Director of the NZZ. In 2020, he was awarded the Premio Masciadri "in recognition of his work in literary criticism."*

Simple respect for the victims of the coronavirus, and the much greater numbers of people who will certainly be affected by the upcoming economic crisis, should forbid us from merely wanting to get back to normal in the quickest possible way. Far preferable is that economic, political, and social expertise demand that we see yesterday's habits as an untenable business model for the future.

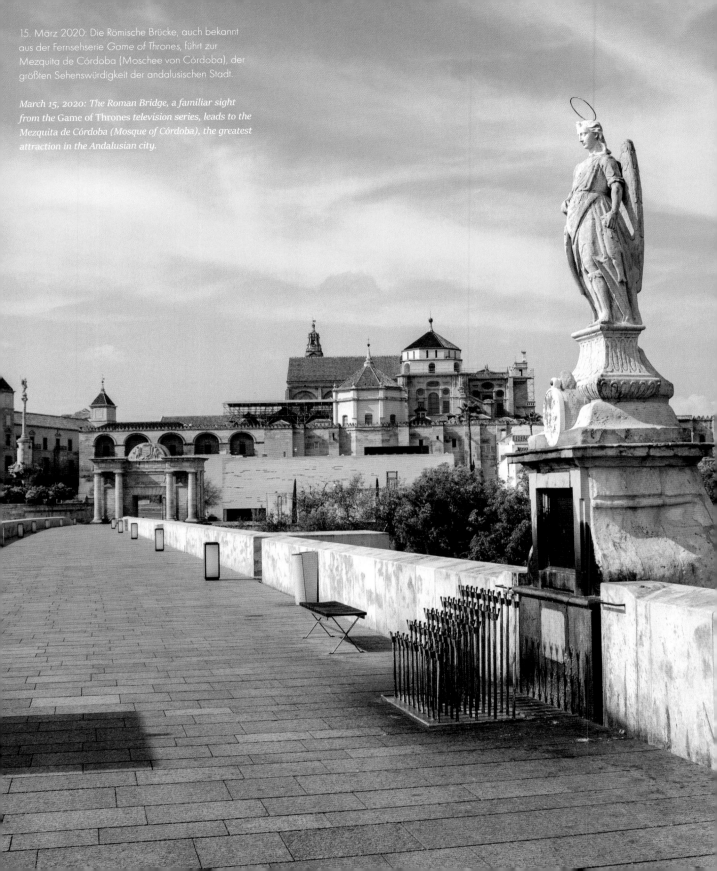

15. März 2020: Die Römische Brücke, auch bekannt
aus der Fernsehserie *Game of Thrones*, führt zur
Mezquita de Córdoba (Moschee von Córdoba), der
größten Sehenswürdigkeit der andalusischen Stadt.

*March 15, 2020: The Roman Bridge, a familiar sight
from the Game of Thrones television series, leads to the
Mezquita de Córdoba (Mosque of Córdoba), the greatest
attraction in the Andalusian city.*

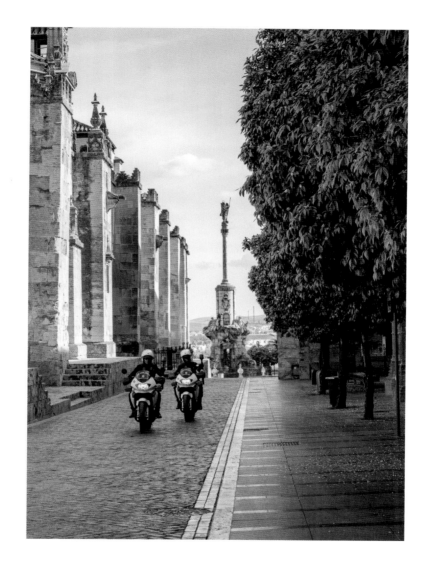

15. März 2020: Polizisten überwachen die Aus-
gehsperre an der Mezquita de Córdoba.

March 15, 2020: Policemen enforce the
stay-at-home order at the Mezquita de Córdoba.

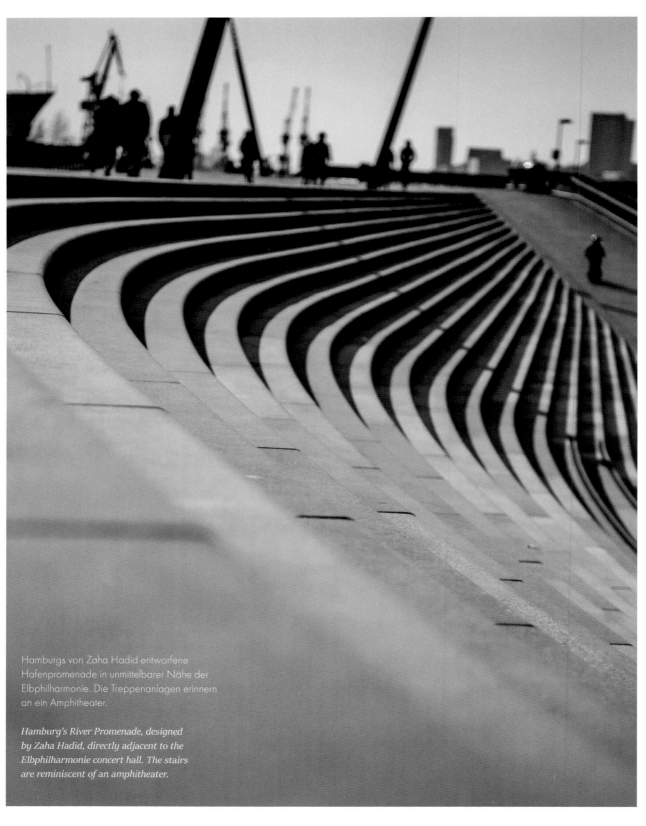

Hamburgs von Zaha Hadid entworfene Hafenpromenade in unmittelbarer Nähe der Elbphilharmonie. Die Treppenanlagen erinnern an ein Amphitheater.

Hamburg's River Promenade, designed by Zaha Hadid, directly adjacent to the Elbphilharmonie concert hall. The stairs are reminiscent of an amphitheater.

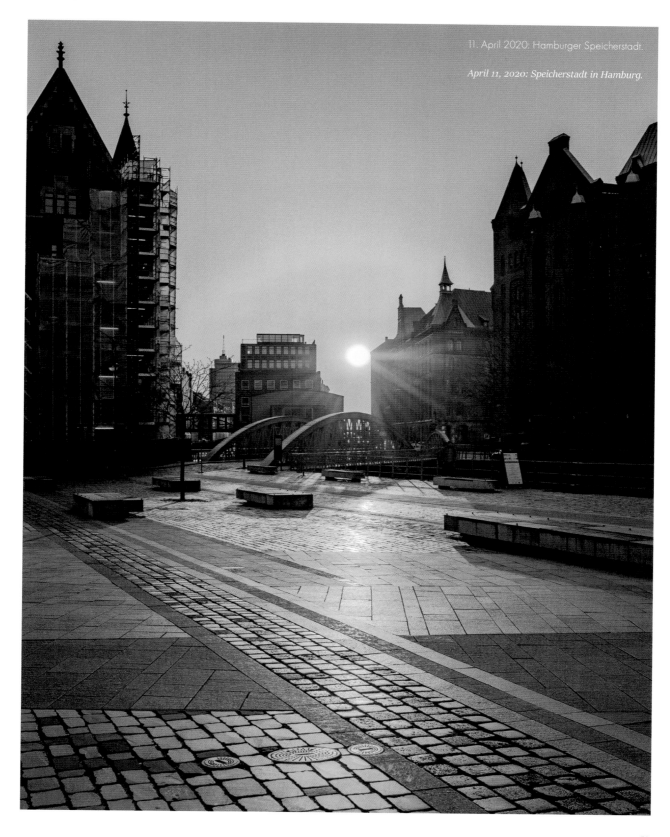

11. April 2020: Hamburger Speicherstadt.

April 11, 2020: Speicherstadt in Hamburg.

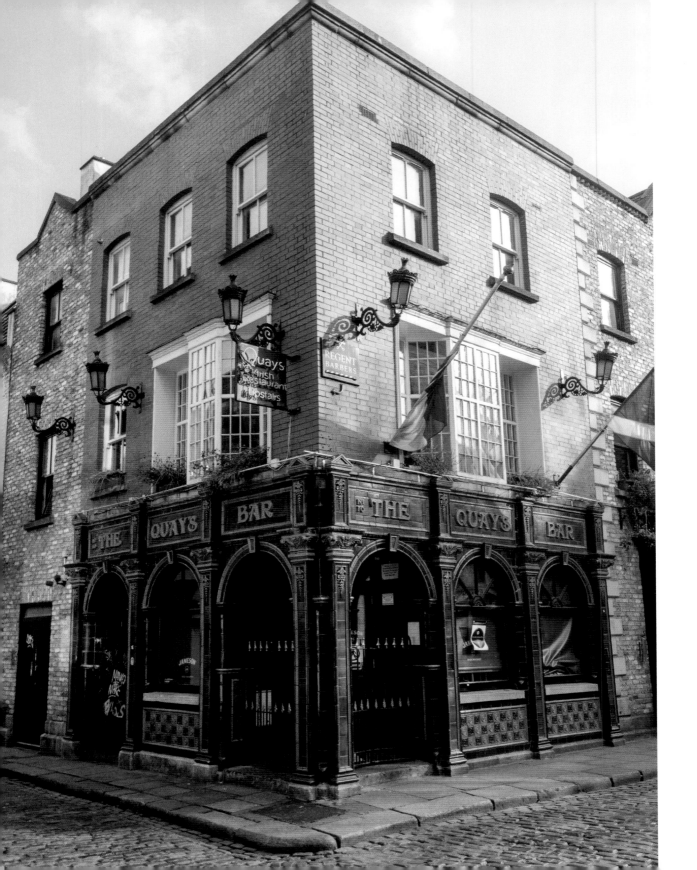

22. März 2020: The Quays Bar im Herzen
von Dublins Ausgehviertel Temple Bar.

March 22, 2020: The Quays Bar in the heart
of Dublin's nightlife district, Temple Bar.

10. August 2017: der übliche Betrieb
in Dublins Amüsierdistrikt.

August 10, 2017: A typical day in
Dublin's entertainment district.

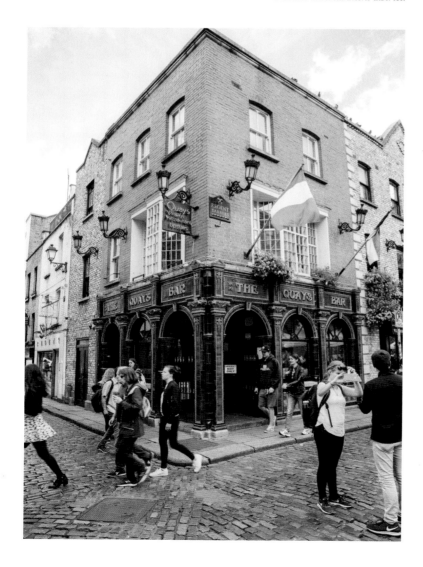

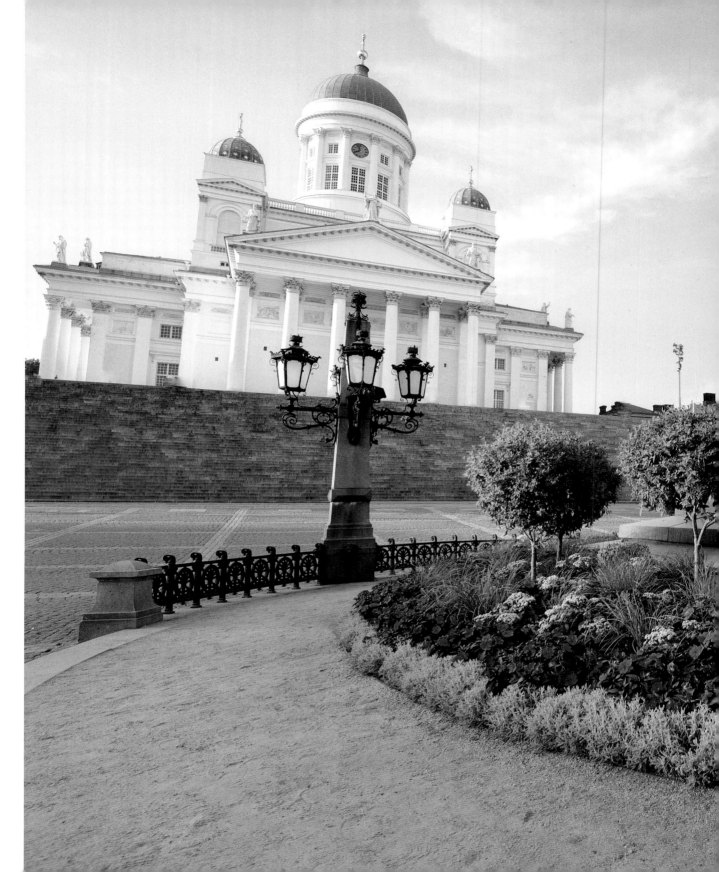

Senatsplatz mit dem Dom von Helsinki, dem Wahrzeichen der finnischen Hauptstadt.

Senate Square with the Helsinki Cathedral, the top landmark of Finland's capital city.

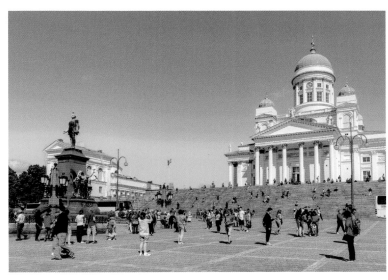

19. Juli 2016: Touristen und Neugierige am Denkmal für den russischen Zaren Alexander II.

July 19, 2016: Tourists and curious passersby at the memorial for Russian czar Alexander II.

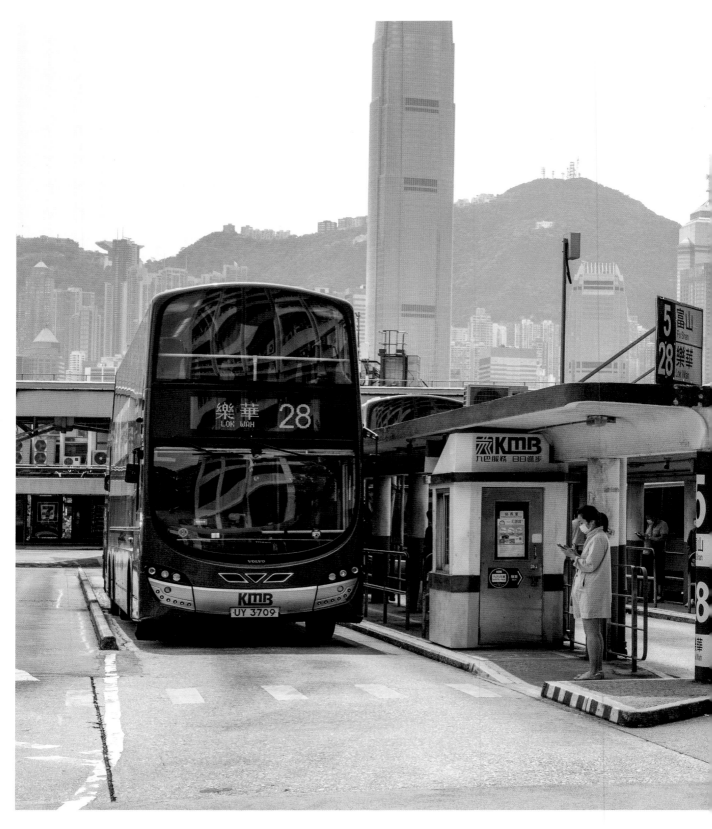

28. März 2020, Busbahnhof Tsim Sha Tsui: Hongkong setzt von Anbeginn auf zielgerichtete Maßnahmen und verzichtet auf den kompletten Shutdown. Dennoch zeigen sich die Folgen der Pandemie am Stadtbild.

March 28, 2020, Tsim Sha Tsui Bus Station: From the very beginning, Hong Kong implements targeted measures to avoid a complete shutdown. Still, the city streets show the effects of the pandemic.

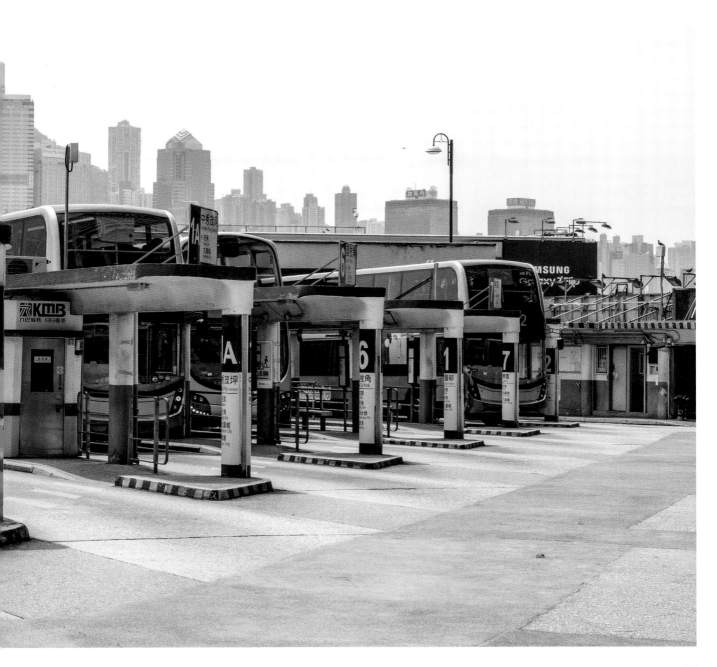

Seltenes Bild im Zentrum der Millionenmetropole Hongkong:
verwaister Fußgängerüberweg trotz Grünphase.

A rare picture in Hong Kong, a metropolis of millions:
an empty crosswalk despite the walk sign.

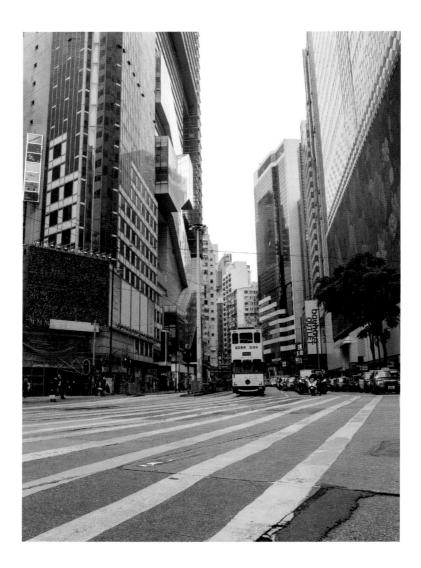

1. April 2020: Hongkongs Causeway Bay ist bekannt
für die zahlreichen Einkaufszentren. Sie bleiben geöffnet,
die Kunden jedoch zurückhaltend.

April 1, 2020: Hong Kong's Causeway Bay is known
for its many malls. They remain open, but customers
are reluctant to visit.

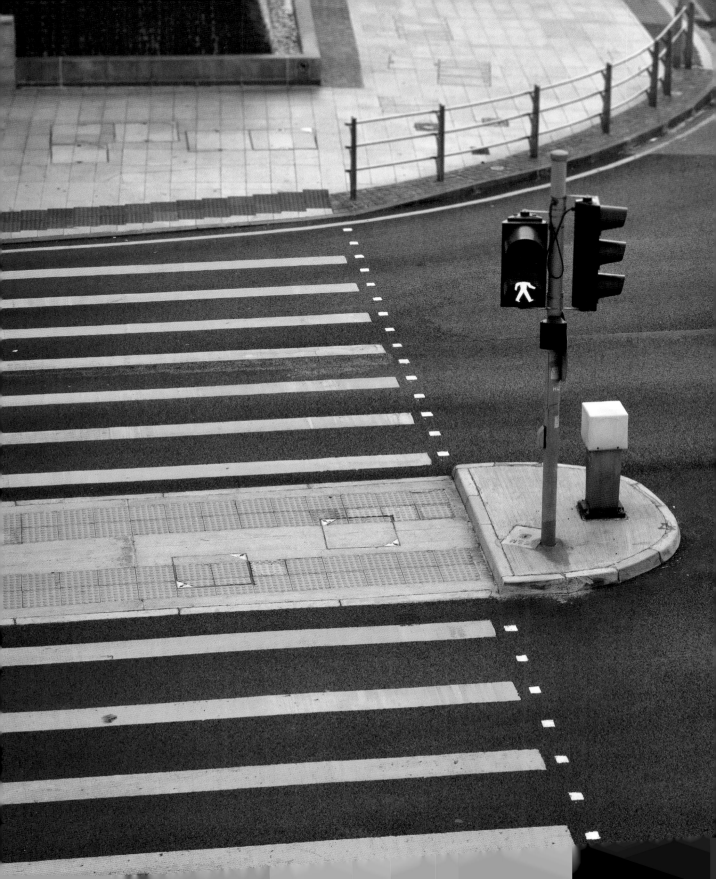

9. April 2020: Die Straße Serdar-I Ekrem
führt zum Galataturm und einer der
schönsten Aussichten auf Istanbul.

*April 9, 2020: The street Serdar-I Ekrem
leads to the Galata Tower and one of the
most beautiful views of Istanbul.*

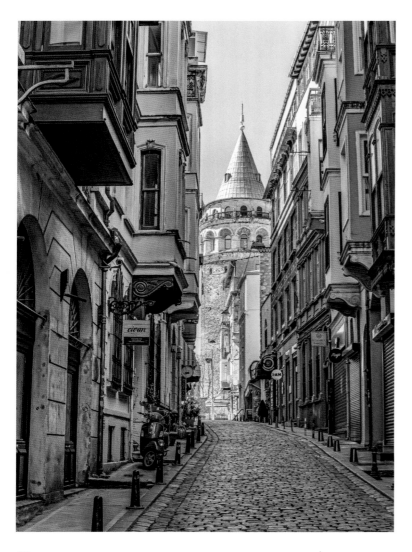

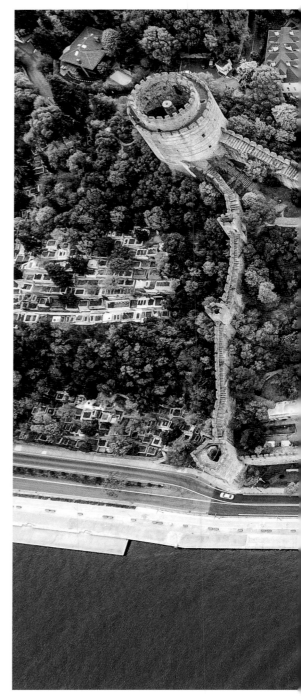

3. Mai 2020: Die Festung Rumeli Hisarı im Istanbuler Stadtteil Sarıyer ist heute Museum und Veranstaltungsort für Konzerte und Kunst-Events.

May 3, 2020: Today, the fortress Rumeli Hisarı in the Sarıyer district of Istanbul is a museum and venue for concerts and art events.

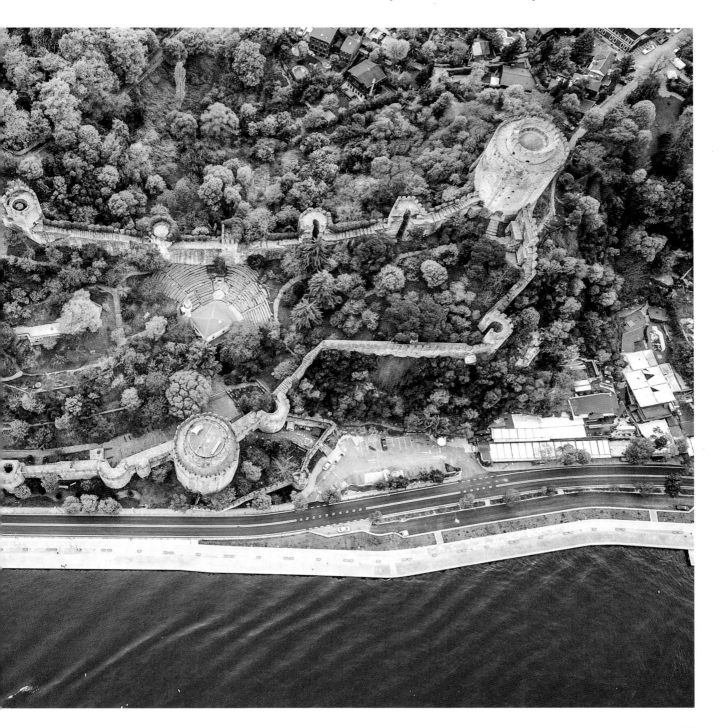

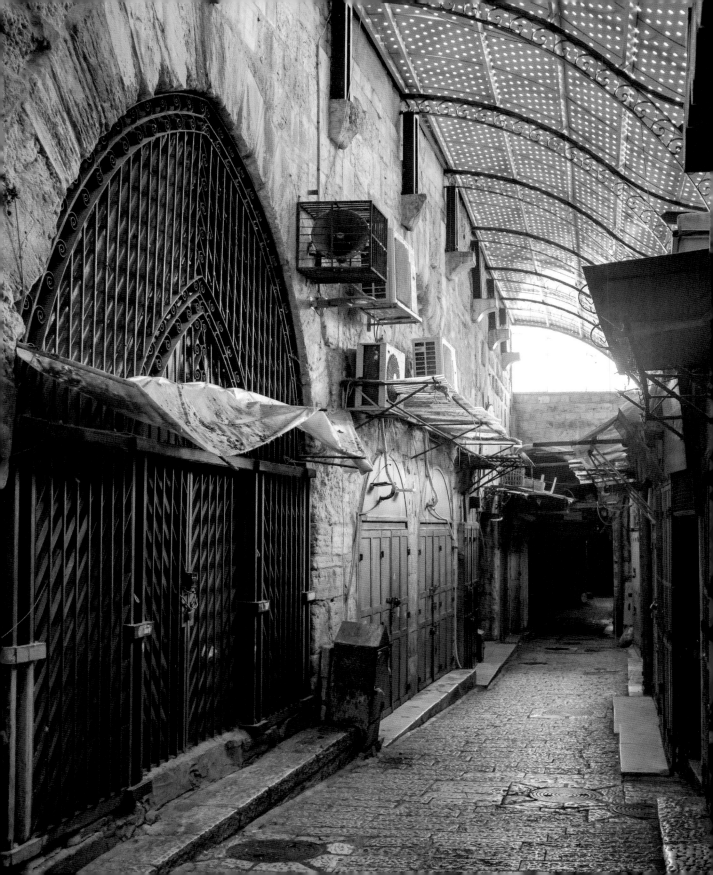

Die engen Gassen in der Altstadt von Jerusalem
sind bekannt für ihr geschäftiges Treiben.
Zu Ostern 2020 wirken sie wie leergefegt.

The narrow streets in Jerusalem's Old City are
known for hustle and bustle. On Easter 2020,
they look utterly deserted.

Der Hayarkon-Park ist Tel Avivs grüne Lunge – der
Bootsverleih muss wochenlang die Luken schließen.

Park HaYarkon is Tel Aviv's green oasis—but boat
rentals had to be suspended for weeks.

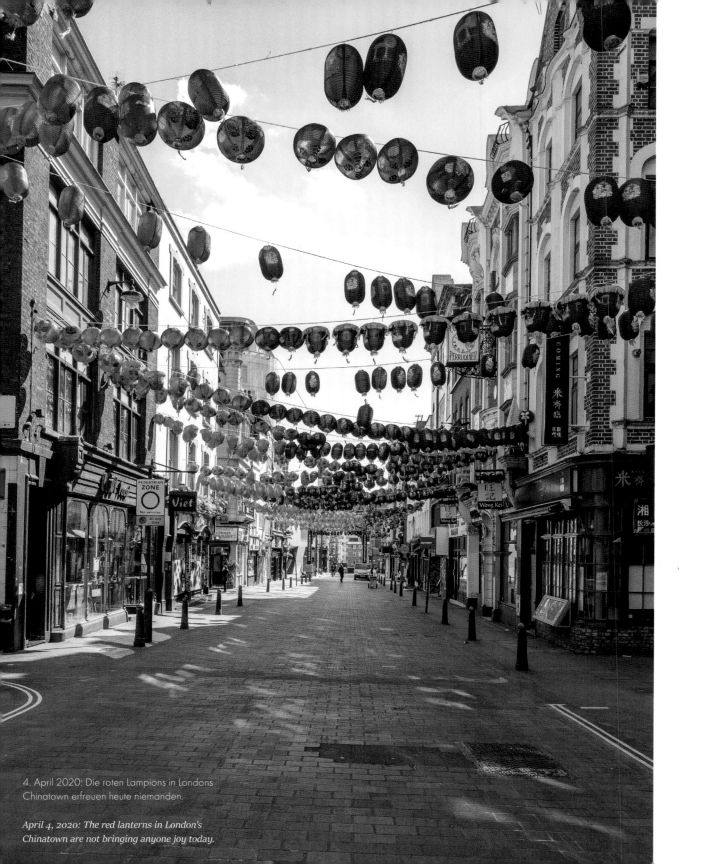

4. April 2020: Die roten Lampions in Londons
Chinatown erfreuen heute niemanden.

*April 4, 2020: The red lanterns in London's
Chinatown are not bringing anyone joy today.*

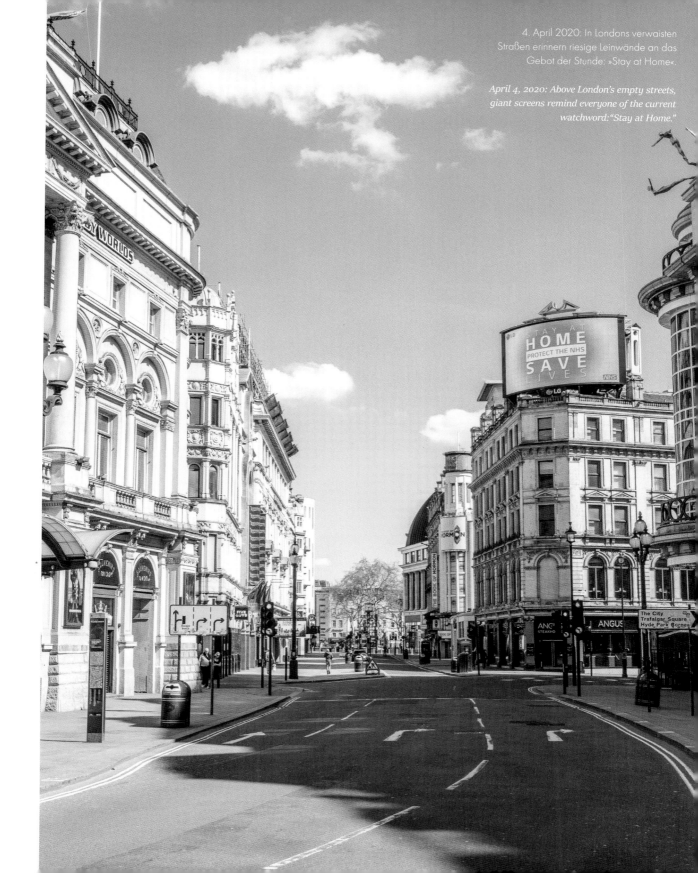

4. April 2020: In Londons verwaisten Straßen erinnern riesige Leinwände an das Gebot der Stunde: »Stay at Home«.

April 4, 2020: Above London's empty streets, giant screens remind everyone of the current watchword: "Stay at Home."

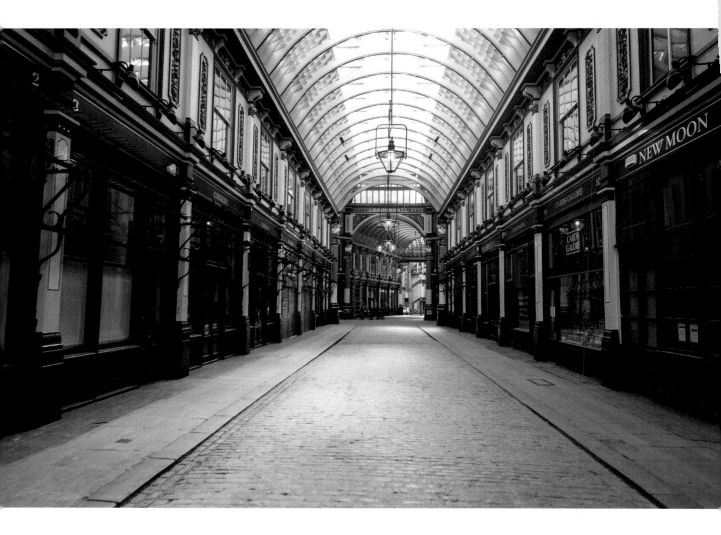

7. Mai 2020: Leadenhall Market im historischen
Zentrum des Financial District von London.

*May 7, 2020: Leadenhall Market in the historic
center of London's Financial District.*

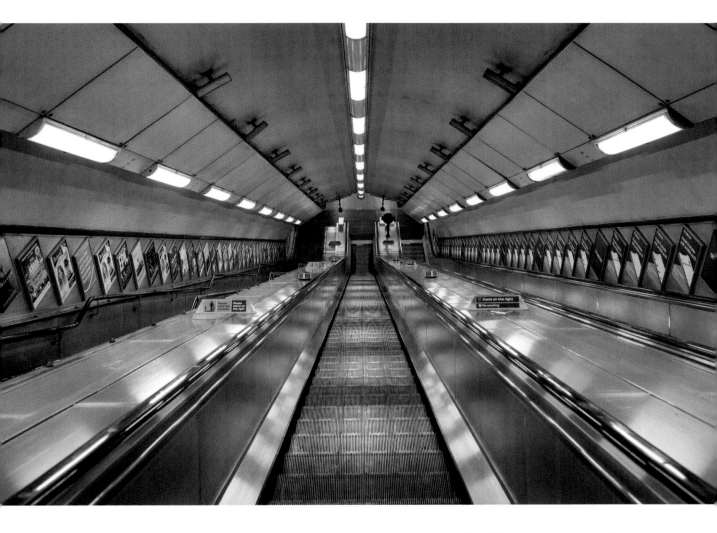

4. Mai 2020: In London kommt der öffentliche
Nahverkehr quasi zum Erliegen.

*May 4, 2020: In London, public transport
basically grinds to a halt.*

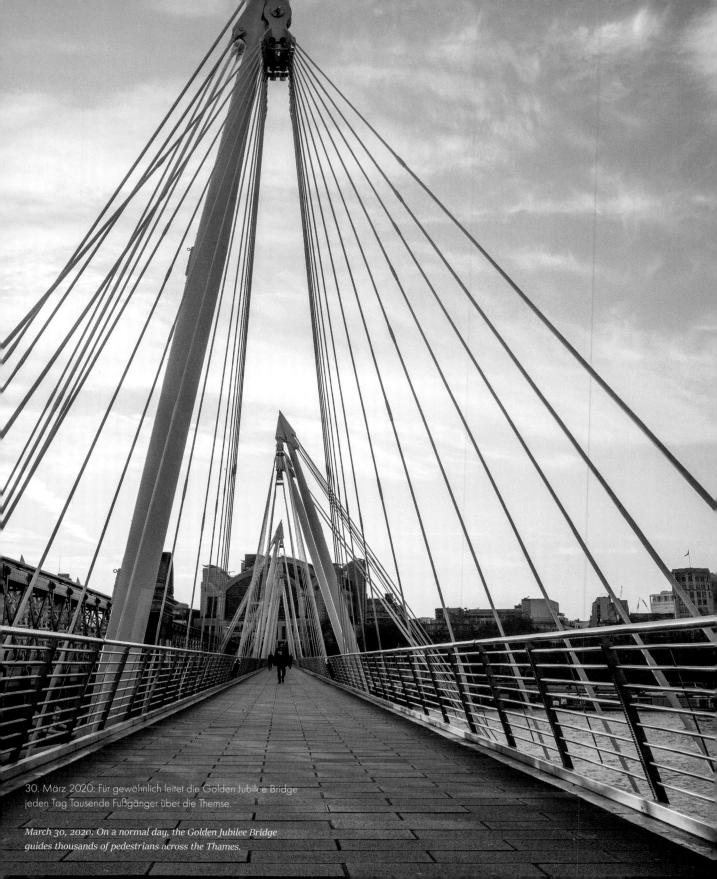

30. März 2020: Für gewöhnlich leitet die Golden Jubilee Bridge
jeden Tag Tausende Fußgänger über die Themse.

*March 30, 2020: On a normal day, the Golden Jubilee Bridge
guides thousands of pedestrians across the Thames.*

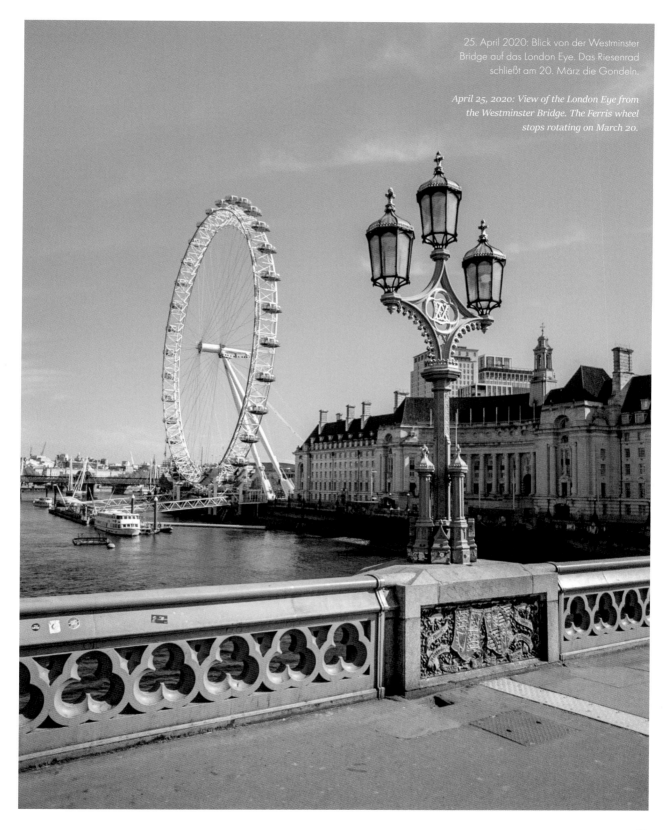

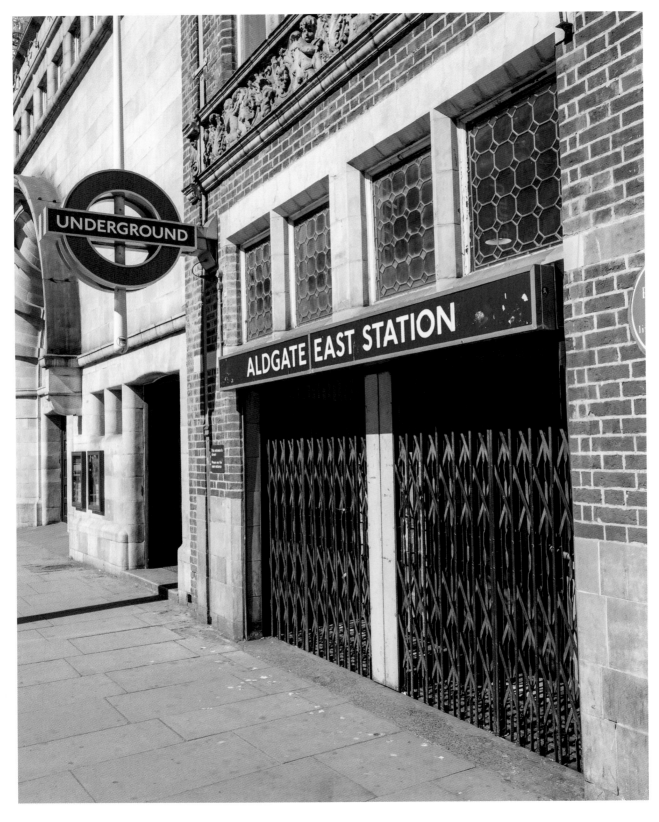

20. April 2020: Dutzende U-Bahn-Stationen sind geschlossen, die Londoner sind gehalten, nur noch unvermeidbare Fahrten zu unternehmen.

April 20, 2020: Dozens of subway stations are closed as Londoners are urged to avoid all non-essential travel.

22. März 2020: Briten tragen's mit Humor – Schild an der Tür eines Geschenkartikelladens in Camden Town, London.

March 22, 2020: The British carry on with humor—sign on the door of a gift shop in Camden Town, London.

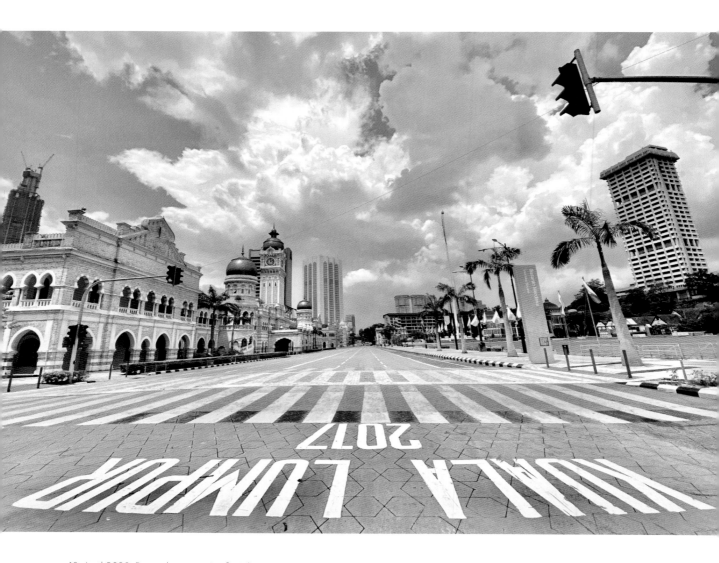

18. April 2020: Die sechsspurige Straße Jalan
Raja am Sultan-Abdul-Samad-Gebäude (links)
in Kuala Lumpur.

April 18, 2020: The six-lane road Jalan Raja
at the Sultan Abdul Samad Building (left) in
Kuala Lumpur.

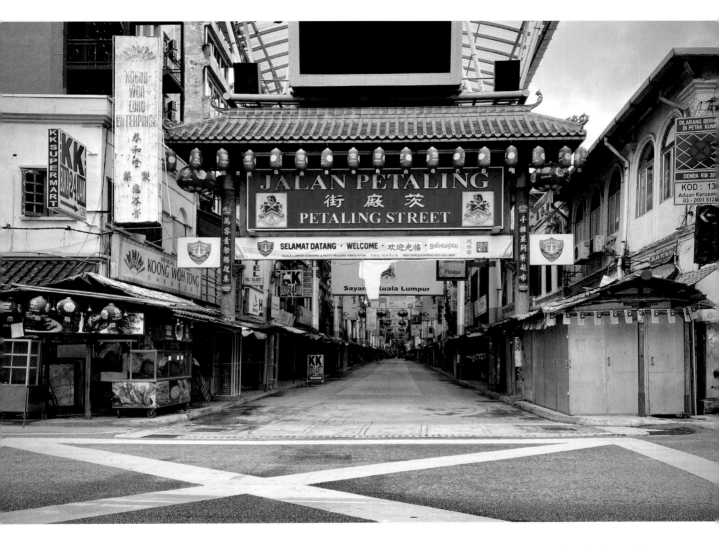

16. April 2020: Die Petaling Street markiert das chinesische
Viertel von Kuala Lumpur, wegen des Nachtmarkts eine der
großen Touristenattraktionen der Metropole.

*April 16, 2020: Petaling Street marks the Chinatown of
Kuala Lumpur, whose night market is one of the city's
biggest tourist attractions.*

26. März 2020: die Avenida da Liberdade ist der knapp einen Kilometer lange, viel befahrene Boulevard im Herzen Lissabons.

March 26, 2020: The Avenida da Liberdade is a heavily traveled boulevard, about a kilometer long, in the heart of Lisbon.

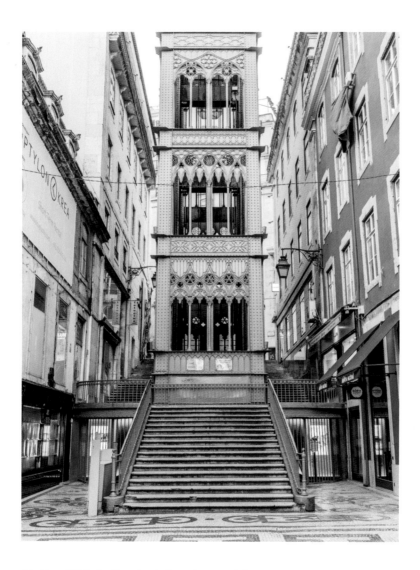

26. März 2020: der Elevador de Santa Justa, ein Aufzug, der in Lissabon den Stadtteil Baixa mit dem höher gelegenen Viertel Chiado verbindet.

March 26, 2020: The Elevador de Santa Justa, an elevator that connects the Baixa neighborhood of Lisbon with the Chiado district at a higher elevation.

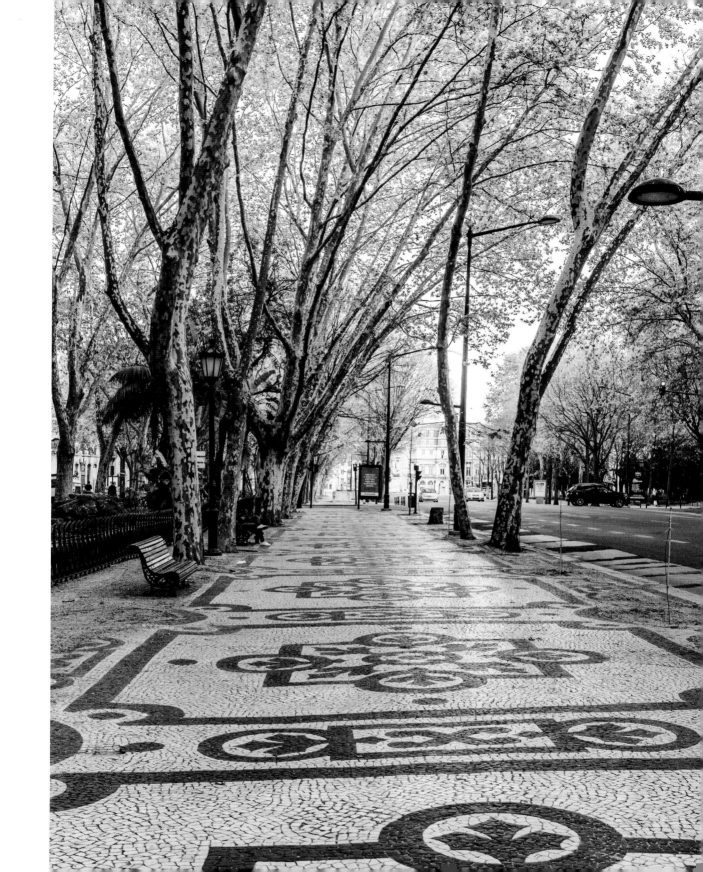

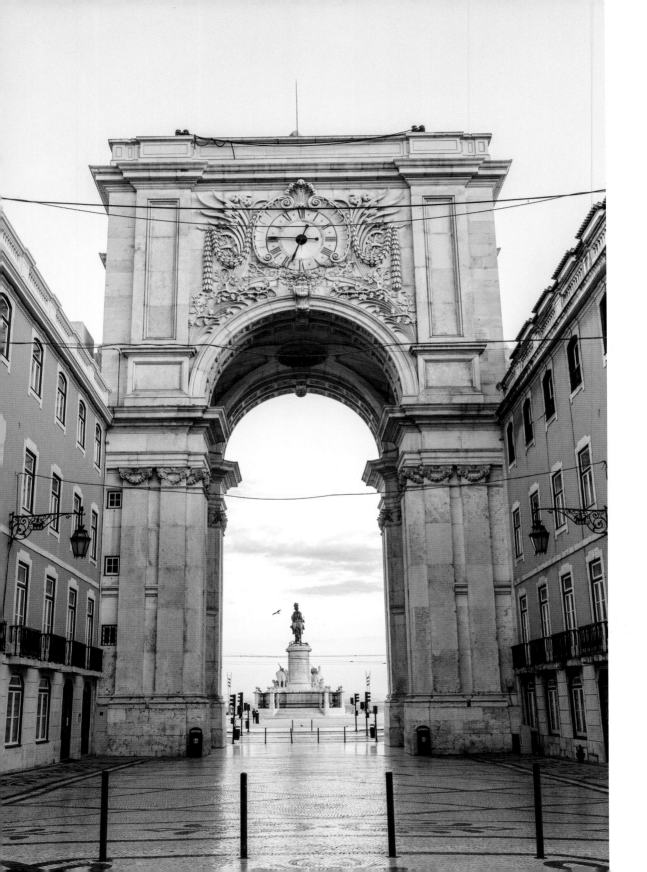

26. März 2020: der Triumphbogen Arco da Rua Augusta mit dem
Reiterdenkmal für König José I. in der portugiesischen Hauptstadt.

March 26, 2020: The arch Arco da Rua Augusta and a monument
of a mounted King José I. in the capital city of Portugal.

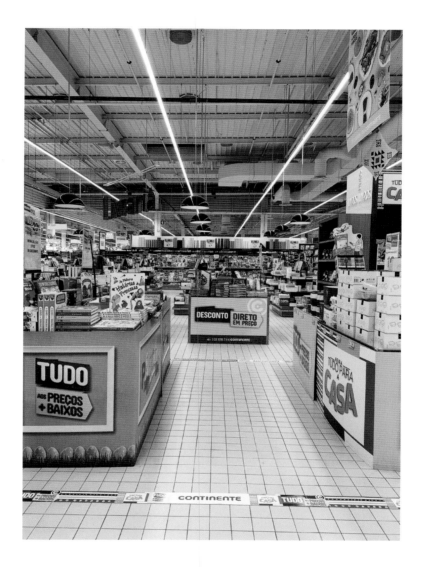

21. März 2020: Die Lissabonner Supermärkte lassen nur
noch 25 Personen auf einmal ins Geschäft – um Chaos
durch Hamsterkäufe zu verhindern.

March 21, 2020: Lisbon's supermarkets only allow 25 people
in at a time to avoid chaos from people hoarding.

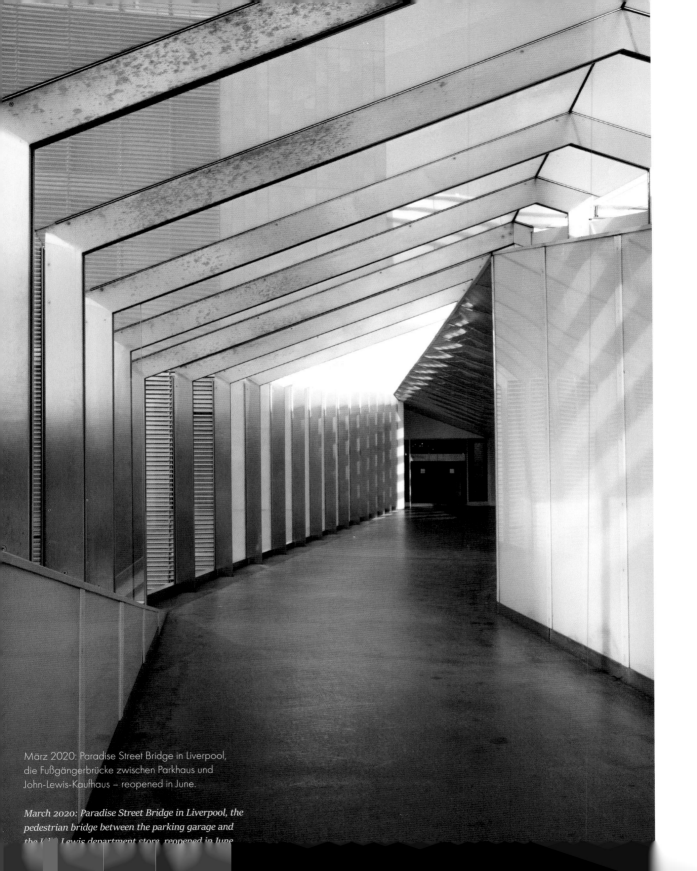

März 2020: Paradise Street Bridge in Liverpool,
die Fußgängerbrücke zwischen Parkhaus und
John-Lewis-Kaufhaus – reopened in June.

*March 2020: Paradise Street Bridge in Liverpool, the
pedestrian bridge between the parking garage and
the John-Lewis department store, reopened in June.*

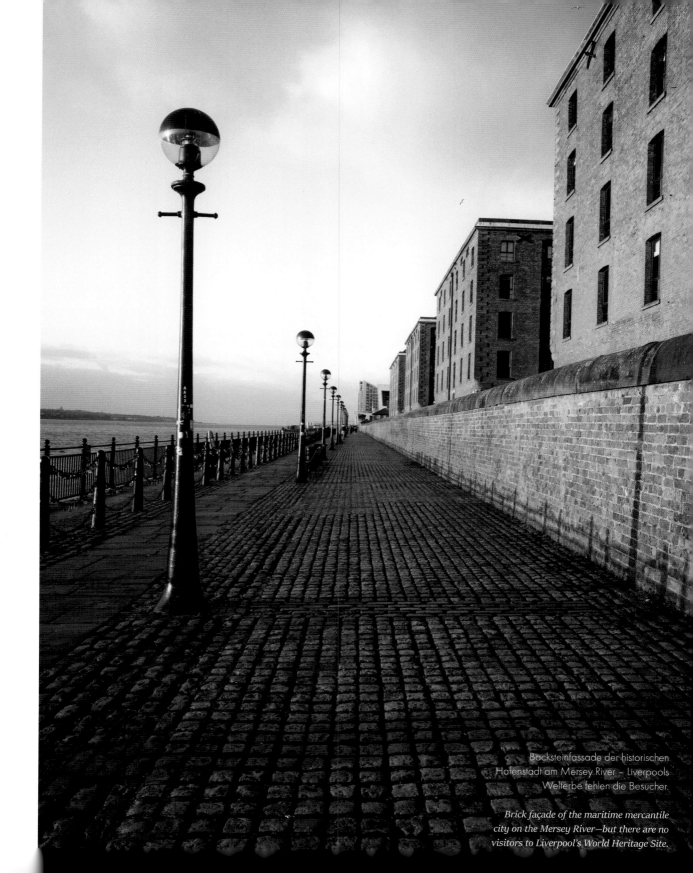

Backsteinfassade der historischen
Hafenstadt am Mersey River – Liverpools
Welterbe fehlen die Besucher.

*Brick façade of the maritime mercantile
city on the Mersey River—but there are no
visitors to Liverpool's World Heritage Site.*

Madrid im April 2020: Lockdown heißt auch,
die Spielplätze abzusperren.

*Madrid in April 2020: Lockdown means
closing down playgrounds as well.*

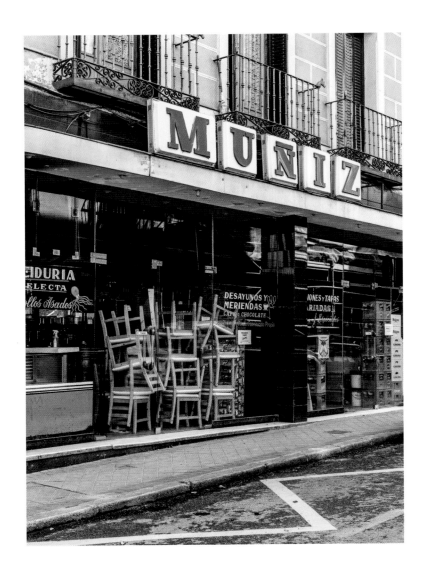

18. April 2020: Die Tapas-Bar Muñiz im Centro
von Madrid steht seit 1942 allen offen. Ihre Stuhl-
Barrikade ist Kunst der gastronomischen Art.

*April 18, 2020: The Muñiz tapas bar in the center
of Madrid has been open to everyone since 1942.
Its chair barricade is art of the gastronomic kind.*

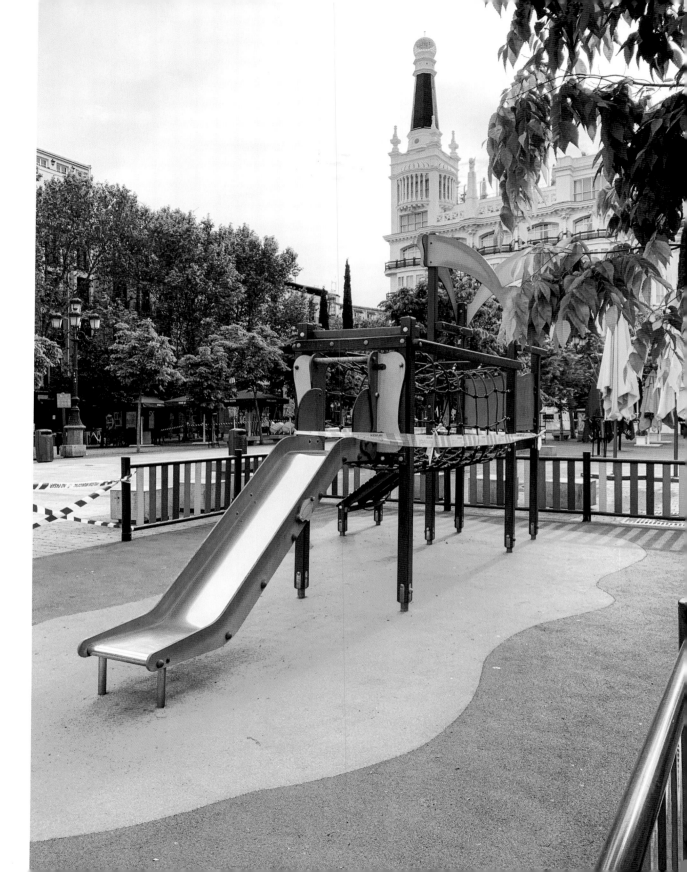

4. April 2020, Los Angeles Downtown:
The American way of ... Schutzmaske.

April 4, 2020, downtown Los Angeles:
The American way of ... masking.

Ausnahmsweise liegestuhlfrei: der Strand von Hollywood in
Florida, USA, zwischen Fort Lauderdale und Miami.

*A rare moment without beach chairs: the beach in Hollywood,
Florida, between Fort Lauderdale and Miami.*

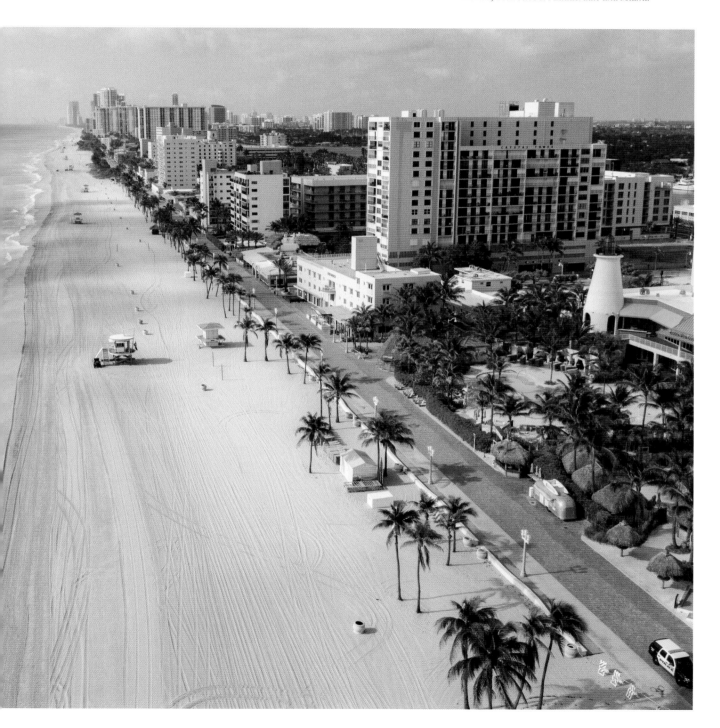

Mallorcas Landwirtschaft
boomt: Während der Coronakrise entdecken die Insulaner die Vorzüge einheimischen Obst und Gemüses. Die wegen des Reiseverbots fehlenden Saisonarbeiter aus Kolumbien ersetzen arbeitslose Reiseführer, Kellner und Hotelangestellte.

Mallorca's agriculture *booms: during the coronavirus crisis, the island's inhabitants discover the advantages of local fruits and vegetables. The seasonal farm workers from Colombia, who are absent due to travel bans, are replaced by unemployed tour guides, waiters, and hotel workers.*

Geister-Kulisse: Das Fußball-Bundesligaspiel zwischen Borussia Mönchengladbach und Bayer Leverkusen findet im Mai 2020 ohne Zuschauer statt – aber vor 12 993 Fans. Das Gladbacher Fanprojekt hatte eine Aktion initiiert, in der bestellte Pappkameraden die Ränge füllen. Die Attrappen werden wunschgemäß bedruckt – mit dem Porträt des Anhängers oder einer Vereinslegende. So „beobachtet" auch der längst verstorbene Meistertrainer Hennes Weisweiler das Match – und gibt dem **»Geisterspiel«** eine doppelte Bedeutung.

Ghost game: The Bundesliga soccer game between Borussia Mönchengladbach and Bayer Leverkusen is played in May 2020 without spectators—but in front of 12,993 fans. A Gladbach fan project allowed people to sponsor cardboard cutouts to be placed in the stands. The cutouts were printed to order with the fan's own likeness or that of a team legend. This allowed the long-dead coach Hennes Weisweiler to "watch" the game—giving the **"ghost game"** *a whole new meaning.*

Arme Öl-Dynastie: Saudi-Arabien muss seine **Ölförderung** auf den niedrigsten Stand seit 18 Jahren senken. Das Haushaltsdefizit könnte deshalb in 2020 auf 112 Milliarden US-Dollar steigen. Deswegen wird im Juli die fünfprozentige Mehrwertsteuer – erst 2018 eingeführt – verdreifacht.

Poor oil dynasty: Saudi Arabia has to reduce its **oil production** *to the lowest level in 18 years. This could cause the country's budget deficit to increase to USD 112 billion in 2020. As a result, Saudi Arabia's five-percent VAT, only recently introduced in 2018, is tripled in July.*

Globalisierte Kettenreaktion: Der Autokonzern **Hyundai** muss Anfang Februar teilweise die Produktion stoppen, obwohl das Virus noch keine dramatischen Auswirkungen im Land hat. Der Grund: Pandemiebedingt brechen die Importe aus China ein – damit fehlen Zulieferprodukte für die Fertigung.

Global chain reaction: Automaker **Hyundai** *has to shut down some production lines in February despite the negligible impact of the virus on South Korea at that point. Why? The pandemic caused a breakdown in imports from China, meaning supplier parts for production are not available.*

Massenarbeitslosigkeit in den USA:
Die Arbeitslosenquote in den USA steigt von 3,5% im Februar auf 14,7% im April. Mehr als 41 Millionen Menschen verlieren ihren Job.

Mass unemployment in the USA:
The unemployment rate in the USA skyrockets from 3.5% in February to 14.7% in April. More than 41 million people lose their jobs.

Gute Luft 1: Die **Luftverschmutzung** geht in den ersten beiden Wochen des Lockdowns um etwa 20% im Vergleich zum Vorjahr zurück – das ergibt eine Studie des Norwegischen Instituts für Naturforschung. Grundlage sind Werte aus rund 10 000 Mess-Stationen in 29 Ländern.

Fresh Air 1: In the first two weeks of lockdown, **air pollution** *drops 20% compared to 2019, according to a study by the Norwegian Institute for Nature Research. Data from about 10,000 measuring stations in 29 countries support the claim.*

Gute Luft 2: Das Max-Planck-Institut für Chemie schätzt, dass durch die verringerte **Feinstaubbelastung** allein in China und Indien 1 400 bzw. 5300 vorzeitige Todesfälle vermieden wurden.

Fresh Air 2: The Max Planck Institute for Chemistry estimates that lower **particulate levels** *will prevent 1,400 premature deaths in China and 5,300 premature deaths in India.*

Frühjahr 2020: die Piazza del Duomo –
ein Tag im Ausnahmezustand.

*Spring 2020: the Piazza del Duomo—
a day in a state of emergency.*

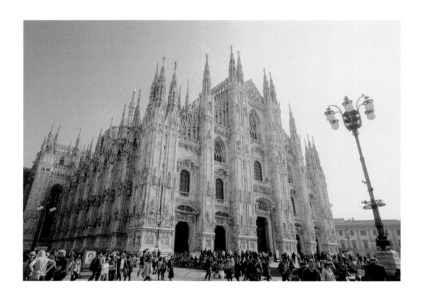

13. Oktober 2018: ein Tag wie jeder andere – der Mailänder
Dom, umgeben von interessierten Besuchergruppen.

*October 13, 2018: A day like any other—the Milan Cathedral,
surrounded by interested groups of visitors.*

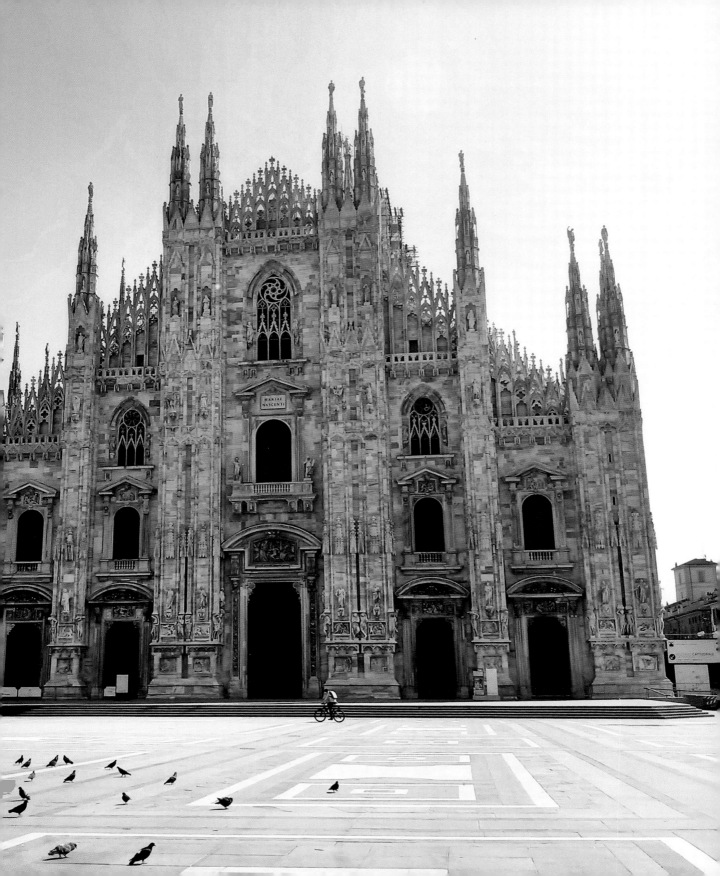

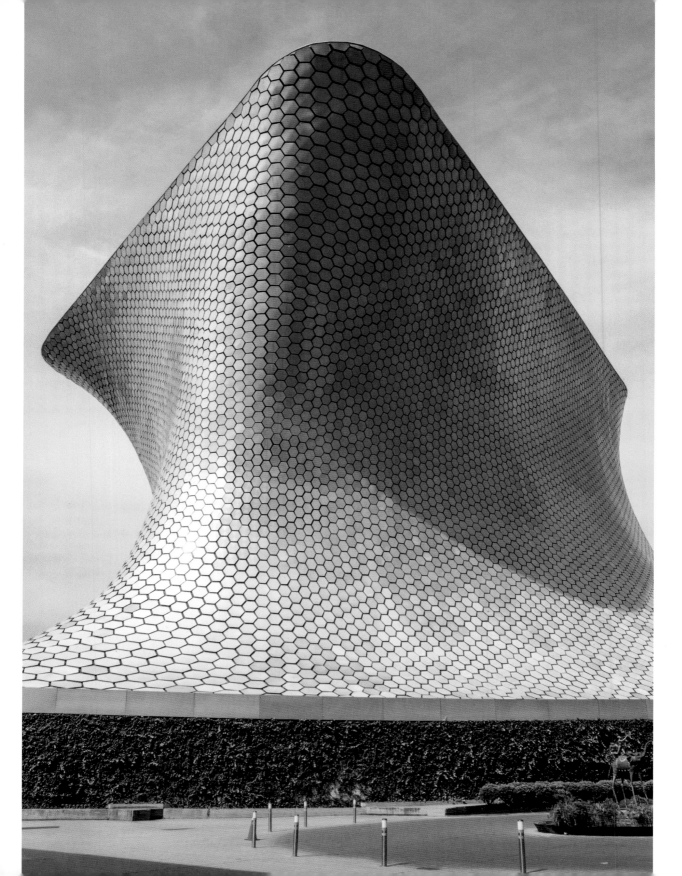

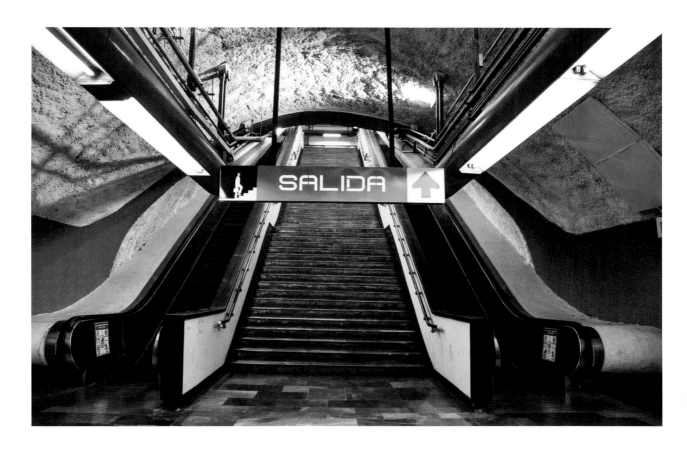

26. April 2020: verlassene U-Bahnstation in Mexiko-Stadt. Normalerweise transportiert die Metro täglich 4,4 Millionen Menschen.

April 26, 2020: Deserted subway station in Mexico City. Normally, the Metro system transports 4.4 million people a day.

24. April 2020: Das Museo Soumaya in Mexiko-Stadt zählte noch 2019 zu den 70 meistbesuchten Kunstmuseen der Welt.

April 24, 2020: The Soumaya Museum in Mexico City was still one of the 70 most-visited museums in the world in 2019.

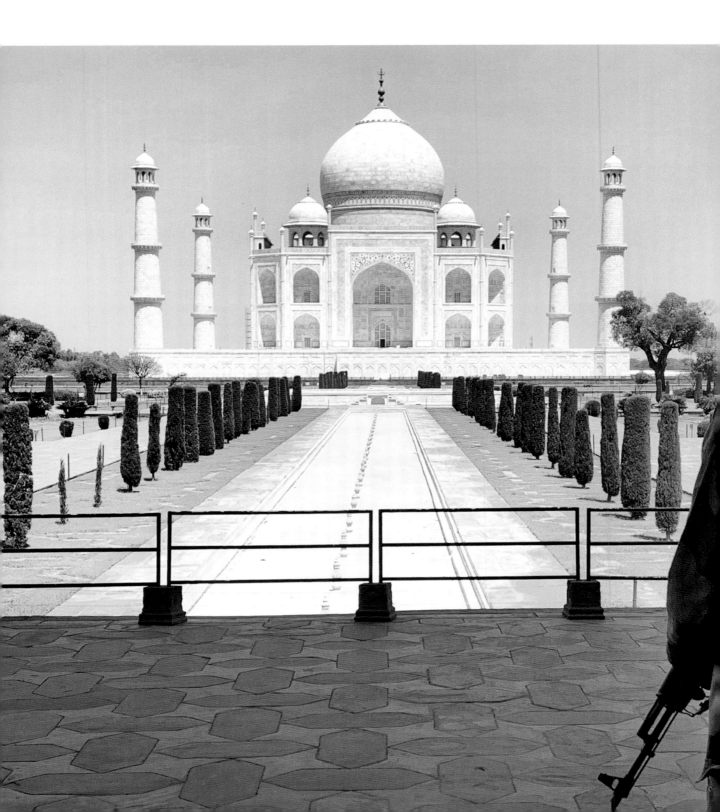

Auch UNESCO-Welterbestätten wie das Taj Mahal in Agra, Indien, werden im März 2020 für den Publikumsverkehr gesperrt.

Even UNESCO World Heritage Sites like the Taj Mahal in Agra, India, are closed to the public in March 2020.

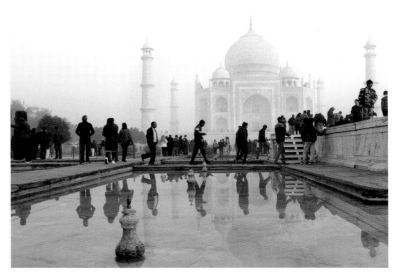

Zuvor besuchten täglich mehrere Zehntausend Menschen das im 17. Jahrhundert errichtete Mausoleum.

Normally, visitors to the mausoleum, built in the 17^{th} century, number in the tens of thousands per day.

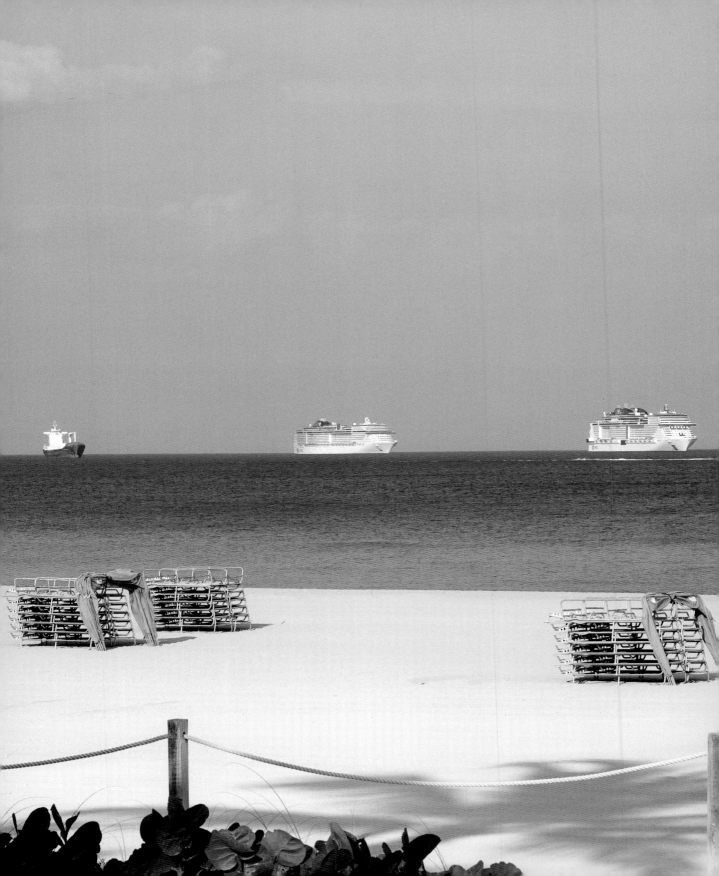

11. April 2020: Lincoln Road,
die Fußgängerzone von Miami Beach.

April 11, 2020: Lincoln Road,
the pedestrian zone of Miami Beach.

9. April 2020: Vor Miami Beach ankern Kreuzfahrt-
schiffe amerikanischer Reedereien. Die USA verweigern
die Aufnahme, da sie unter fremden Flaggen fahren.
Nur noch die Crewmitglieder sind an Bord.

April 9, 2020: Cruise ships from American cruise lines
anchored offshore near Miami Beach. The USA refuses to
admit them because they are flying under foreign flags.
Only the crewmembers are still on board.

26. April 2020: Manila, Hauptstadt der
Philippinen, auf dem Höhepunkt
der Pandemie.

*April 26, 2020: Manila, capital city of the
Philippines, at the height of the pandemic.*

17. Oktober 2019: Alltag in Makati, einer Großstadt auf den
Philippinen in der Hauptstadtregion Metro Manila.

*October 17, 2019: A typical day in Makati, a large city
in the Philippines in the Metro Manila capital region.*

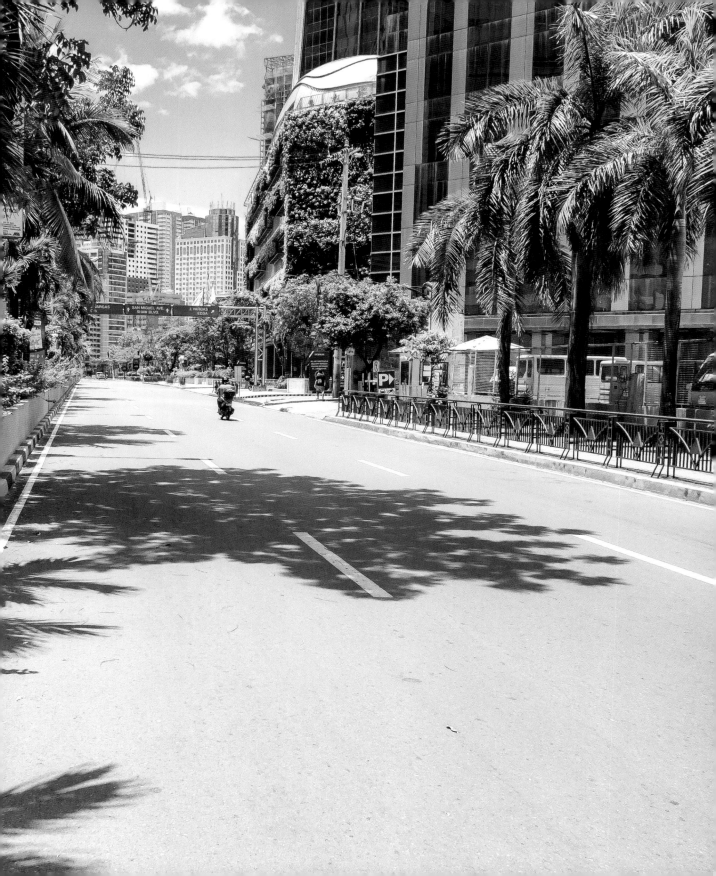

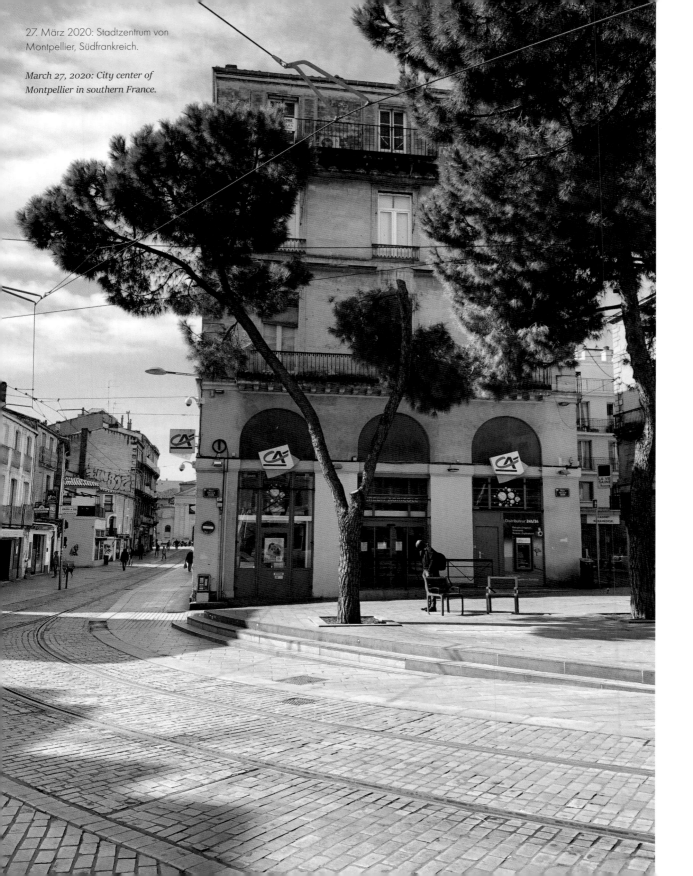

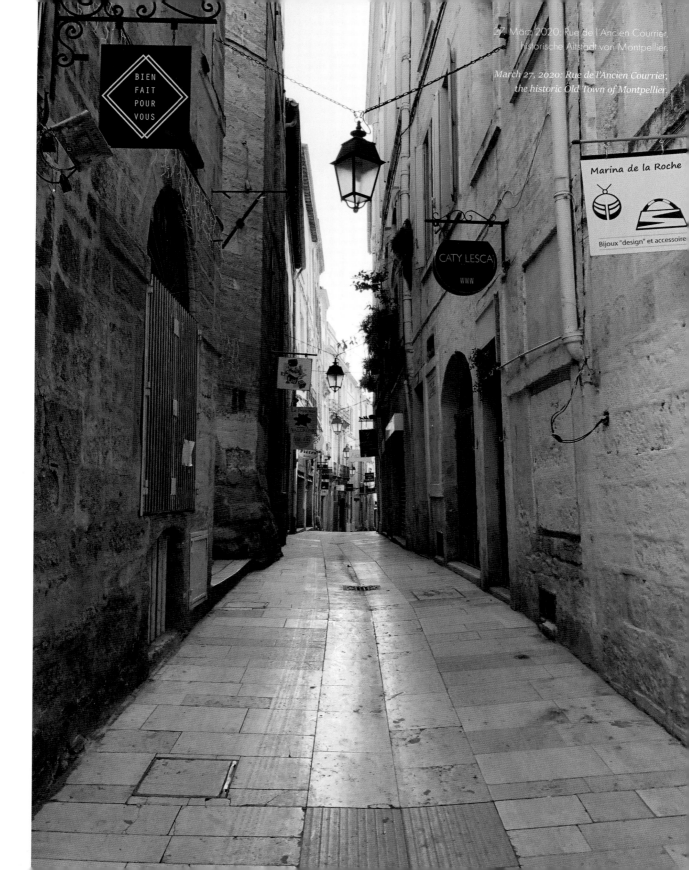

27. März 2020: Rue de l'Ancien Courrier,
historische Altstadt von Montpellier.

March 27, 2020: Rue de l'Ancien Courrier,
the historic Old Town of Montpellier.

BIEN
FAIT
POUR
VOUS

CATY LESCA
WWW

Marina de la Roche

Bijoux "design" et accessoire

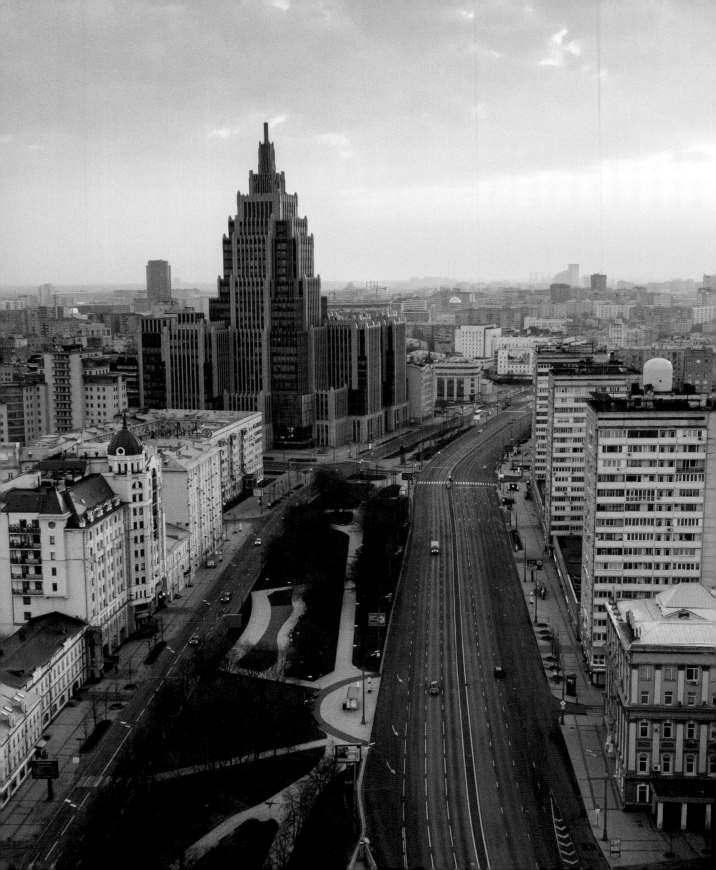

April 2020: Moskau, Tverskoy-Distrikt mit dem
165 m hohen Oruzheiny-Komplex.

*April 2020: Moscow, Tverskoy District
with the 165-meter-tall Oruzheiny office
and retail complex.*

26. April 2020: überschaubare Verkehrslage vor dem
helixförmigen Evolution Tower im Moskauer Finanzdistrikt.

*April 26, 2020: Not much traffic in front of the
helix-shaped Evolution Tower in Moscow's financial district.*

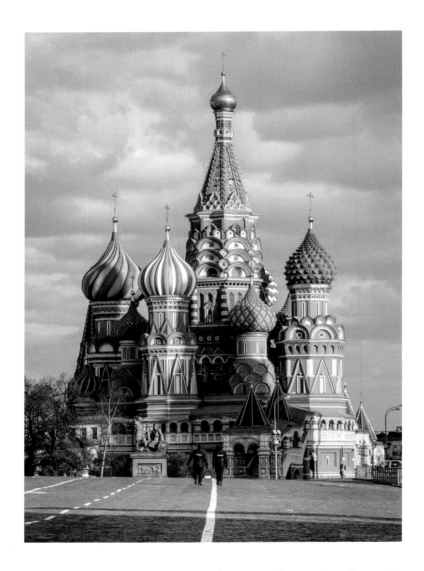

Polizisten patrouillieren am Roten Platz vor der
Basilius-Kathedrale.

*Policemen patrol Red Square in front of
St. Basil's Cathedral.*

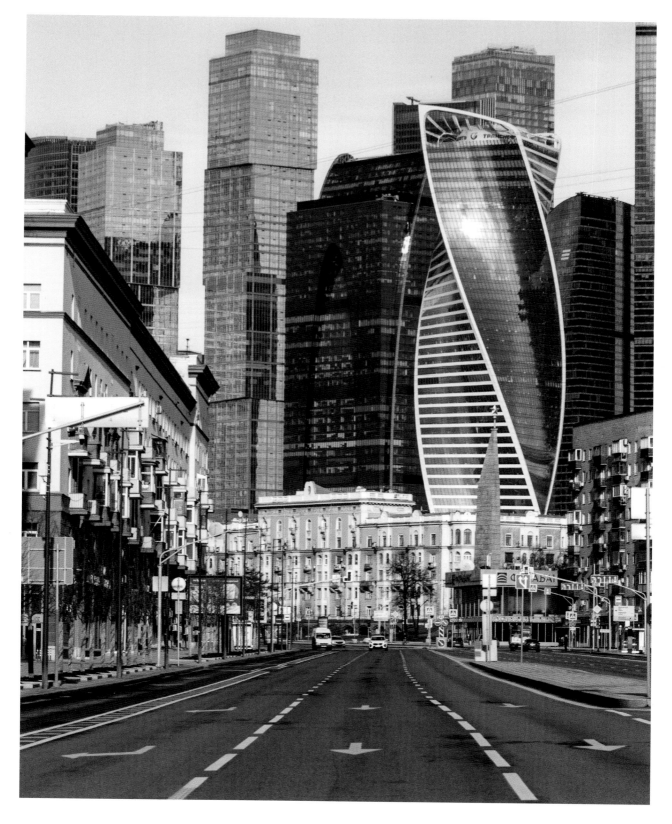

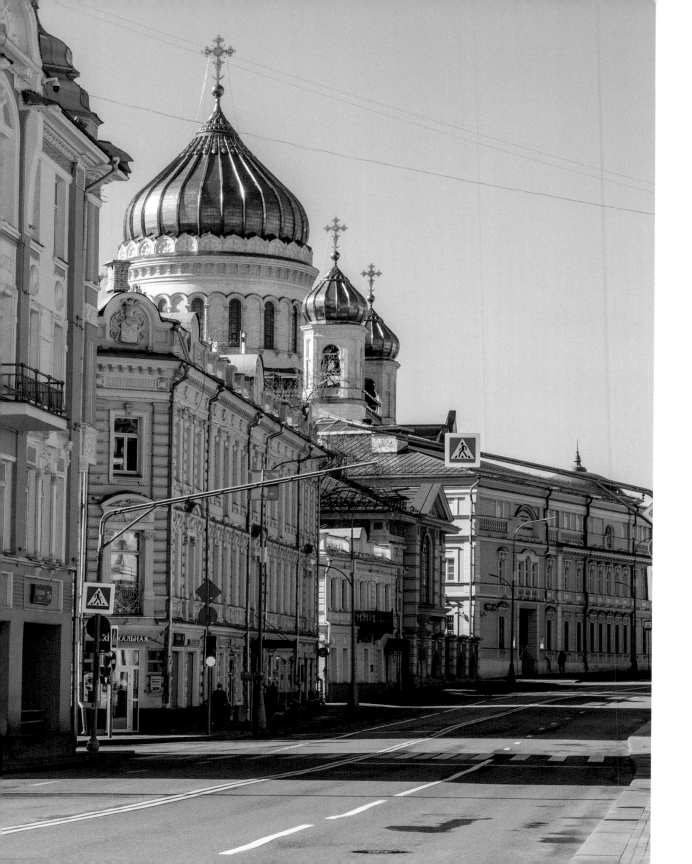

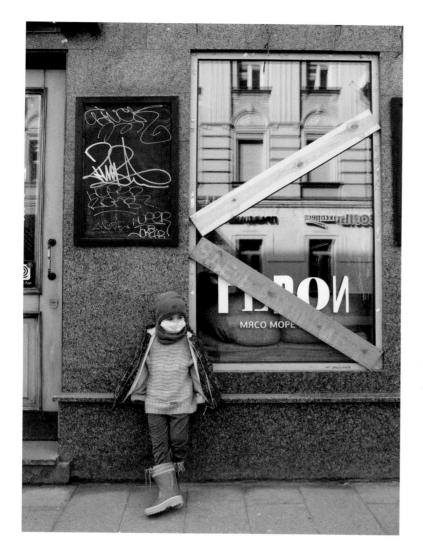

9. April 2020: Die Türen und Fenster der Moskauer
Bar »Helden« (Герои) sind verrammelt, auch Kinder
sind angehalten, Schutzmaske zu tragen.

*April 9, 2020: The doors and windows of the
Moscow bar "Heroes" (Герои) are boarded up;
children are also admonished to wear masks.*

21. April 2020: im Hintergrund die Christ-Erlöser-
Kathedrale am Nordufer der Moskwa.

*April 21, 2020: The Cathedral of Christ the Savior
(in the background) on the north bank of the
Moskva River.*

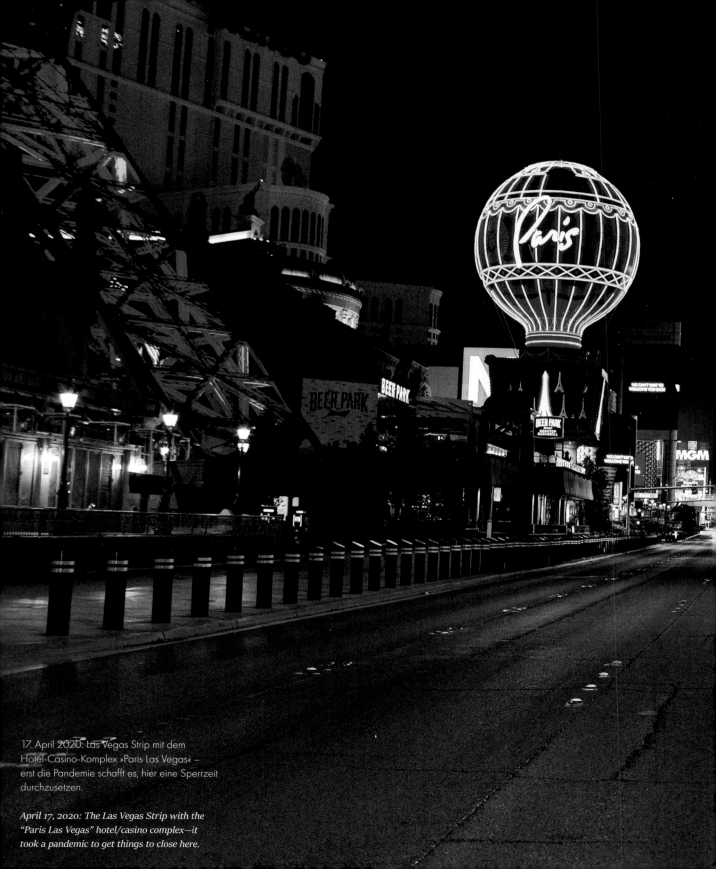

17. April 2020: Las Vegas Strip mit dem Hotel-Casino-Komplex »Paris Las Vegas« – erst die Pandemie schafft es, hier eine Sperrzeit durchzusetzen.

April 17, 2020: The Las Vegas Strip with the "Paris Las Vegas" hotel/casino complex—it took a pandemic to get things to close here.

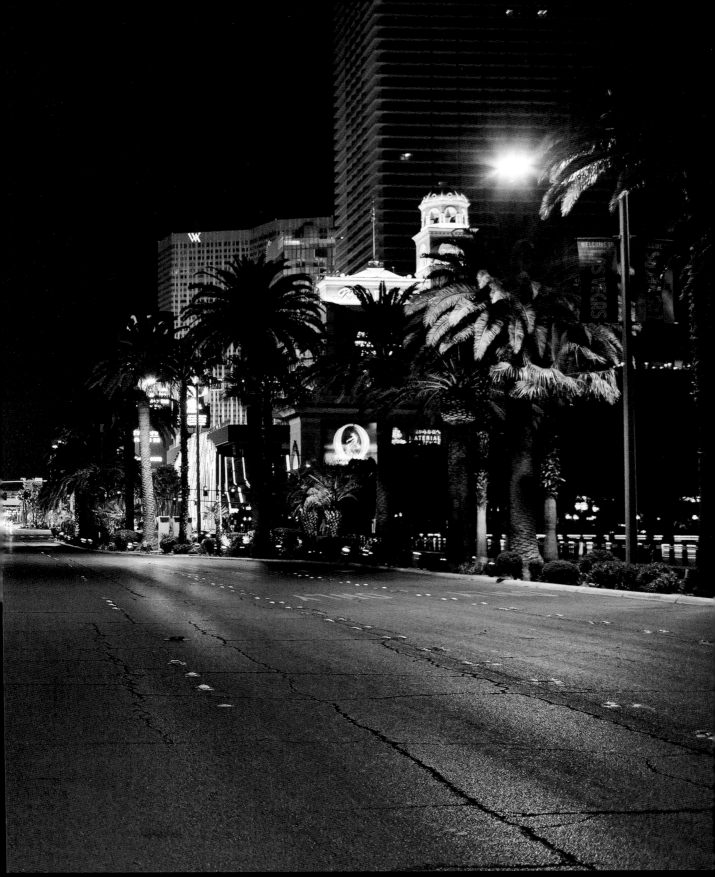

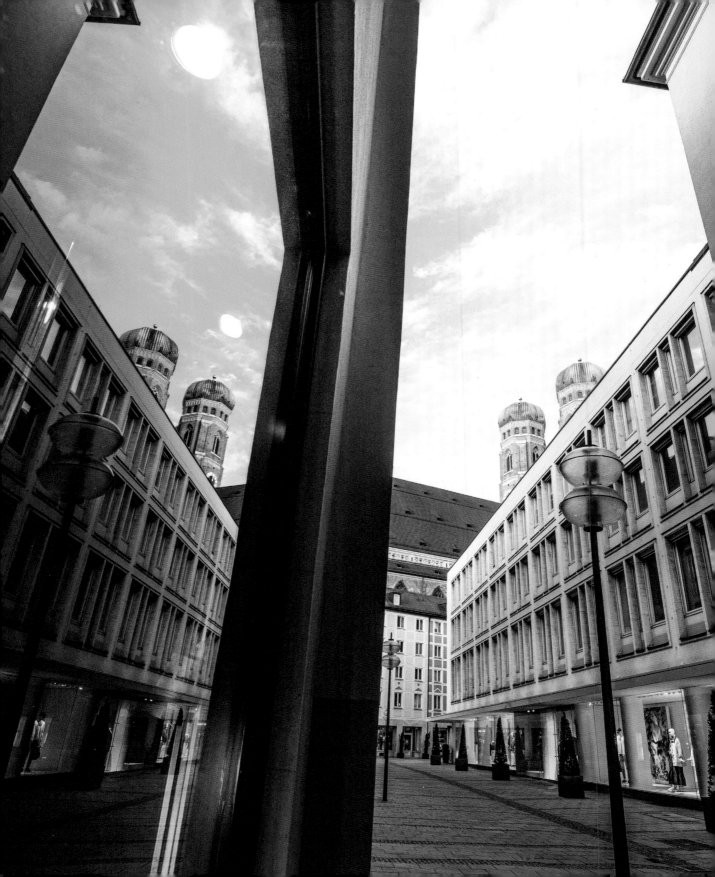

Die Innenstadt von München an der Frauenkirche: gähnende Leere.

Downtown Munich near the Frauenkirche: great, yawning emptiness.

Das Münchner Hofbräuhaus: In Spitzenzeiten bewirten die Kellnerinnen und Kellner bis zu 30 000 Gäste am Tag.

The Munich Hofbräuhaus: At their busiest, the waiters and waitresses serve up to 30,000 people a day here.

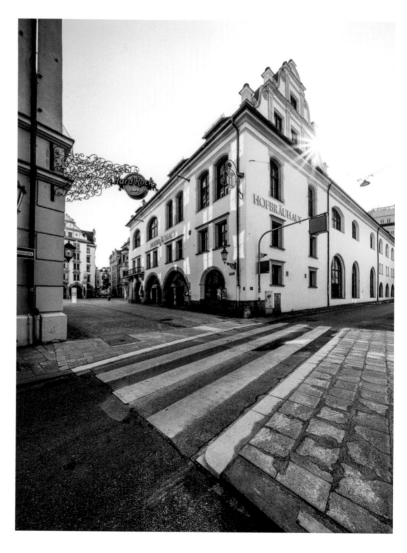

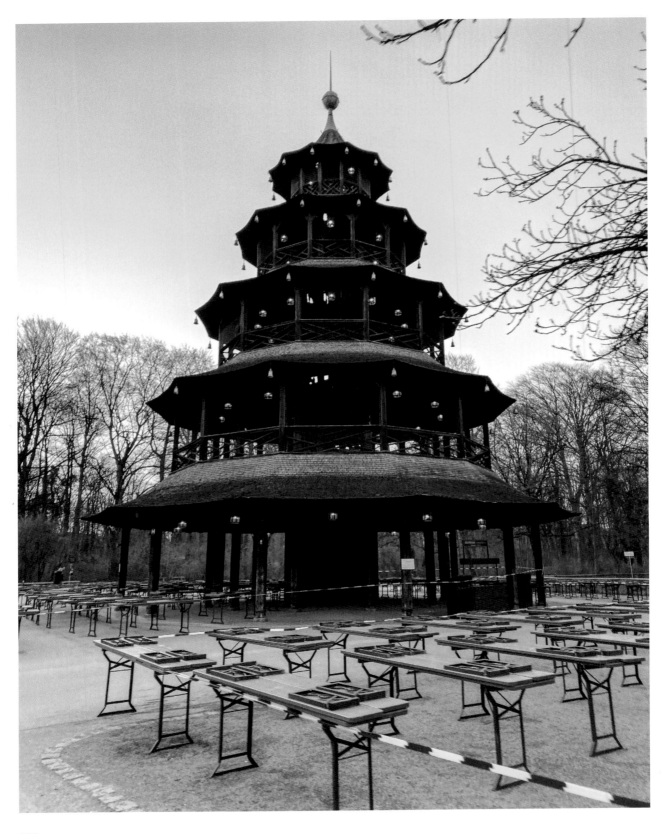

24. März 2020: Rot-weiße Absperrbänder signalisieren es – der berühmte Biergarten am Chinesischen Turm in München muss geschlossen bleiben.

March 24, 2020: The red-and-white tape tells the story—the famed beer garden at the Chinese Tower in Munich must remain closed.

An sonnigen Tagen ist die Pagode im Englischen Garten ein kultureller Schmelztiegel: Bis zu 7000 Münchner und Gäste aus aller Welt treffen sich hier.

On sunny days, the pagoda in the English Garden is a cultural melting pot: up to 7,000 locals and guests from around the world meet right here.

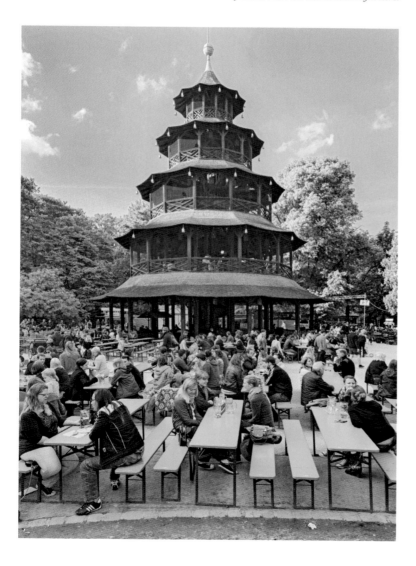

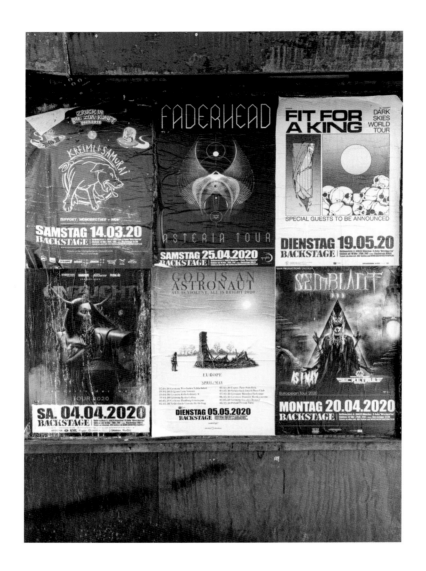

Verlegt, verschoben, abgesagt: Ankündigungen des
Münchner Indie-Clubs Backstage.

*Rescheduled, postponed, cancelled: Concert posters
at the Munich indie club Backstage.*

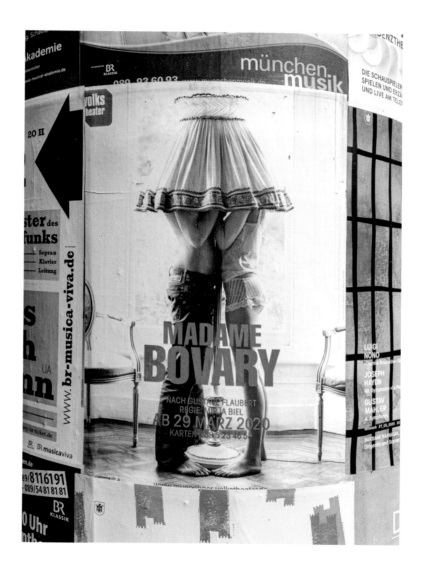

Verlegt, verschoben, abgesagt: Flauberts
Madame Bovary im Münchner Volkstheater.

Rescheduled, postponed, cancelled: Flaubert's
Madame Bovary *at the Munich Volkstheater.*

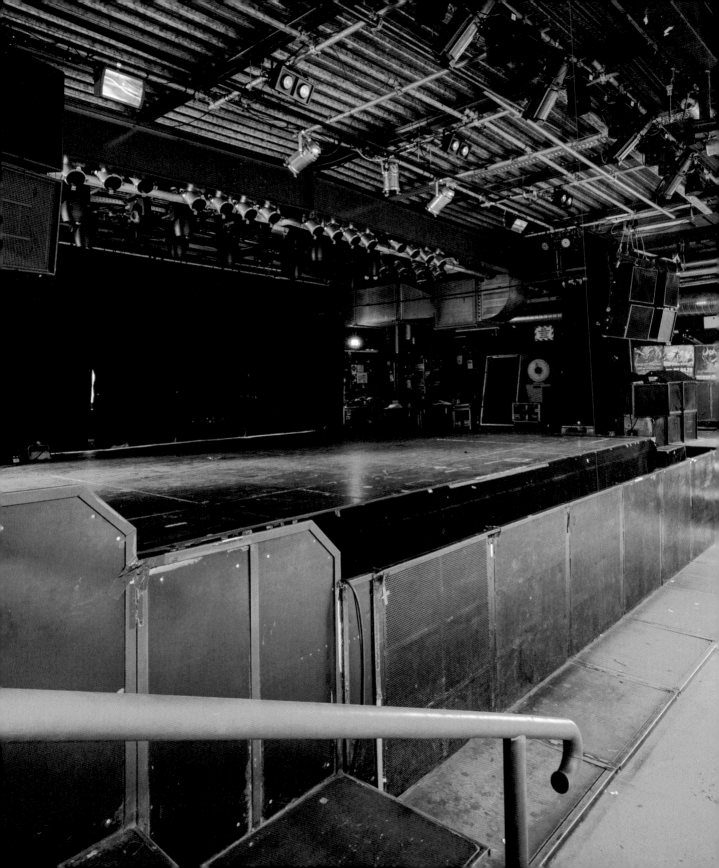

Keine Kultur vor Publikum: Bühnen wie
das Münchner Backstage Werk bleiben
monatelang verschlossen.

No culture for a public audience:
stages like the Backstage Werk in Munich
remain closed for months.

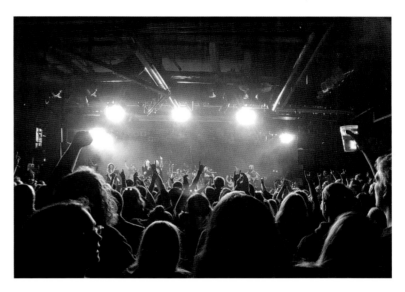

Die Münchner Institution – Konzert-Venue, Biergarten, Party-
zone und kulturelle Begegnungsstätte – ist überregional
bekannt, weil sie gerade den vielen Musikern einen Raum
bietet, die 500 bis 1 500 Zuhörer anziehen.

The Munich institution—concert venue, beer garden, party
zone, and cultural meeting place—is known across Germany
because it provides a space for the many musical acts
that draw from 500 to 1,500 fans.

Die Einladung zu einer Hochzeit

Auf die niemand gehen wird

Das Plakat für eine Show

Die niemals stattfindet

Zwei Tickets für eine Reise

Die ich nicht mehr machen kann

Und ein Geschenk zum Muttertag

Das ich nicht verpacken werde

Das ist alles, was mir bleibt

In einer Welt im Shutdown

Aus dem Song *Can't Be There Today* von Billy Bragg.
Steven William Bragg ist ein britischer Sänger, Songwriter
und politischer Aktivist. Zu seinen bekanntesten Songs gehört
A New England von 1983.

From the song Can't Be There Today *by Billy Bragg.*
Steven William Bragg is a British singer, songwriter,
and a political activist. One of his best-known songs is
A New England *from 1983.*

An invite to a wedding

That no one can attend

A poster for a show that

never happened

Two tickets for a holiday

I can no longer spend

And a gift for Mother's Day

I won't be wrapping

This is all I'm left with

In a world that's been shut down

CLOSED

25. April 2020: Design-Boutique in
New Plymouth, Neuseeland.

*April 25, 2020: Design boutique in
New Plymouth, New Zealand.*

Eigentlich sind die Straßen Skārņu iela und Kaļķu iela im Zentrum der lettischen Hauptstadt ein beliebtes Revier für Restaurantbesucher und Kneipengänger.

The streets Skārņu iela and Kaļķu iela in the Latvian capital's downtown are normally filled with restaurant diners and bar goers.

Blick auf das Hotel Neiburgs in Rigas verwaister Altstadt. Die Gäste, wenn sie denn hier wären, hätten direkten Blick auf den Dom.

View of the Neiburgs Hotel in Riga's deserted Old Town. Hotel guests, if there were any, would have an unobstructed view of the cathedral.

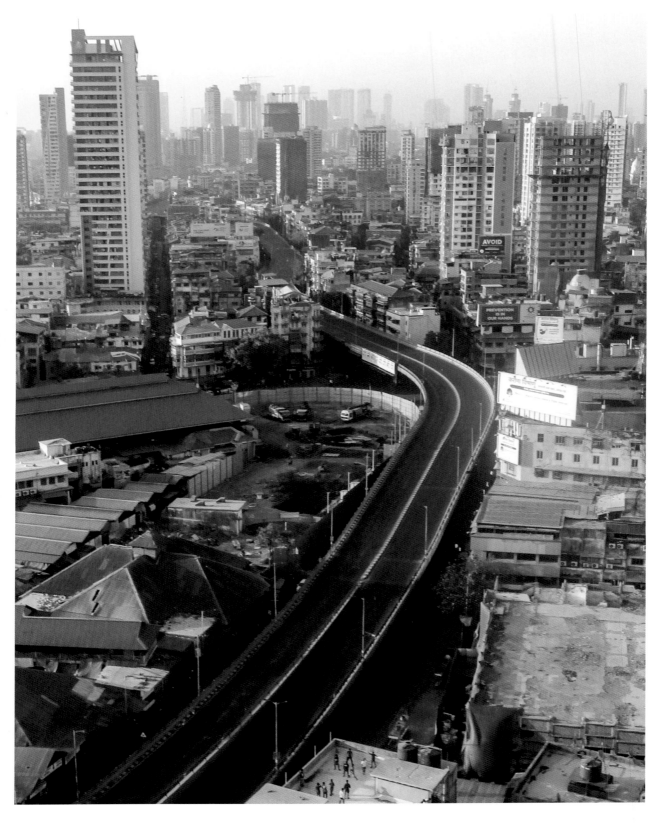

22. März 2020: Eine Ausgangssperre sorgt in der indischen
15-Millionen-Metropole Mumbai für leere Straßen.

*March 22, 2020: A stay-at-home order makes for empty
streets in the Indian metropolis of Mumbai, a city of 15 million.*

23. März 2020: Einige wenige Angestellte kümmern sich um einen Bahn-
hof in Mumbai, nachdem die Behörden den Betrieb geschlossen haben.

*March 23, 2020: A precious few workers take care of a train station
in Mumbai after the authorities suspend operations.*

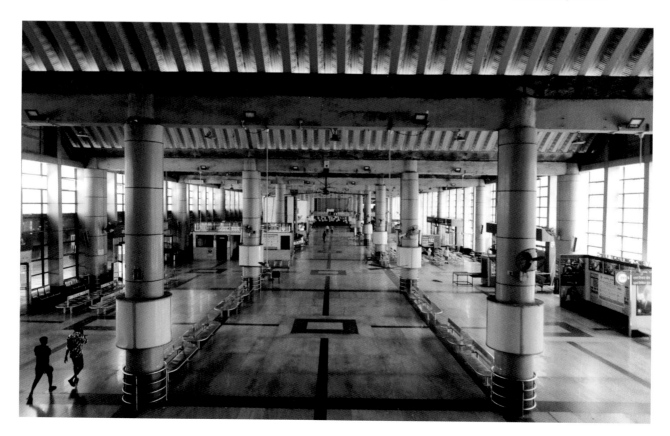

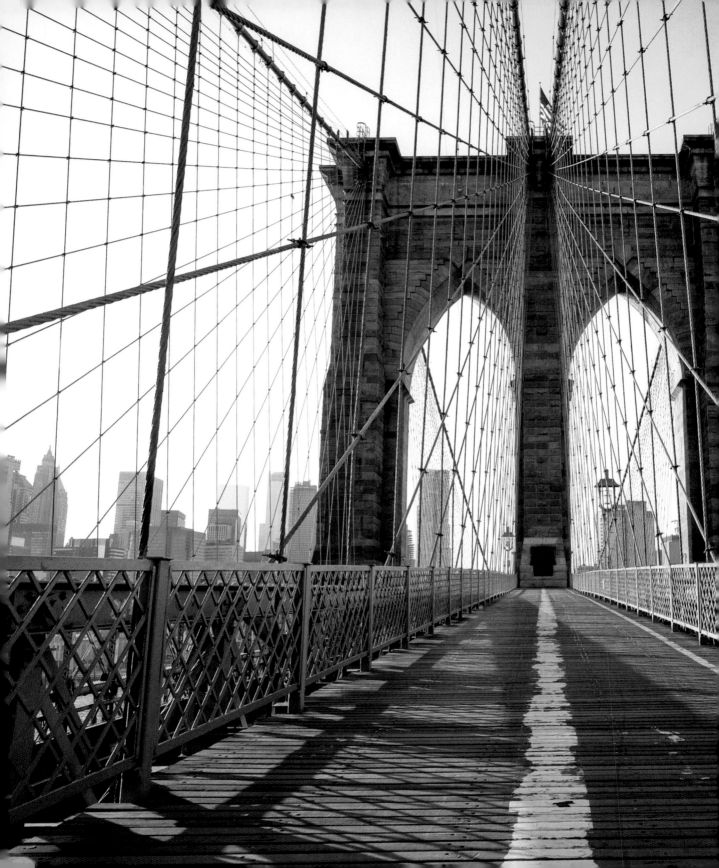

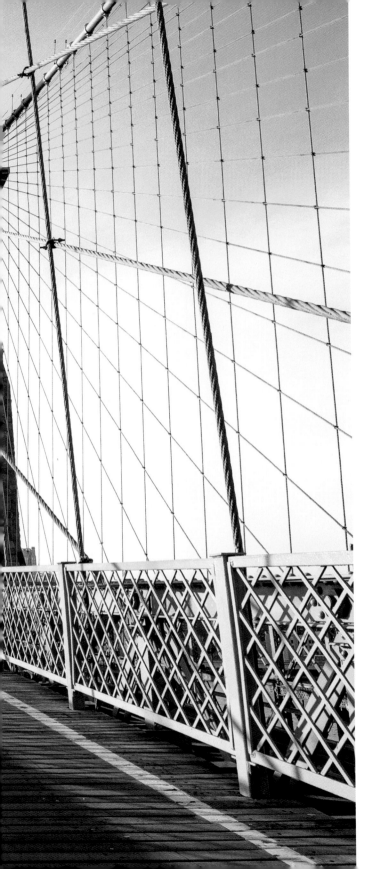

Brooklyn Bridge, New York.

Brooklyn Bridge, New York.

26. März 2020: Der Streamingdienst Hulu wirbt auf dem menschenleeren Times Square in New York City für den Start der Serie *Mrs. America* am 15. April.

March 26, 2020: The streaming service Hulu advertises the premiere of the series Mrs. America on April 15 to an empty Times Square.

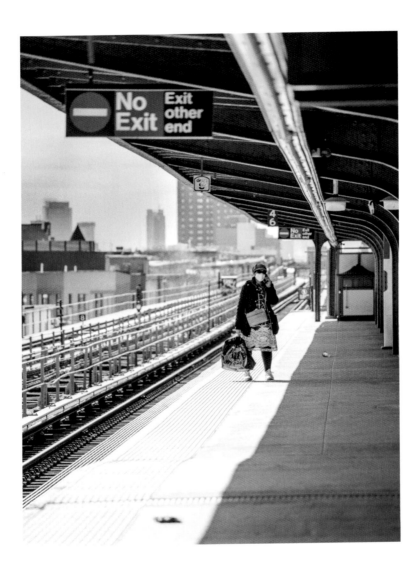

29. März 2020, Bundesstaat New York: »No Exit« ist keine Perspektive im öffentlichen Personennahverkehr.

March 29, 2020, New York state: "No Exit" is not an option for public passenger transit systems.

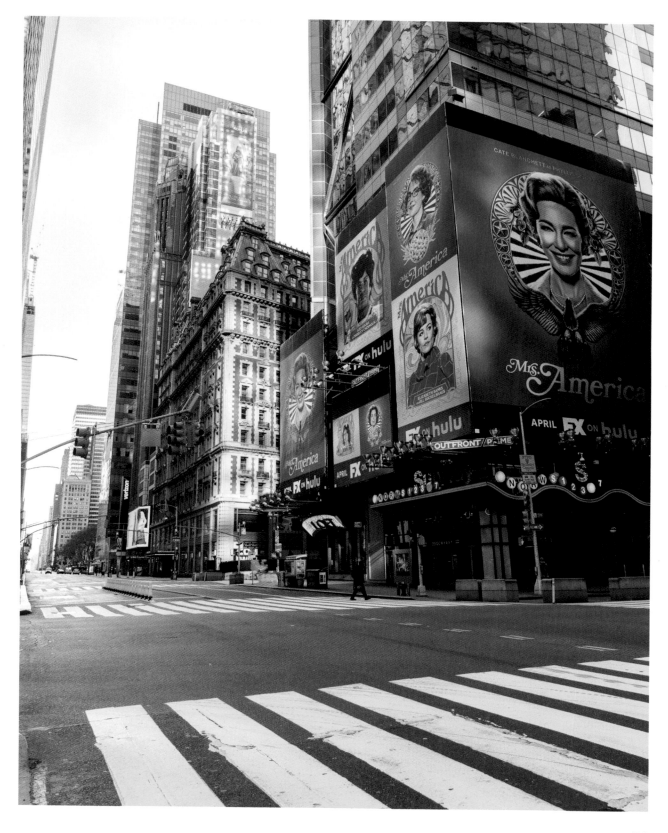

24. März 2020: Robert John Burck, der »Nackte Cowboy«,
spielt seit 21 Jahren für Touristen am Times Square – selbst dann,
wenn nur ein Fotograf anwesend ist.

*March 24, 2020: Robert John Burck, the "Naked Cowboy,"
has been performing for Times Square tourists for 21 years—
even if a photographer is the only one present.*

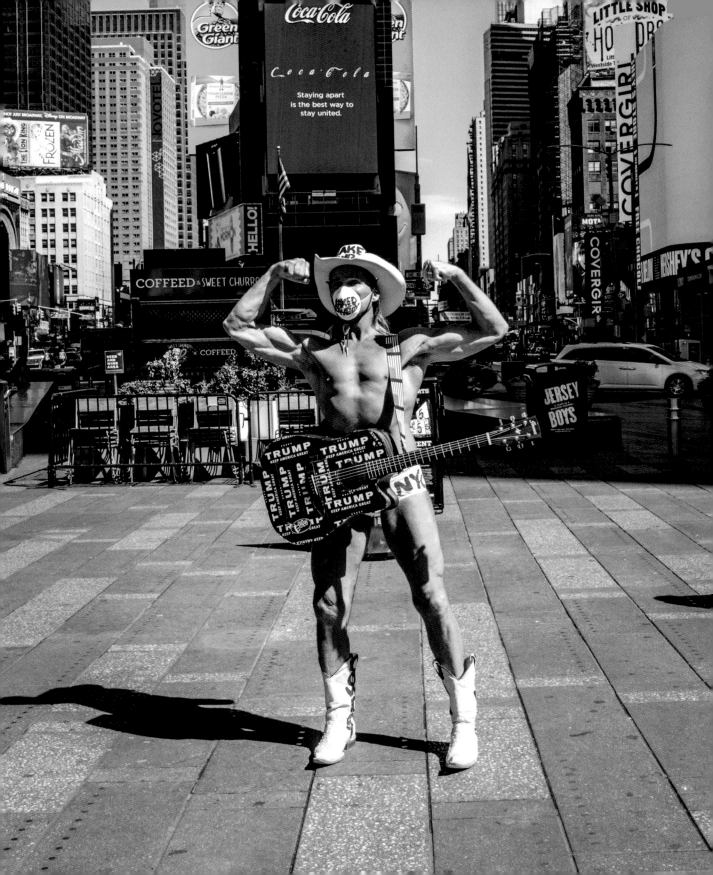

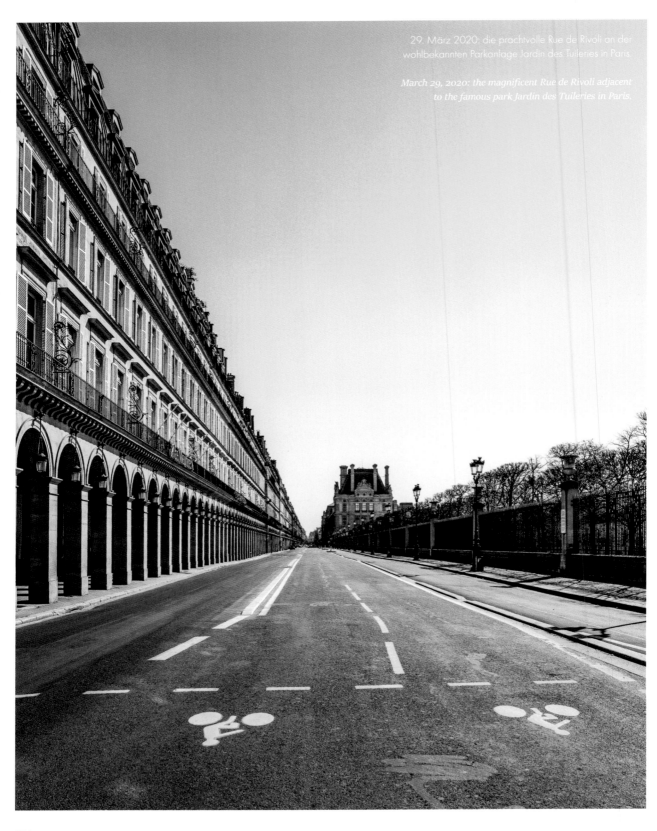

29. März 2020: die prachtvolle Rue de Rivoli an der wohlbekannten Parkanlage Jardin des Tuileries in Paris.

March 29, 2020: the magnificent Rue de Rivoli adjacent to the famous park Jardin des Tuileries in Paris.

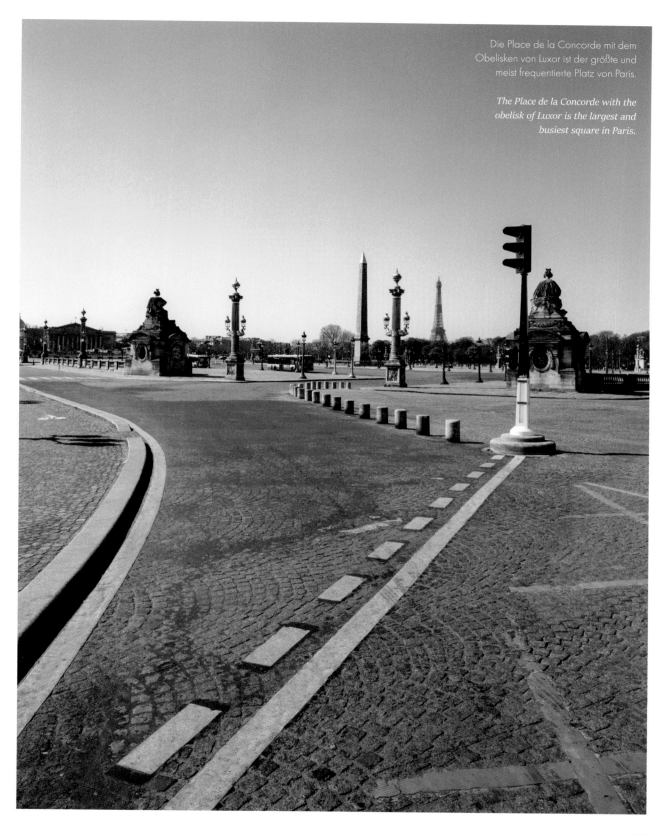

Die Place de la Concorde mit dem Obelisken von Luxor ist der größte und meist frequentierte Platz von Paris.

The Place de la Concorde with the obelisk of Luxor is the largest and busiest square in Paris.

Sacré-Cœur de Montmartre: Die engen Gassen hinauf zur Basilika gehören zu den Lieblingszielen für Besucher der französischen Hauptstadt.

Sacré-Cœur de Montmartre: The narrow lanes leading up to the basilica are a favorite destination for visitors to the French capital.

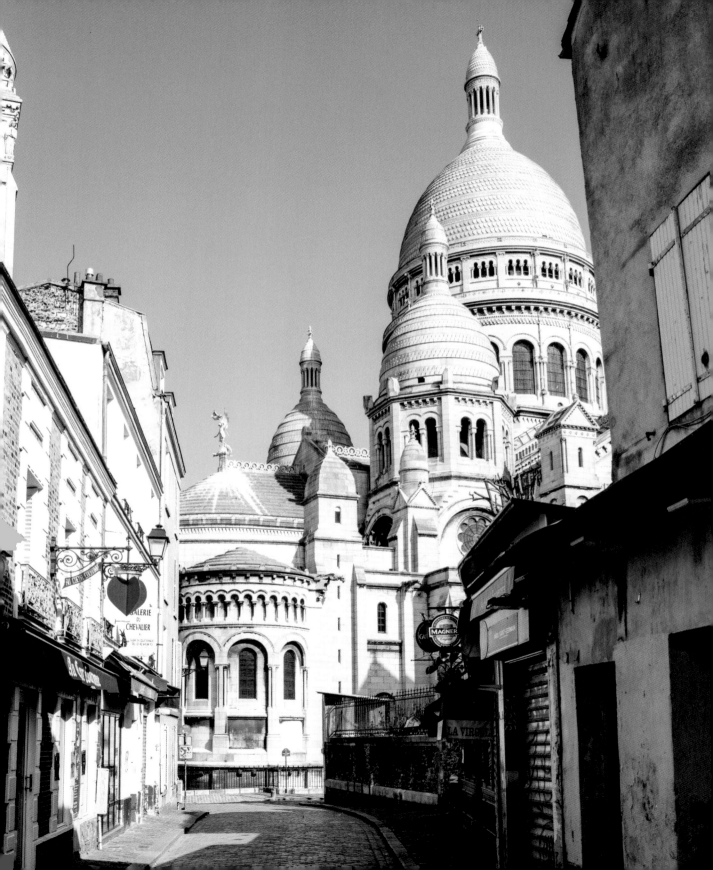

Das berühmte Café de Flore am Pariser Boulevard Saint-Germain bediente sogar während des Zweiten Weltkriegs seine Gäste und war jeden Tag geöffnet – bis das Virus kam.

The famed Café de Flore on Paris' Boulevard Saint-Germain continued to serve customers even during World War II and was open every day—until the virus came.

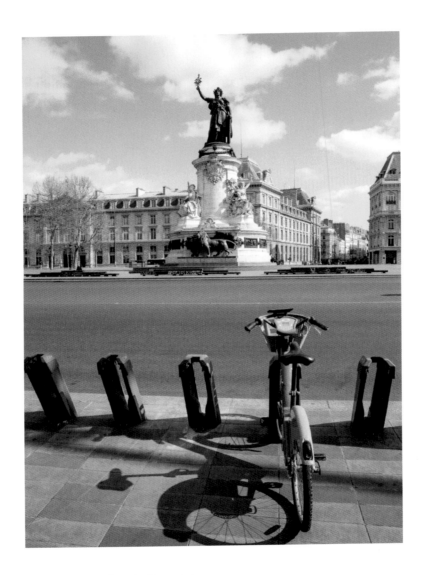

Marianne, Nationalfigur der Französischen Republik, mit Olivenzweig an der Place de la République.

Marianne, the national figure of the French Republic, holds an olive branch at the Place de la République.

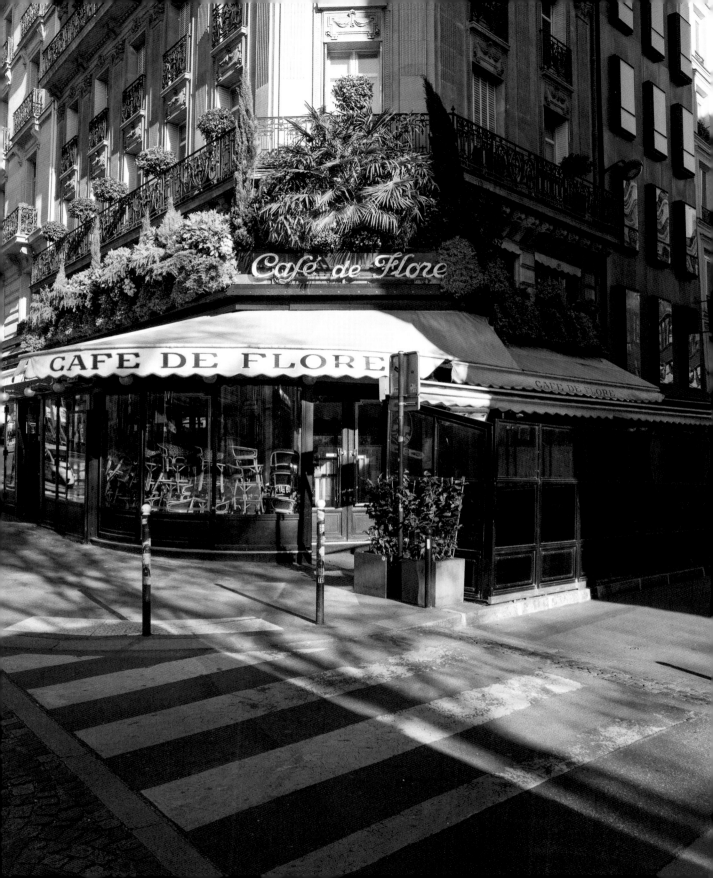

Ungewohnt einsam: Rio de Janeiros Praia de Ipanema
mit dem Zwei-Brüder-Felsen im Hintergrund.

*Unusually lonely: Rio de Janeiro's Praia de Ipanema
with the Two Brothers Mountain in the background.*

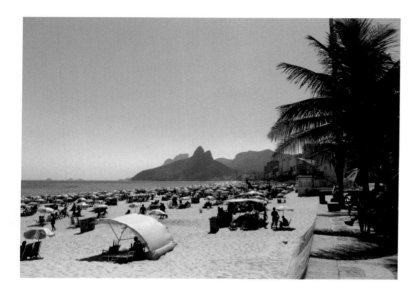

Gewohnter Anblick: Der Strand von Ipanema, bevölkert von
sonnenhungrigen Touristen und Einheimischen.

*The usual view: Ipanema Beach, filled with sun-seeking
tourists and locals.*

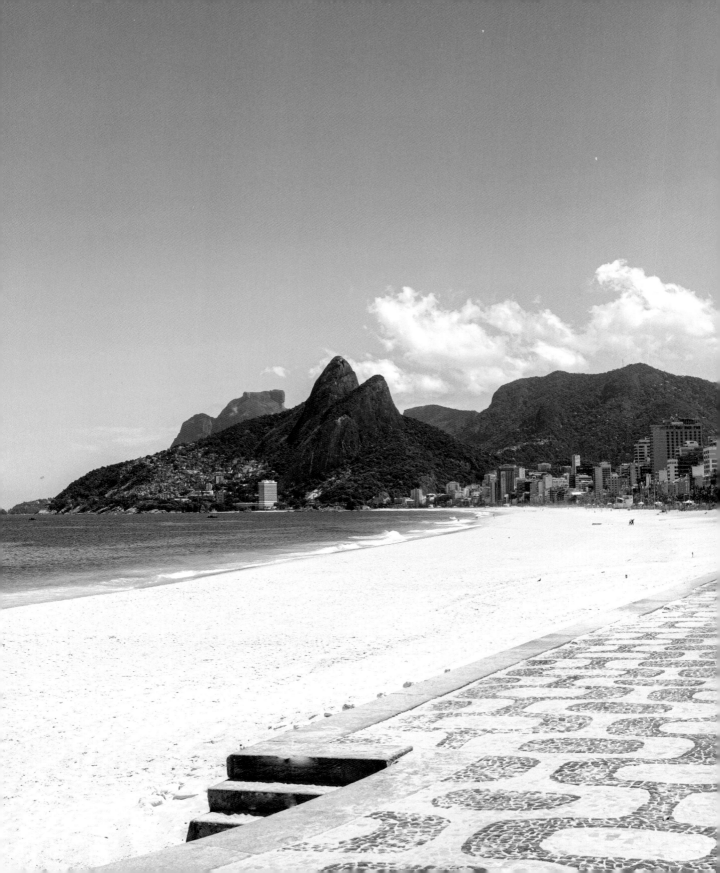

Ändert die Pandemie unsere Art zu leben? In der Welt der Mode verzichtet **Yves Saint Laurent** auf eine Teilnahme an der Paris Fashion Week und will künftig den Rhythmus neuer Produkte selbst bestimmen. Gucci kündigt an, dass die Lebensdauer seiner Kollektionen fortan länger als eine Saison sein werde.

*Is the pandemic changing how we live? In the fashion world, **Yves Saint Laurent** declines to participate in Paris Fashion Week and wants to schedule future collection rollouts independently. Gucci announces that the life cycle of its collections will be longer than one season from now on.*

Luftbrücke Mallorca: Etwa ein halbes Dutzend Frachtschiffe versorgt die Insel täglich mit allem Lebenswichtigen. Der Flughafen registriert während des Lockdowns zwischen 20 und 50 Frachtmaschinen pro Tag – normalerweise landen und starten im Frühjahr etwa tausend Flieger täglich mit Touristen aus aller Welt.

Mallorca Airlift: *About a half-dozen cargo ships supply the island with daily shipments of essentials. During the lockdown, the airport logs between 20 and 50 cargo planes a day—in a normal spring, a thousand planes per day arrive and depart with tourists from around the world.*

Krisengewinnler **Netflix**: Der US-amerikanische Streamingdienst vermeldet in den ersten drei Monaten des Jahres traumhafte Zugewinne. 15,7 Millionen Menschen haben ein Abo gebucht, 13,5 Millionen davon im Ausland – der größte Zuwachs aller Zeiten. Das Unternehmen aus Los Gatos zählt jetzt 182,8 Millionen Kunden.

Crisis champ **Netflix***: The American video streaming service posts incredible numbers for the first three months of the year. 15.7 million new subscribers were added, of whom 13.5 million were outside the United States—the largest growth the company has ever seen. The Los Gatos, California-based company now has 182.8 million customers.*

Tiefpunkt wie 2006: Die staatlichen Beschränkungen sorgen für den stärksten Rückgang an **CO_2-Emissionen** seit mindestens 60 Jahren, errechnet eine Studie im Wissenschaftsmagazin *Nature Climate Change* – dennoch ist der globale Ausstoß selbst auf dem Tiefpunkt immer noch so hoch wie im Durchschnitt des Jahres 2006.

A low equal to 2006: According to a study published in the journal Nature Climate Change, *government restrictions cause the steepest decline in* **CO_2 emissions** *in at least 60 years. Still, even at their lowest point, global emissions are still equal to average emissions for 2006.*

E-Commerce: Trotz der Beschränkungen zählt der Onlinehandel nicht so deutlich zu den Gewinnern der Krise wie gemeinhin erwartet. Lediglich die Kategorien Lebensmittel, Medikamente, Drogeriewaren und Tierbedarf legen zu. Die Segmente Kleidung und Schuhe, Schmuck oder Auto & Zubehör verlieren dagegen deutlich. Insgesamt bleibt in den ersten vier Monaten ein Plus von 5,8%.

E-commerce: *Despite stay-at-home orders, online commerce isn't the big winner everyone thought it would be. Only the grocery, medicine, drugstore, and pet supply sectors post increases. Clothing and shoes, jewelry, and car and car accessories, by contrast, are big losers. Overall, the first four months of the year see online purchases increase by 5.8%.*

Rätselhafte Infektion: Im April 2020 werden 1 041 der 2 300 Besatzungsmitglieder des französischen **Flugzeugträgers Charles de Gaulle** und seiner Begleitschiffe positiv auf Sars-CoV-2 getestet. Seit einem Zwischenstopp vom 13. bis 16. März in Brest hatte die Mannschaft keinen Kontakt mehr zur Außenwelt. Zuvor war sie zu einem dreimonatigen Einsatz im Atlantik unterwegs.

Puzzling infection: in April 2020, 1,041 of the 2,300 crewmembers of the French **aircraft carrier Charles de Gaulle** *and its escort ships test positive for Sars-CoV-2. After docking in Brest from March 13 to March 16, the crew had no further contact with the outside world. Prior to the stop in Brest, the ships were on a three-month tour of the Atlantic.*

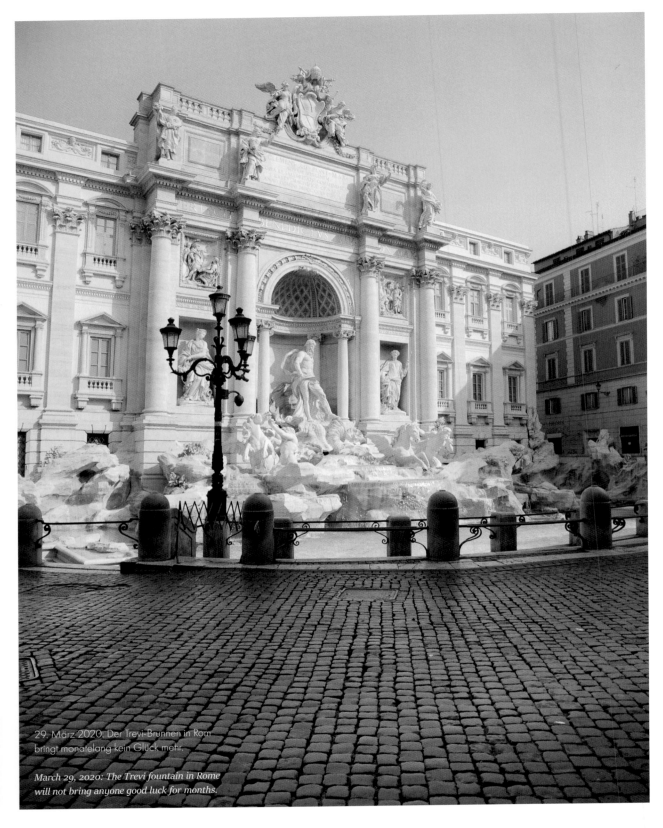

29. März 2020: Der Trevi-Brunnen in Rom
bringt monatelang kein Glück mehr.

*March 29, 2020: The Trevi fountain in Rome
will not bring anyone good luck for months.*

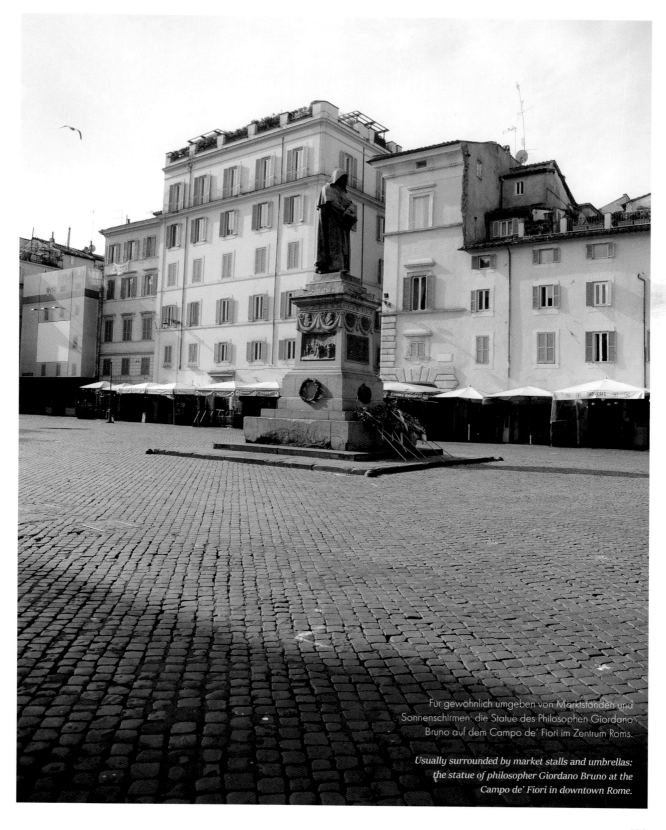

Für gewöhnlich umgeben von Marktständen und
Sonnenschirmen: die Statue des Philosophen Giordano
Bruno auf dem Campo de' Fiori im Zentrum Roms.

*Usually surrounded by market stalls and umbrellas:
the statue of philosopher Giordano Bruno at the
Campo de' Fiori in downtown Rome.*

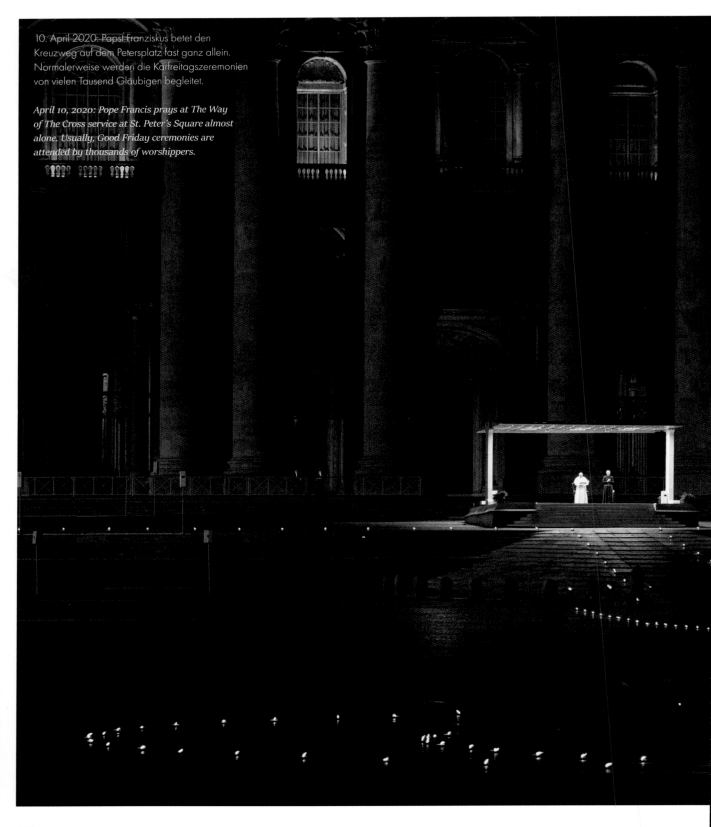

10. April 2020: Papst Franziskus betet den
Kreuzweg auf dem Petersplatz fast ganz allein.
Normalerweise werden die Karfreitagszeremonien
von vielen Tausend Gläubigen begleitet.

April 10, 2020: Pope Francis prays at The Way
of The Cross service at St. Peter's Square almost
alone. Usually, Good Friday ceremonies are
attended by thousands of worshippers.

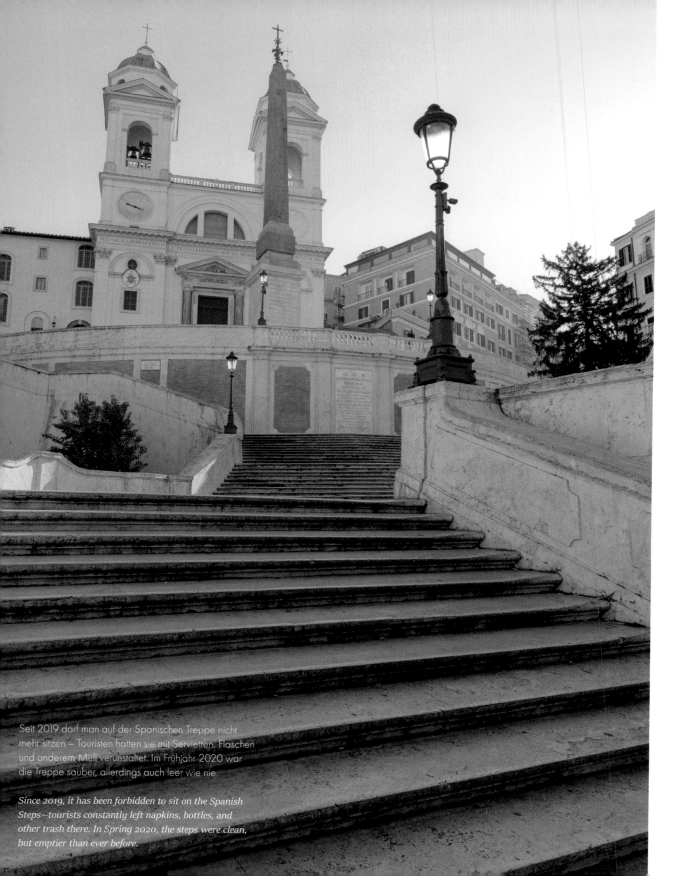

Seit 2019 darf man auf der Spanischen Treppe nicht mehr sitzen – Touristen hatten sie mit Servietten, Flaschen und anderem Müll verunstaltet. Im Frühjahr 2020 war die Treppe sauber, allerdings auch leer wie nie.

Since 2019, it has been forbidden to sit on the Spanish Steps—tourists constantly left napkins, bottles, and other trash there. In Spring 2020, the steps were clean, but emptier than ever before.

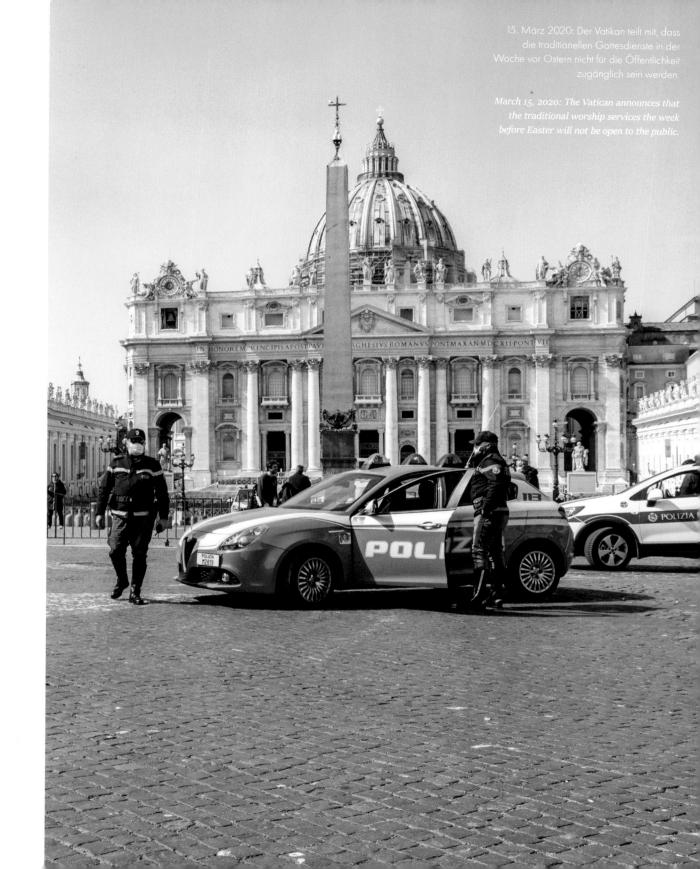

15. März 2020: Der Vatikan teilt mit, dass die traditionellen Gottesdienste in der Woche vor Ostern nicht für die Öffentlichkeit zugänglich sein werden.

March 15, 2020: The Vatican announces that the traditional worship services the week before Easter will not be open to the public.

6. Mai 2020: wird nur noch selten
gekreuzt – der Regenbogen-Zebrastreifen
in der 18th Street in San Francisco.

May 6, 2020: Rarely being crossed—
the rainbow crosswalks on 18th Street
in San Francisco.

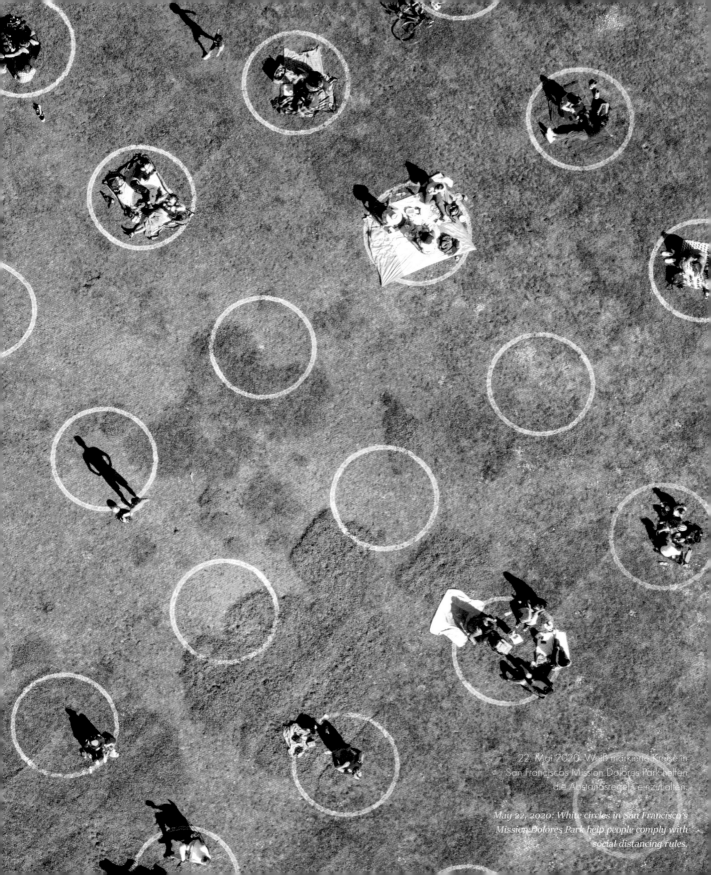

Der Mestni trg (Stadtplatz) von Ljubljana, der Hauptstadt
Sloweniens, mit seinem Robba-Brunnen wirkt während
der Quarantänemaßnahmen wie ausgestorben.

*The Mestni trg (town square) of Ljubljana, the capital
of Slovenia, with its Robba fountain, looks abandoned
during the quarantine period.*

Keine Besucher, keine Bewohner: leere Gassen
in der Altstadt von Ljubljana.

*No visitors, no residents: empty side streets
in Ljubljana's Old Town.*

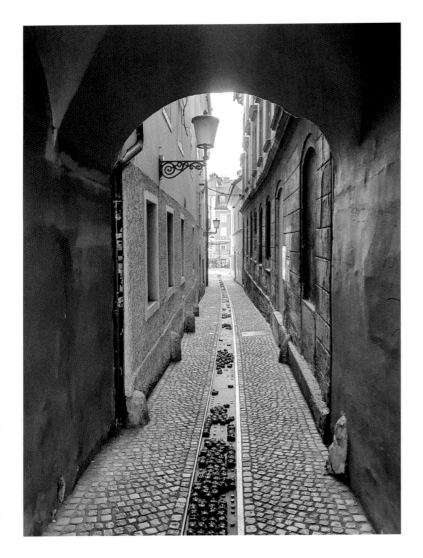

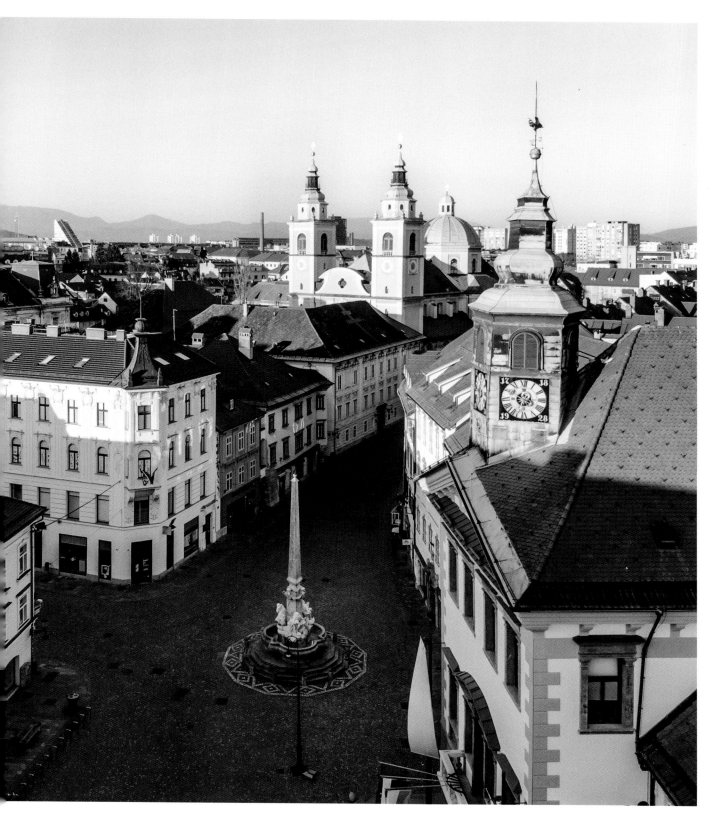

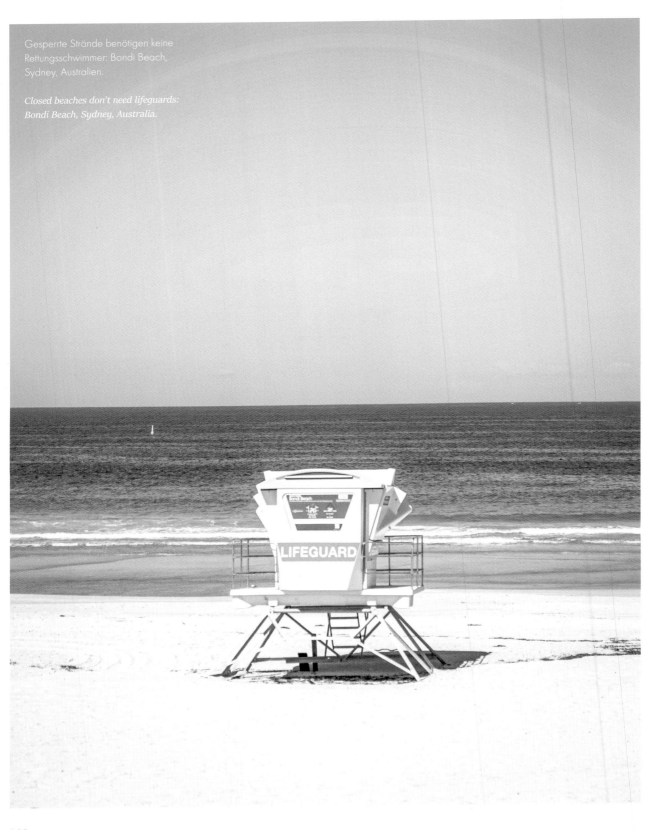

Gesperrte Strände benötigen keine
Rettungsschwimmer: Bondi Beach,
Sydney, Australien.

Closed beaches don't need lifeguards:
Bondi Beach, Sydney, Australia.

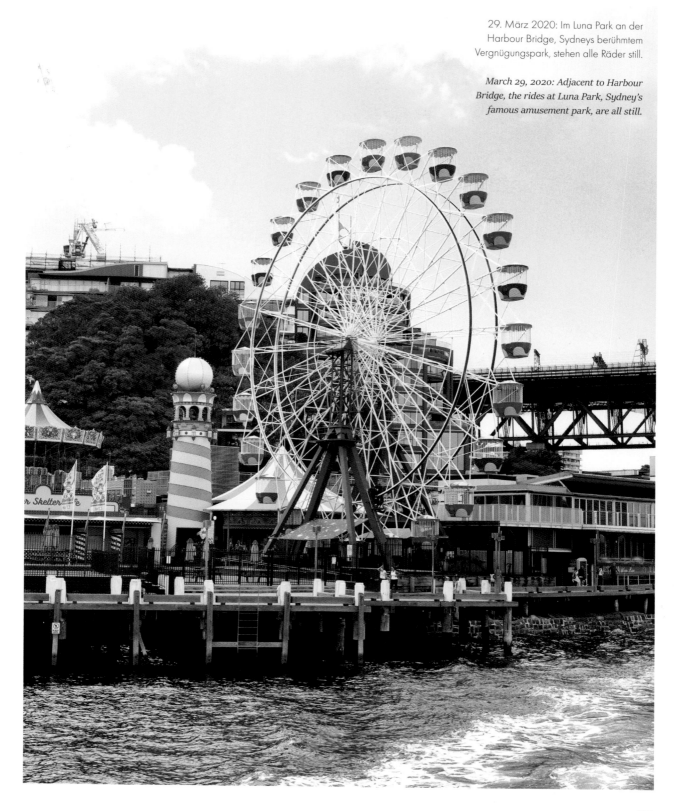

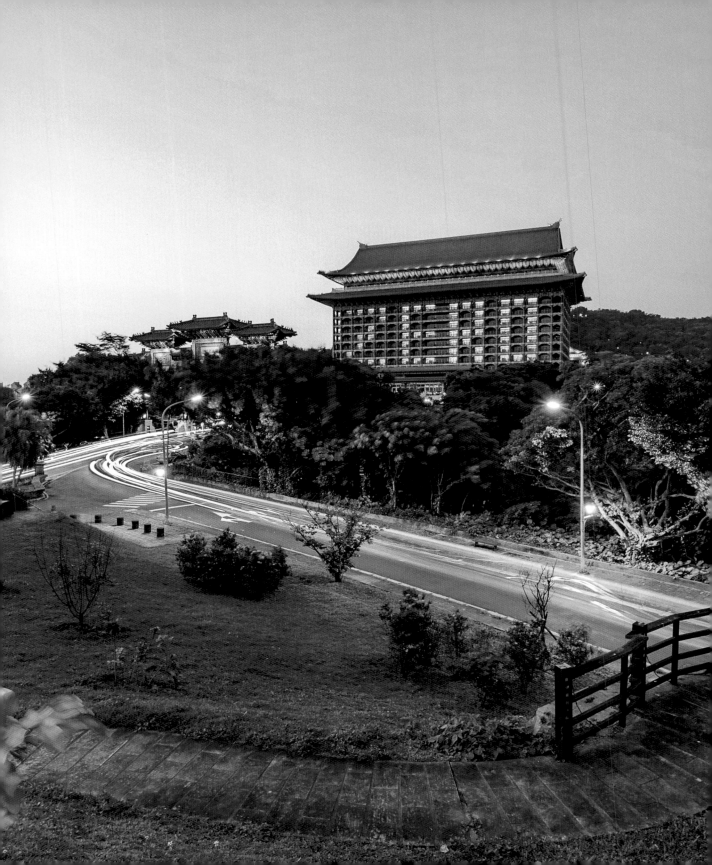

29. April 2020: Das vierzehnstöckige Grand Hotel
Taipeh in Taiwan signalisiert mit Hilfe der Zimmer-
beleuchtungen die Zahl der COVID-19-Infektionen.

*April 29, 2020: The fourteen-story Grand Hotel Taipei
in Taiwan uses the room lights to indicate the number
of COVID-19 infections.*

5. Februar 2020: Mundschutz im öffentlichen
Nahverkehr ist in Taiwan Pflicht. Erst Anfang Juni lockert
der Inselstaat die Bestimmung.

*February 5, 2020: Taiwan requires all passengers to
wear masks on public transportation. The island country
does not relax the requirement until early June.*

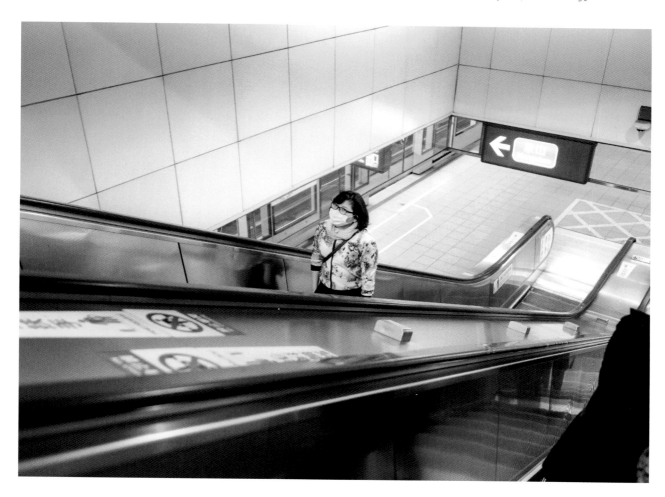

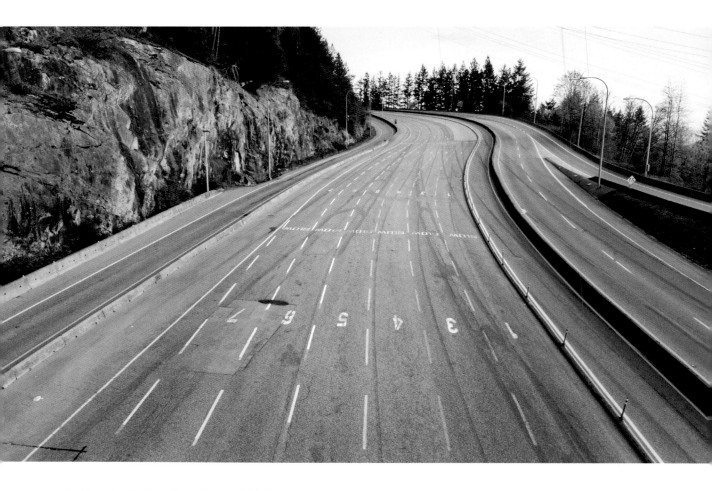

Am Horseshoe Bay Ferry Terminal, einem Fährhafen
in der Howe-Sound-Bucht, British Columbia, Kanada,
bleiben die Check-in-Spuren leer.

At the Horseshoe Bay Ferry Terminal on
Howe Sound in British Columbia, Canada,
the check-in lanes remain empty.

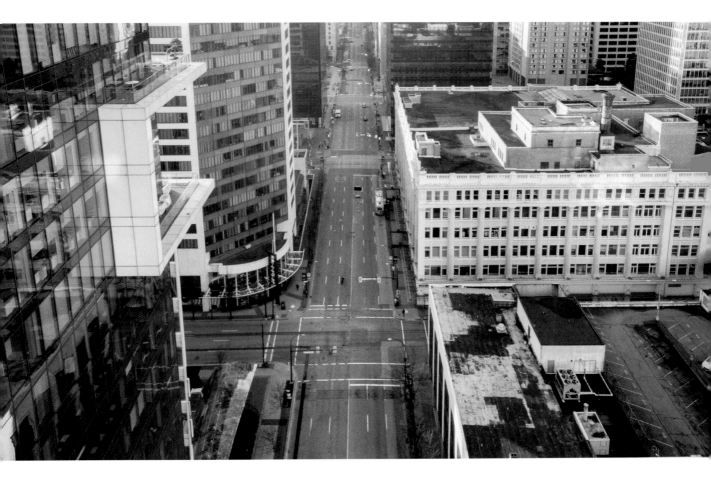

Gespenstisch: In der Georgia Street
im Zentrum von Vancouver regulieren
Ampeln Verkehr, der nicht existiert.

*Ghostly: On Georgia Street in
downtown Vancouver, traffic lights
control non-existent traffic.*

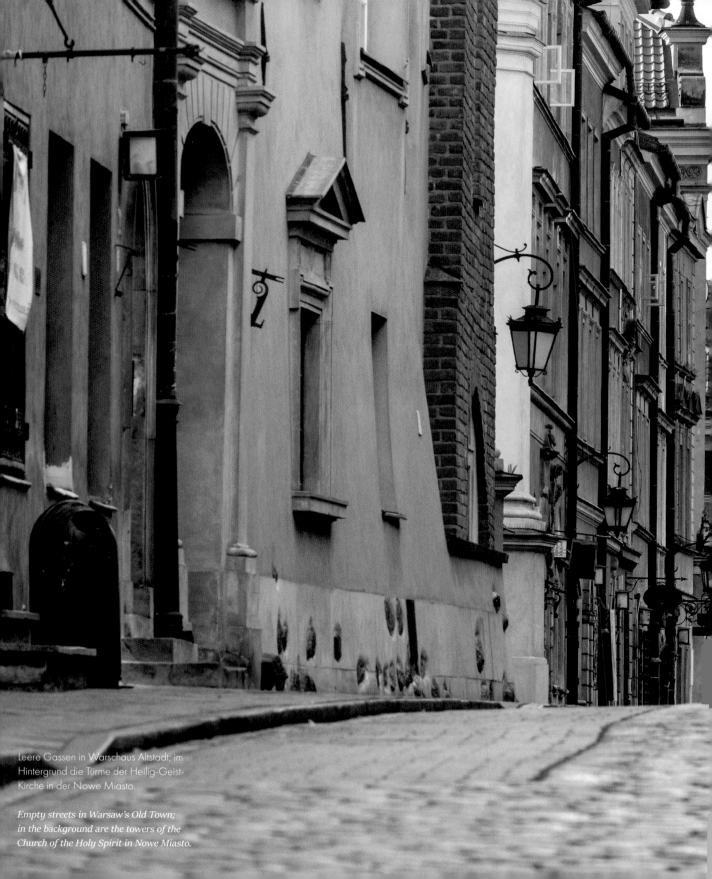

Leere Gassen in Warschaus Altstadt; im
Hintergrund die Türme der Heilig-Geist-
Kirche in der Nowe Miasto.

Empty streets in Warsaw's Old Town;
in the background are the towers of the
Church of the Holy Spirit in Nowe Miasto.

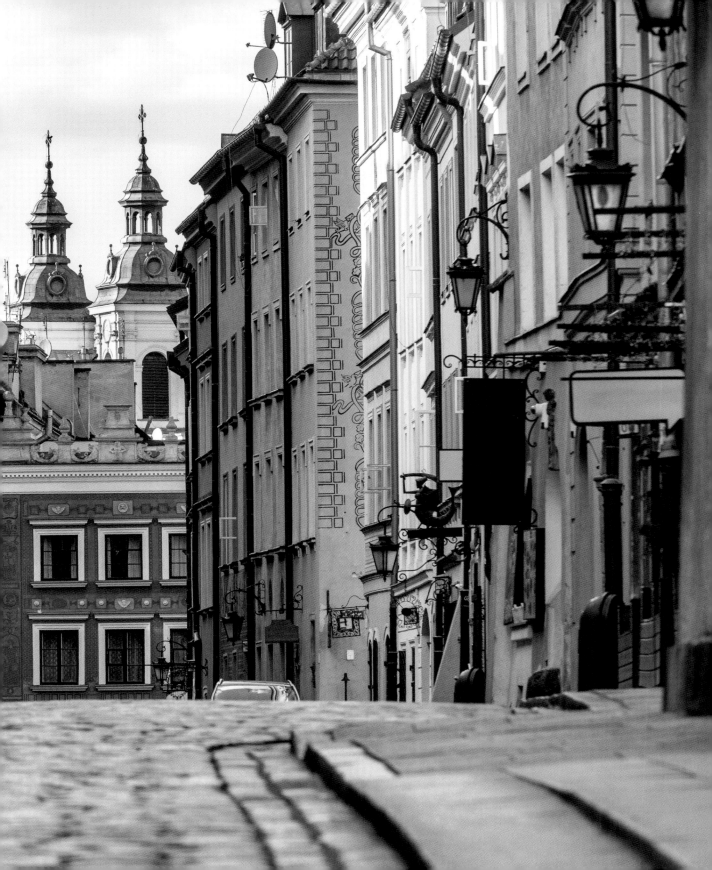

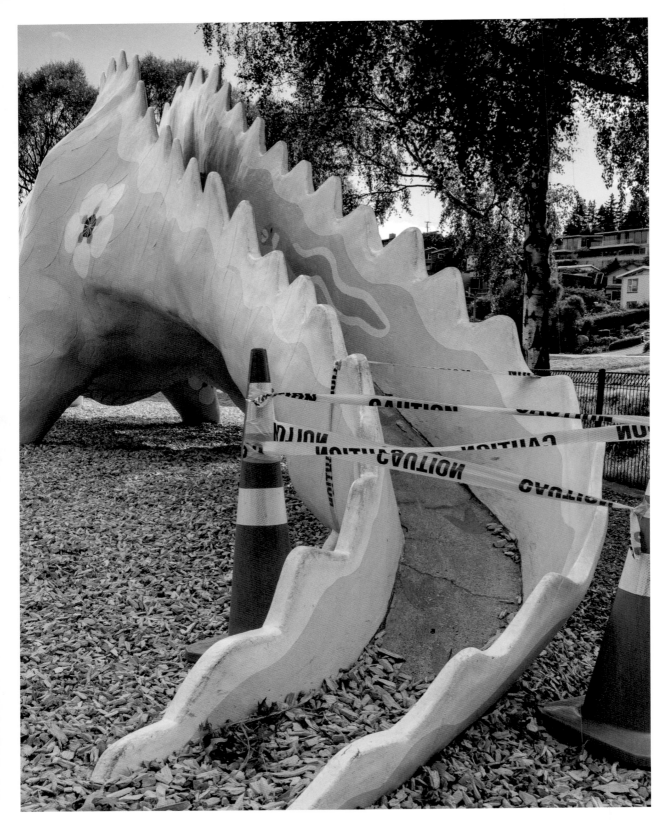

25. März 2020: abgesperrter Spielzeug-Dino
in Wanaka, Neuseeland.

*March 25, 2020: Taped-off playground
dinosaur in Wanaka, New Zealand.*

Blitzblank: Alle Stationen, alle Fahrzeuge und alle Flächen,
mit denen Fahrgäste der Wiener U-Bahn in Berührung
kommen, werden täglich gereinigt und desinfiziert.

*Spic and span: All stations, subway cars, and contact
surfaces in the Vienna subway system are cleaned and
disinfected daily.*

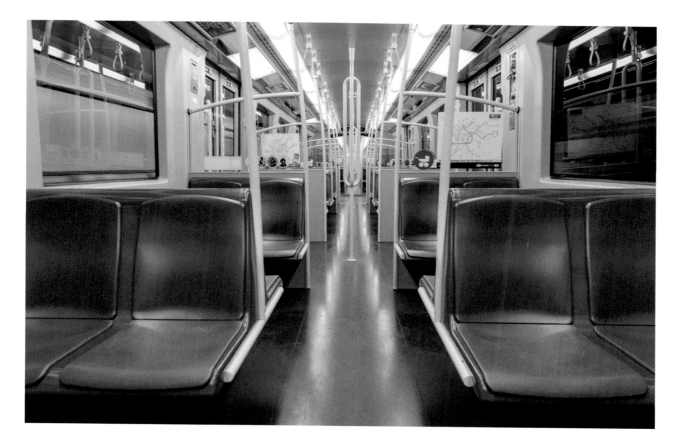

Der Stephansplatz in Wien mit dem
altehrwürdigen Dom im Mai 2020.

*Stephansplatz in Vienna with its
historic cathedral in May 2020.*

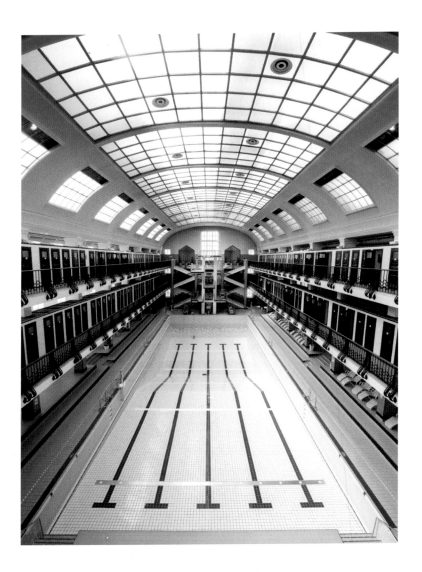

Das Amalienbad in der österreichischen Hauptstadt bleibt
während der Coronazeit geschlossen. Bei seiner Eröffnung in
den 1920er-Jahren zählte es zu den größten Bädern Europas.

*The Amalienbad pool in the Austrian capital remains closed
during the coronavirus period. It was one of the largest pools
in Europe when it opened in the 1920s.*

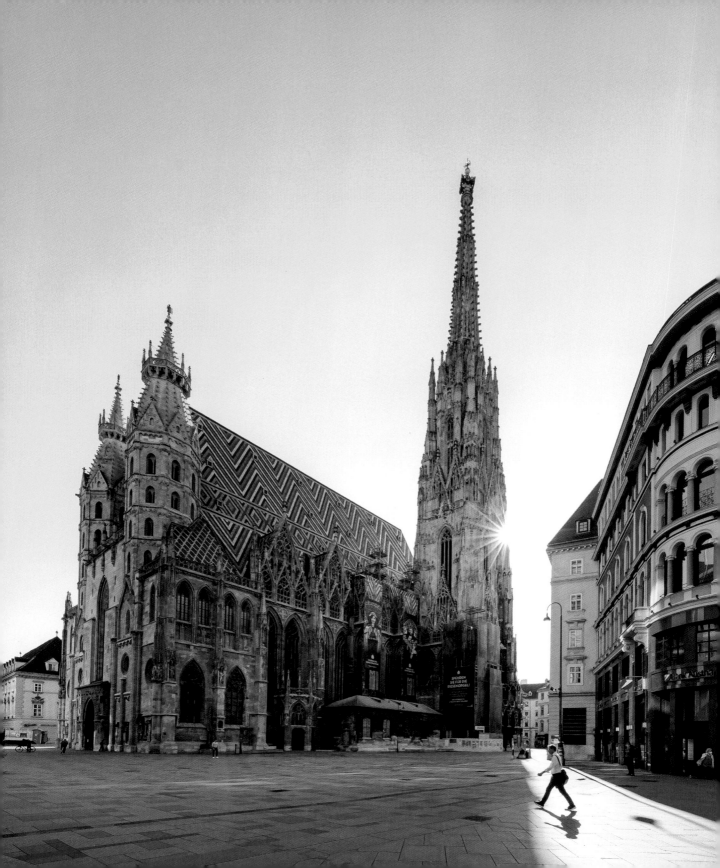

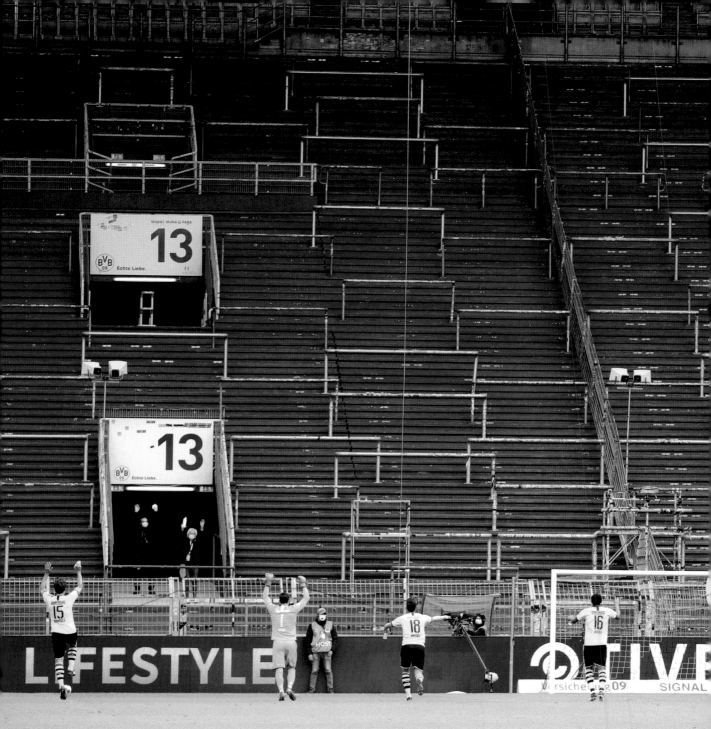

16. Mai 2020, der erste »Geisterspieltag« der Fußball-Bundesliga.
Die Spieler von Borussia Dortmund feiern nach dem 4:0-Sieg
über Schalke 04 mit virtuellen Fans der Südtribüne.

May 16, 2020, the first "ghost day" for Bundesliga soccer:
Borussia Dortmund players celebrate with virtual fans in
the south stands after their 4-0 win over Schalke 04.

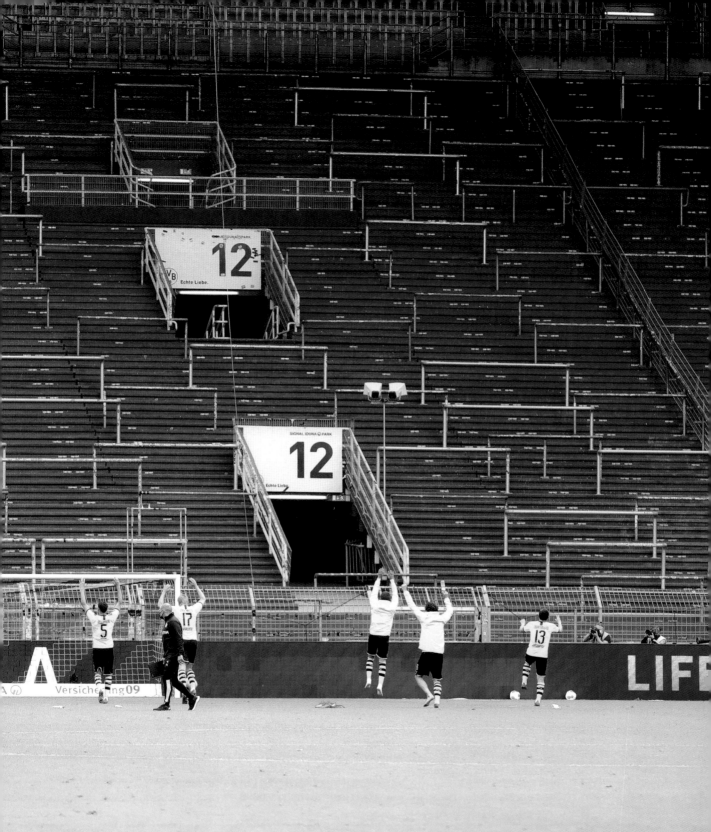

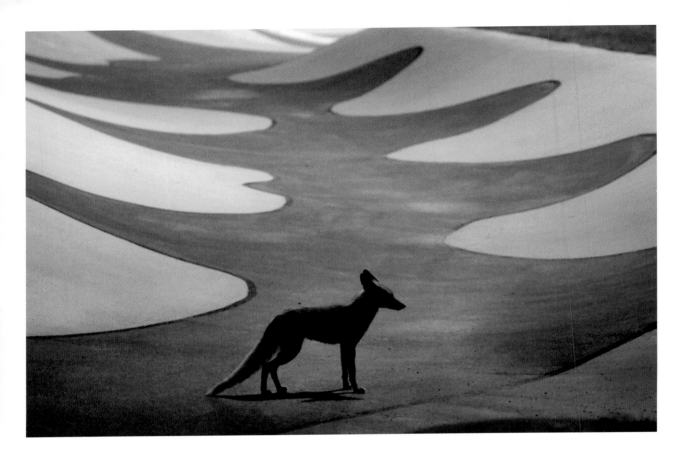

22. April 2020: Ein Rotfuchs wagt
sich in einen gesperrten Skatepark in
Aschkelon, einer Stadt in Israel an
der Mittelmeerküste.

April 22, 2020: A red fox
ventures into a closed skate park
in Ashkelon, a city in Israel on
the Mediterranean coast.

Weltweit schließen die
Schulen, hier ein Pausenhof in
Zürich im März 2020.

Schools close worldwide.
This is a schoolyard in Zürich
in March 2020.

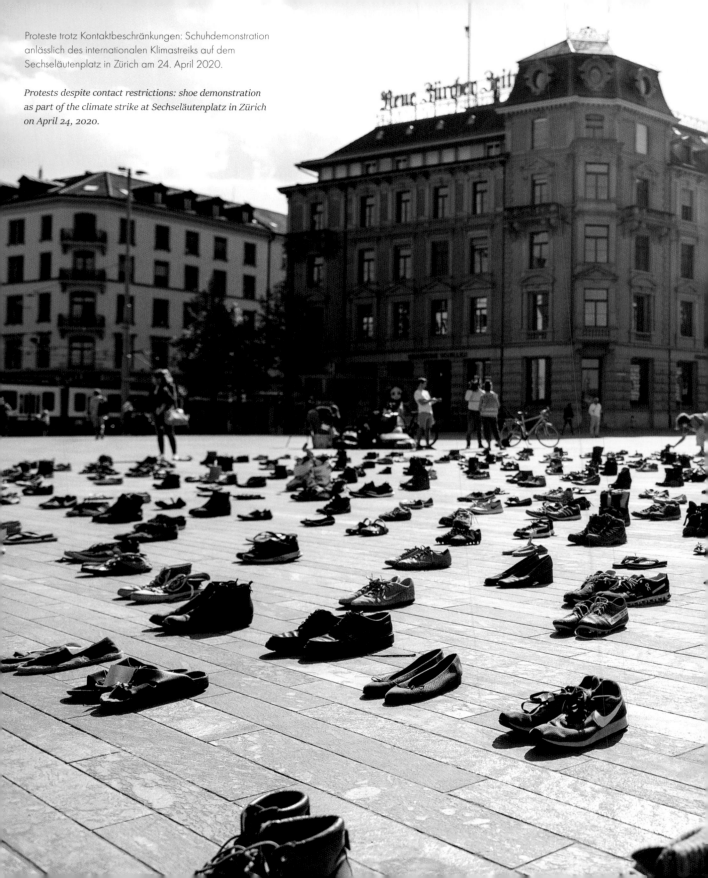

Proteste trotz Kontaktbeschränkungen: Schuhdemonstration anlässlich des internationalen Klimastreiks auf dem Sechseläutenplatz in Zürich am 24. April 2020.

Protests despite contact restrictions: shoe demonstration as part of the climate strike at Sechseläutenplatz in Zürich on April 24, 2020.

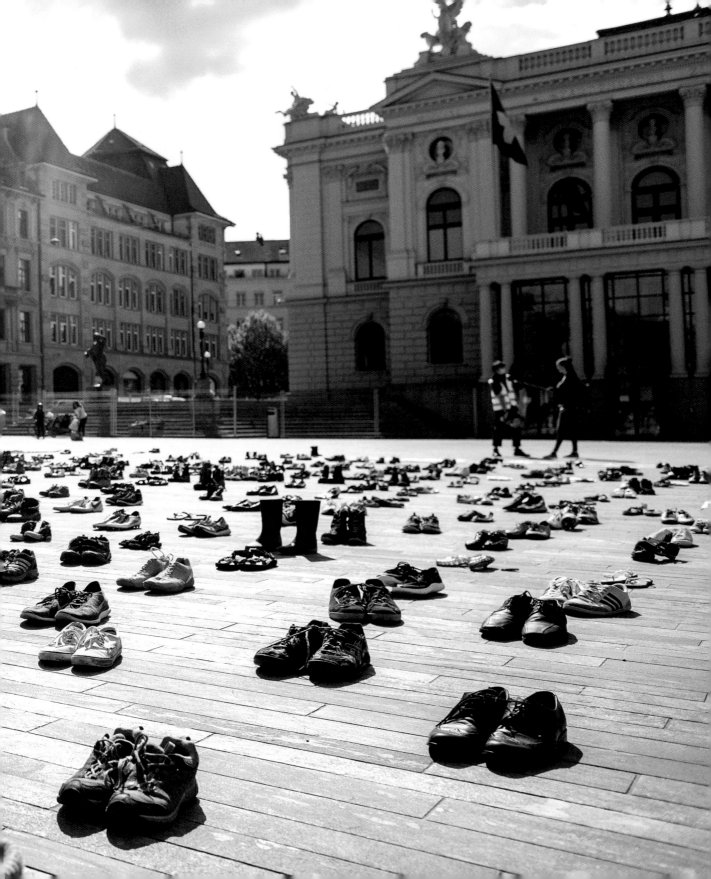

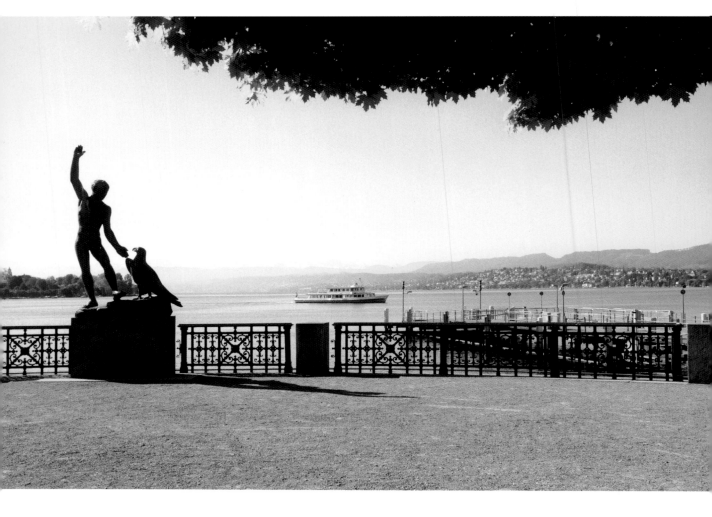

Keine Touristen, keine Segelboote:
Der Verkehr auf dem Zürichsee bleibt
auf das Nötigste beschränkt.

*No tourists, no sailboats: only
essential traffic is permitted on
Lake Zürich.*

24. März 2020: Ein Jogger hat die
Stufen des Schlosses Sanssouci in
Potsdam für sich allein.

*March 24, 2020: A jogger has the
steps of the Sanssouci Palace in
Potsdam all to himself.*

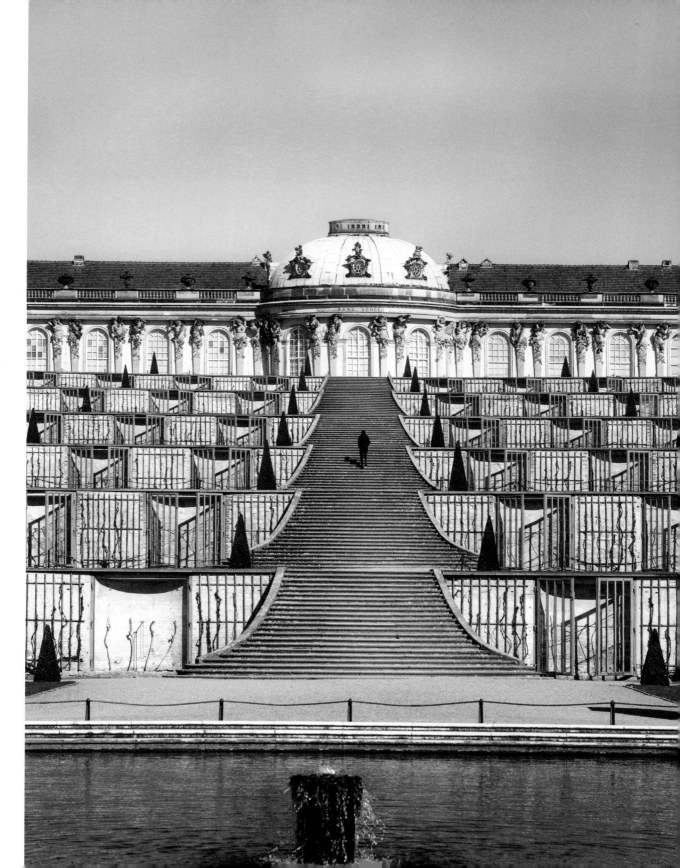

Wir durchleben eine Zeit der Suspendierung des Alltags, eine Unterbrechung des Rhythmus, wie manchmal in Songs, wenn das Schlagzeug verstummt und es wirkt, als würde die Musik angehalten. Schulen und Universitäten ge-schlossen, wenige Flugzeuge am Himmel, einsam hallende Schritte in den Museen, überall mehr Stille als normal.

Aus dem Buch *In Zeiten der Ansteckung* von Paolo Giordano.
Paolo Giordano ist ein italienischer Physiker und Bestsellerautor.
Sein erster Roman, *Die Einsamkeit der Primzahlen*, wurde in
40 Sprachen übersetzt.

From the book How Contagion Works *by Paolo Giordano.*
Paolo Giordano is a physicist and a bestselling writer.
His first novel, The Solitude of Prime Numbers,
was translated into more than 40 languages.

We're living through a suspension of daily activities and routines, a pause in the usual rhythm of our lives—like one of those songs where the drums stop abruptly and the music seems to expand in the emptiness left behind. Schools are closed, very few planes are moving across the sky, solitary footsteps echo in the museum corridors. Everywhere is shrouded in more silence than usual.

April 2020: Nur noch eine Handvoll Passanten nutzen die Möglichkeit, die Shibuya-Kreuzung diagonal zu queren.

April 2020: Only a handful of pedestrians are taking advantage of the diagonal Shibuya crosswalk.

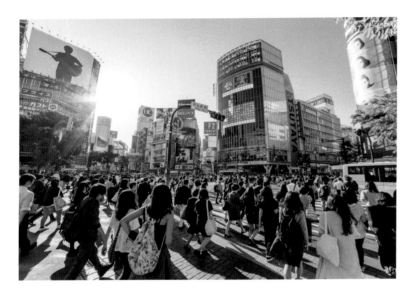

Mai 2016, nahe des Bahnhof Shibuya in Tokio: Mehr als zwei Millionen Menschen steigen hier an gewöhnlichen Werktagen ein und aus.

May 2016, near Shibuya Station in Tokyo: more than two million people hop on and off trains here on a typical workday.

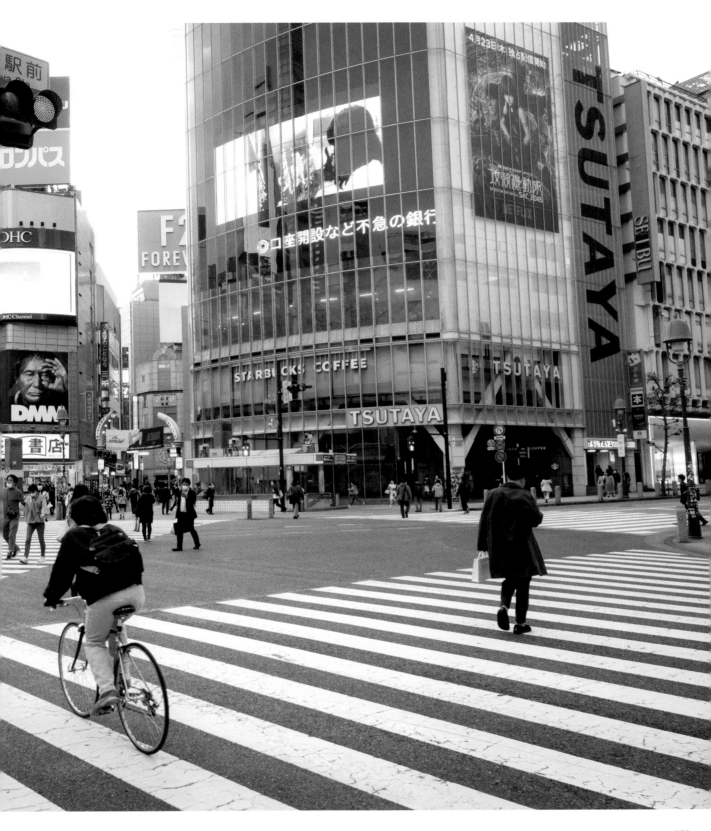

173

7. Mai 2020: die Takeshita-Straße in Tokio, wie
ausgestorben. Die Fußgängerzone ist bekannt
für ihre Modeboutiquen, Cafés und Restaurants.

*May 7, 2020: Takeshita Street in Tokyo is
deserted. The pedestrian zone is known for
its fashion boutiques, cafés, and restaurants.*

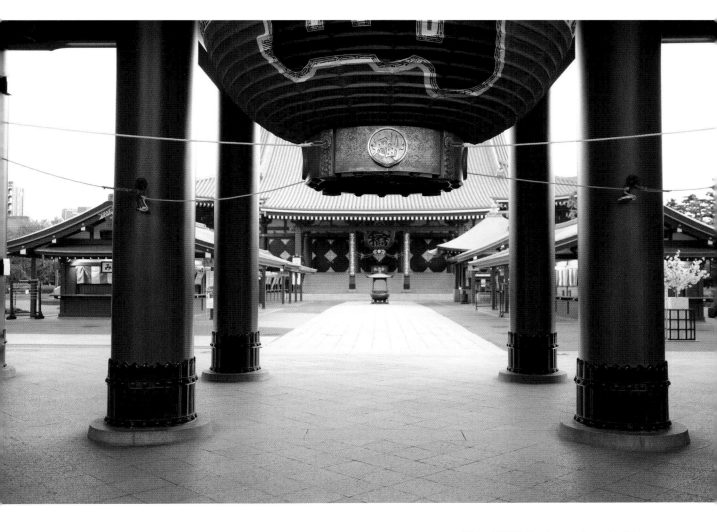

27. April 2020: Der Sensō-ji-Tempel in Tokio
ist der bedeutendste Schrein Japans. Während
der Pandemie appellierte die Regierung an die
Bevölkerung, ihn zu meiden.

*April 27, 2020: The Sensō-ji-Temple in
Tokyo is the most sacred shrine in Japan.
During the pandemic, the government
urged the people to stay away.*

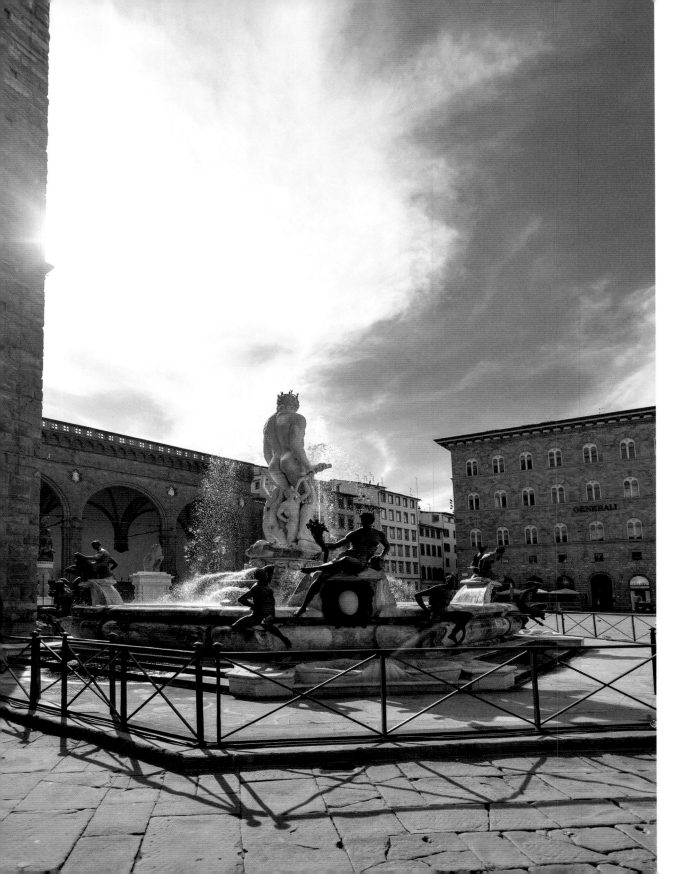

20. März 2020: Der Neptunbrunnen an der Piazza della
Signoria in Florenz sprudelt auch ohne Zuschauer.

*March 20, 2020: The Fountain of Neptune at the Piazza della
Signoria in Florence sprays merrily even without an audience.*

20. März 2020, Piazza Santa Croce: Blick vom
Denkmal für Dante Alighieri, im Vordergrund ein
Marzocco, das florentinische Wappentier.

*March 20, 2020, Piazza Santa Croce: View from the
Dante Alighieri monument, with a marzocco (the heral-
dic animal and symbol of Florence) in the foreground.*

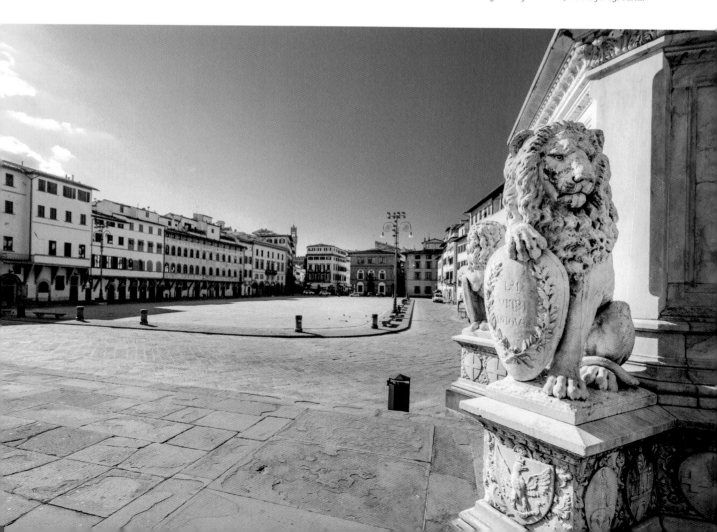

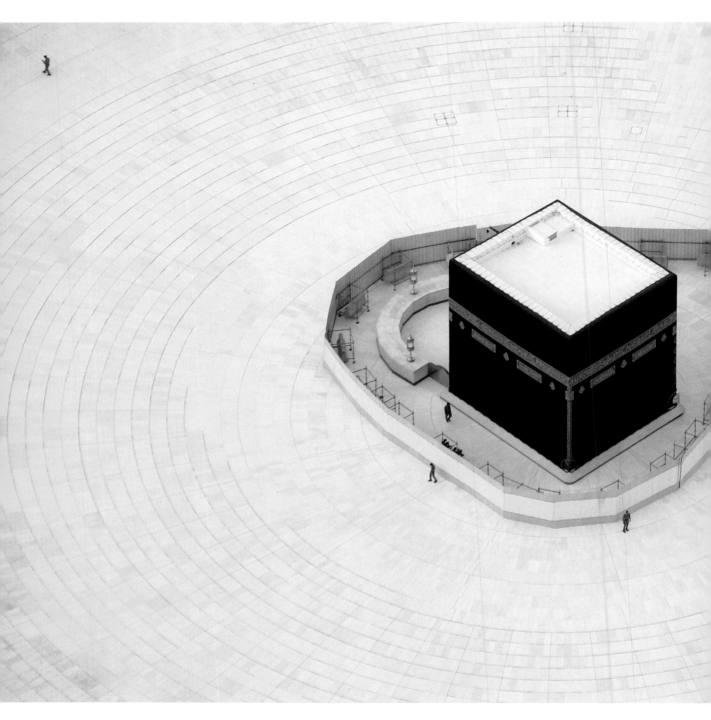

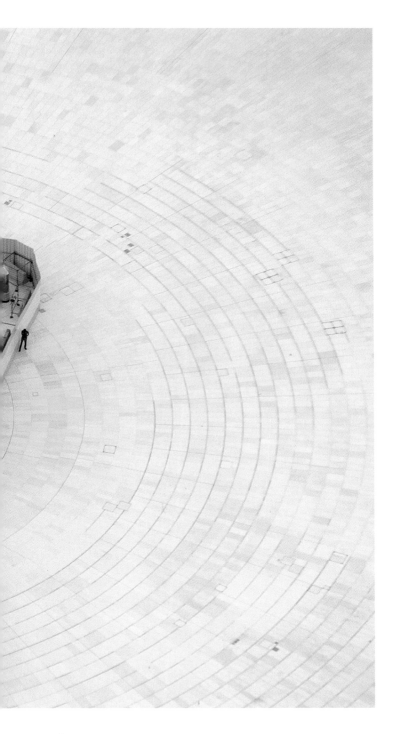

6. März 2020: Im Fastenmonat Ramadan müssen die traditionellen Pilgerreisen nach Mekka ausfallen. Am Hadsch, der Pilgerfahrt nach Mekka, dürfen im Juli/August 2020 nur wenige Tausend Muslime teilnehmen, während es im Jahr zuvor noch 2,5 Millionen gewesen sind.

March 6, 2020: The traditional pilgrimage to Mecca during Ramadan, the month of fasting, had to be cancelled. Only a few thousand Muslim pilgrims were allowed to attend the rites of hajj in July/August 2020. In 2019 2.5 million came.

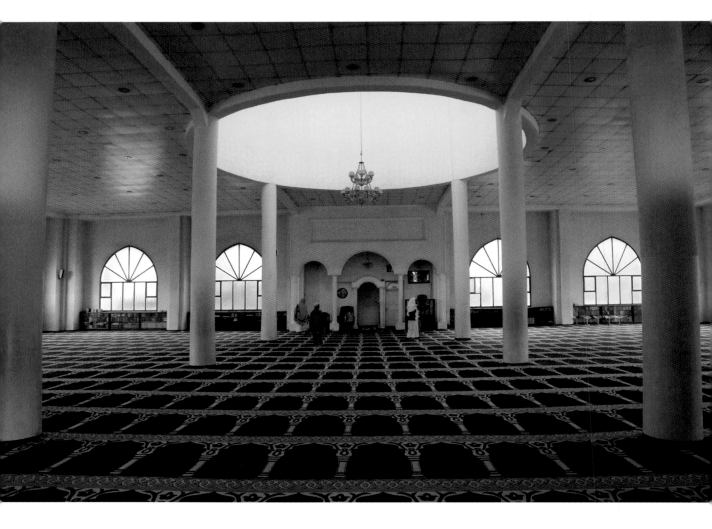

24. April 2020: Das Freitagsgebet ist im Koran das wichtigste der Woche und soll möglichst gemeinschaftlich begangen werden – Sumaya Moschee, Addis Abeba, Äthiopien.

April 24, 2020: In the Koran, the Friday prayer is the most important of the week and should be recited with others if at all possible—Sumaya Mosque, Addis Ababa, Ethiopia.

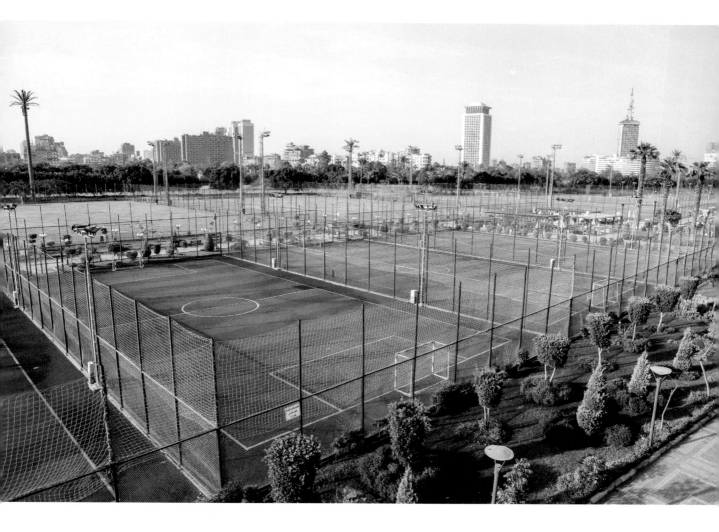

17. Mai 2020: Trainingsplätze des
Gezira Sporting Club im Bezirk
Zamalek, Kairo, Ägypten.

*May 17, 2020: Training fields of the
Gezira Sporting Club in the Zamalek
district, Cairo, Egypt.*

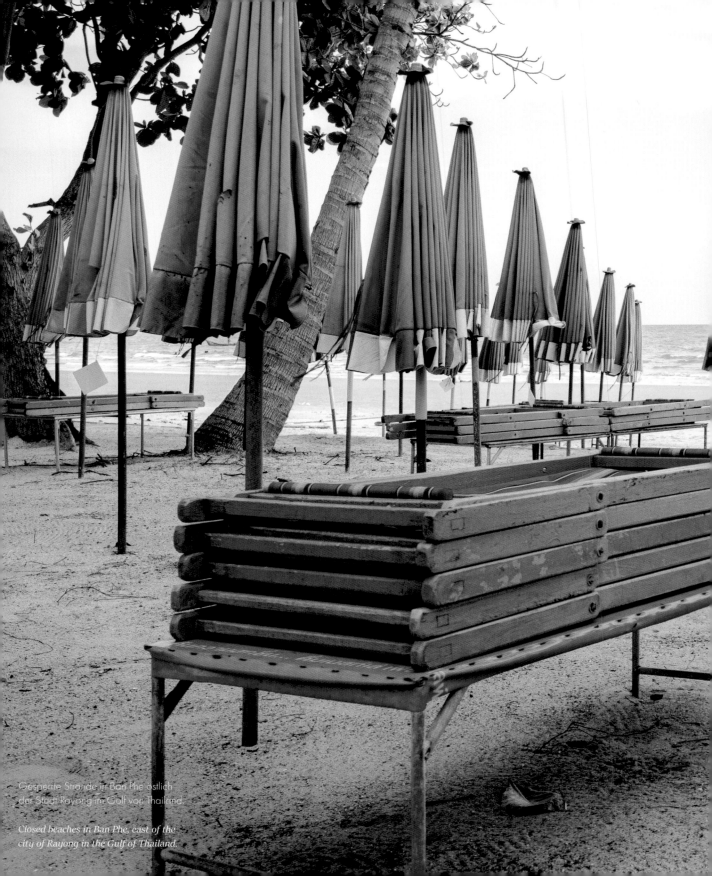

Gesperrte Strände in Ban Phe östlich
der Stadt Rayong im Golf von Thailand.

*Closed beaches in Ban Phe, east of the
city of Rayong in the Gulf of Thailand.*

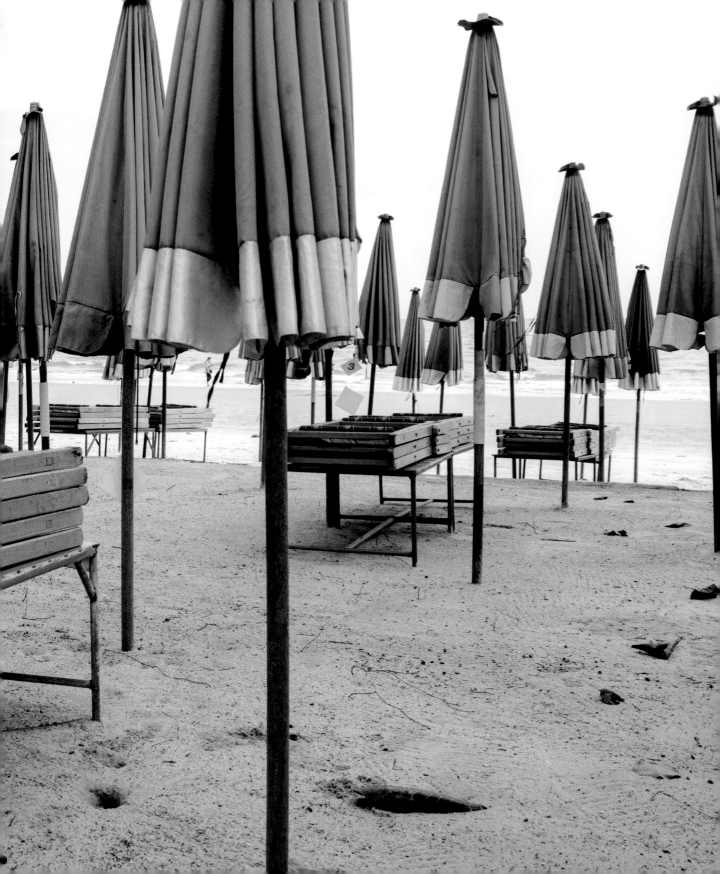

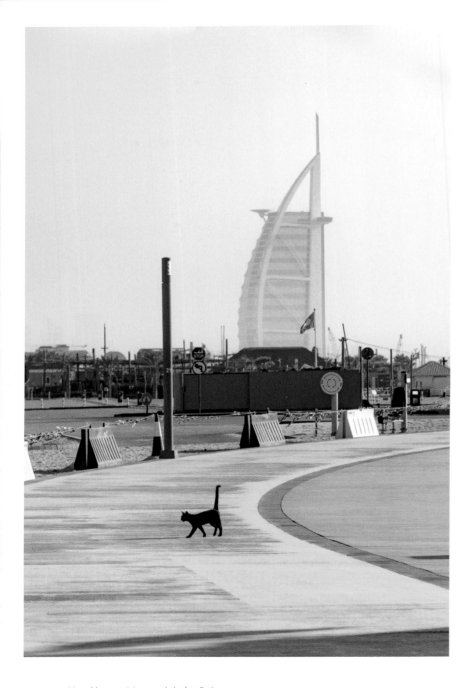

Verschlossen: Niemand darf in Dubai
die öffentlichen Strände aufsuchen.

*Closed: No one is allowed to visit
the public beaches in Dubai.*

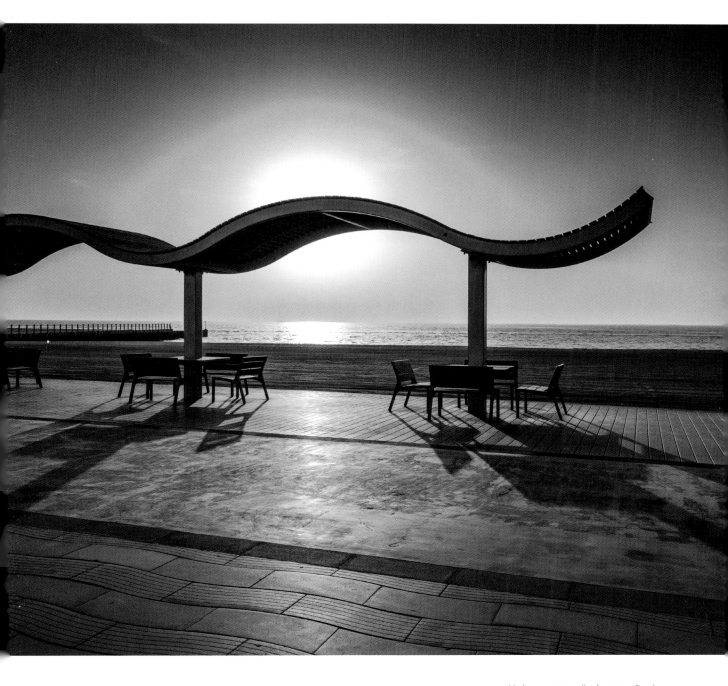

Verlassen: ein wellenförmiges Dach
am Strand von Dubai, unter dem
niemand Schutz sucht.

*Deserted: a wave-shaped roof on the
Dubai beach, under which no one
seeks shelter.*

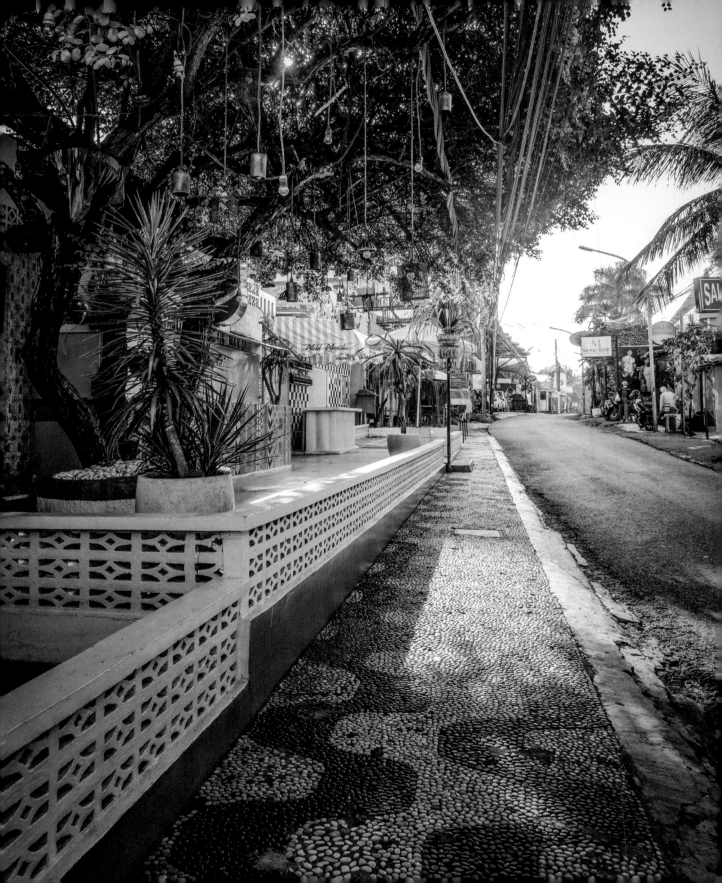

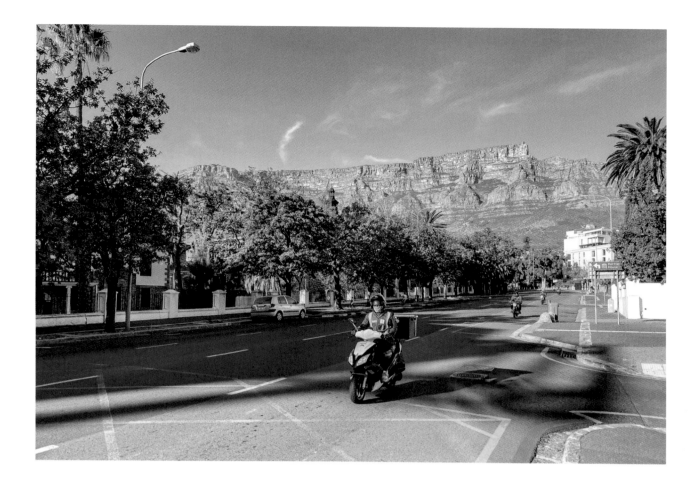

Kapstadt, Südafrika: Im Straßenbild fallen
allein die Kurierfahrer auf, die Waren und
Mahlzeiten nach Hause liefern.

*Cape Town, South Africa: The only vehicles
on the road are couriers bringing goods
and meals to people at home.*

Keine Gäste: Motel Mexicola in
Seminyak auf der indonesischen
Insel Bali.

*No guests: Motel Mexicola in
Seminyak on the Indonesian
island of Bali.*

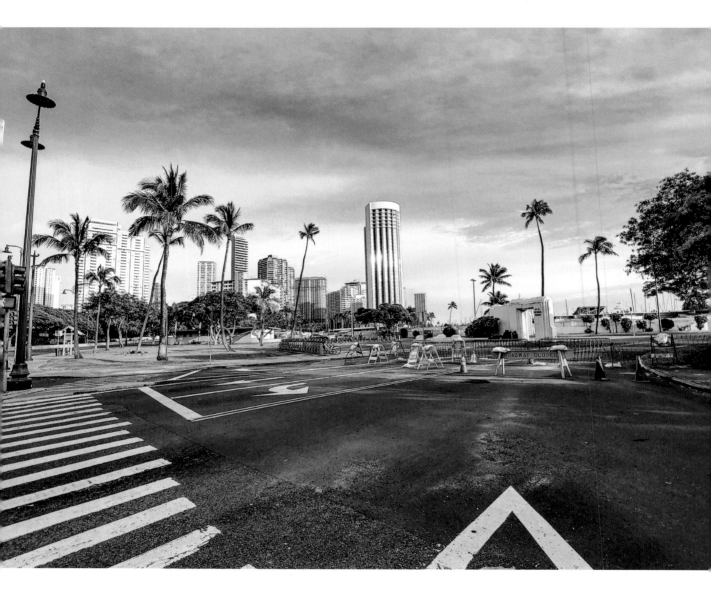

Verrammelter Parkplatz am Ala Moana
Beach Park in Honolulu.

*Barricaded parking lot at Ala Moana
Beach Park in Honolulu.*

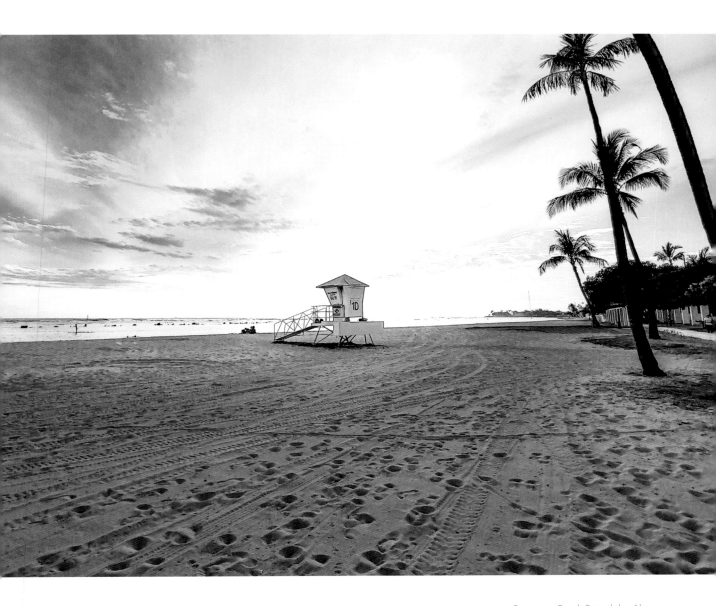

Spuren im Sand: Strand des Ala
Moana Beach Park auf Hawaii.

*Tracks in the sand: Beach at the
Ala Moana Beach Park on Hawaii.*

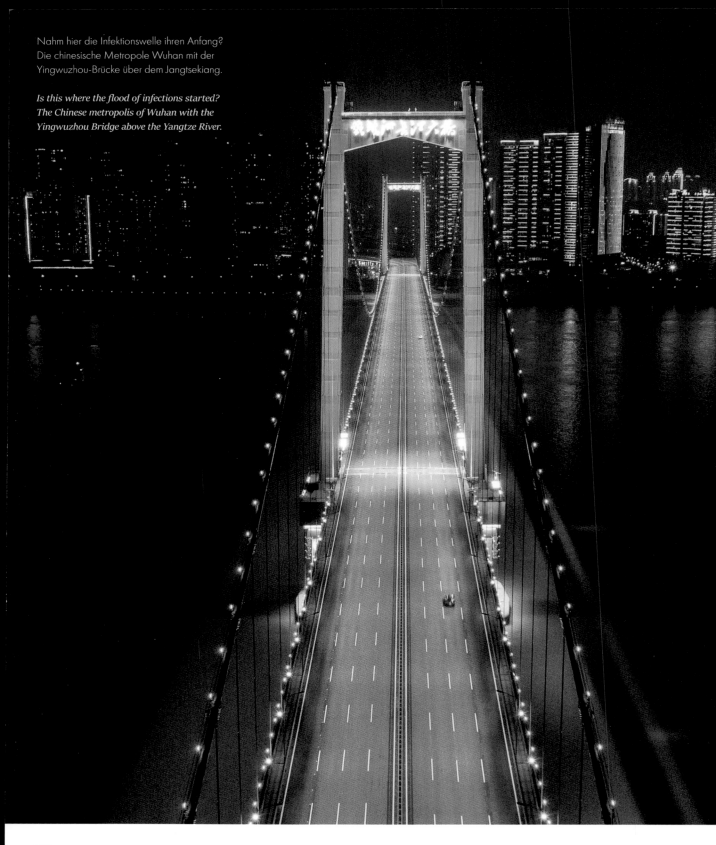

Nahm hier die Infektionswelle ihren Anfang?
Die chinesische Metropole Wuhan mit der
Yingwuzhou-Brücke über dem Jangtsekiang.

Is this where the flood of infections started?
The Chinese metropolis of Wuhan with the
Yingwuzhou Bridge above the Yangtze River.

S. 10/11: © govdo/Shutterstock.com; S. 12: © govdo/ Shutterstock.com; S. 13: © govdo/Shutterstock.com; S. 14: © LiveMediaSrl/Shutterstock.com; S. 15: © Stefano Mazzola/Shutterstock.com; S. 16/17: © Dmitri Ometsinsky/ Shutterstock.com; S. 17: © Aron M/Shutterstock.com; S. 20: © Jan Jerman/Shutterstock.com; S. 21: © kasakphoto/ Shutterstock.com; S. 22/23: © picture alliance/AA; S. 24: © Wut_Moppie/Shutterstock.com; S. 25: © Elisabeth Aardema/Shutterstock.com; S. 26/27: © picture alliance/ nordphoto; S. 27: © Shutterstock.com; S. 28/29: © picture alliance/ZUMA Press; S. 30: © picture alliance/REUTERS/ Nacho Doce; S. 31: © ikumaru/Shutterstock.com; S. 32: © Benbkk/Shutterstock.com; S. 33: © Holiday62/ Shutterstock.com; S. 34: © peter jesche/Shutterstock. com; S. 35: © Aimur Kytt/Shutterstock.com; S. 36: © S-F/ Shutterstock.com; S. 37: © DeAntes/Shutterstock.com; S. 38/39: © Werner Spremberg/Shutterstock.com; S. 40: © Eric Isselee/Shutterstock.com; S. 41: © CapturePB/ Shutterstock.com; S. 42: © Big Joe/Shutterstock.com; S. 43: © Big Joe/Shutterstock.com; S. 44: © Yurii Andreichyn/Shutterstock.com; S. 45: © Sodel Vladyslav/ Shutterstock.com; S. 48: © Socialtruant/Shutterstock.com; S. 49: © Socialtruant/Shutterstock.com; S. 50: © R_Pilguj/ Shutterstock.com; S. 51: © R_Pilguj/Shutterstock.com; S. 52: © jksz.photography/Shutterstock.com; S. 53: © Brian S/ Shutterstock.com; S. 54/55: © Alex Stemmer/Shutterstock. com; S. 55: © Andrei Nekrassov/Shutterstock.com; S. 56/57: © Yung Chi Wai Derek/Shutterstock.com; S. 58: © Yung Chi Wai Derek/Shutterstock.com; S. 59: © Prasun Surana/ Shutterstock.com; S. 60: © ErsinTekkol/Shutterstock.com; S. 60/61: © Ozan Kose/AFP via Getty Images; S. 62: © Mazur Travel/Shutterstock.com; S. 63: © StockStudio Aerials/Shutterstock.com; S. 64: © picture alliance/Loop Images/HarrisDro; S. 65: © picture alliance/Loop Images/ HarrisDro; S. 66: © picture alliance/empics/Dominic Lipinski/ PA Wire; S. 67: © picture alliance/empics/Aaron Chown/ PA Wire; S. 68: © Marton Kerek/Shutterstock.com; S. 69: © Agent Wolf/Shutterstock.com; S. 70: © Alex Yeung/ Shutterstock.com; S. 71: © lazyllama/Shutterstock.com; S. 72: © Hafiz Johari/Shutterstock.com; S. 73: © Hafiz Johari/ Shutterstock.com; S. 74: © Alex_Sunderland/Shutterstock. com; S. 75: © Alex_Sunderland/Shutterstock.com; S. 76: © Alex_Sunderland/Shutterstock.com; S. 77: © Ruben Olavo Vicente/Shutterstock.com; S. 78: © Liam Jones/Shutterstock. com; S. 79: © Liam Jones/Shutterstock.com; S. 80: © Sergio Reviejo Maroto/Shutterstock.com; S. 81: © Photo_Traveller/ Shutterstock.com; S. 82: © Horatio Baltz/Shutterstock.com; S. 82/83: © Felix Mizioznikov/Shutterstock.com; S. 86: © Thana Thanadechakul/Shutterstock.com; S. 86/87: © Luca Santilli/Shutterstock.com; S. 88: © Z Vargas/Shutterstock. com; S. 89: © Eve Orea/Shutterstock.com; S. 90/91: © picture alliance/REUTERS/Rupak De Chowdhuri; S. 91: © dowraik/Shutterstock.com; S. 92: © baileyc1/Shutterstock. com; S. 93: © Felix Mizioznikov/Shutterstock.com; S. 94: © Somphop Krittayaworagul/Shutterstock.com; S. 94/95: © Zenith Pictures/Shutterstock.com; S. 96: © Guillaume Garin/Shutterstock.com; S. 97: © Guillaume Garin/ Shutterstock.com; S. 98: © Andrey Bayda/Shutterstock. com; S. 100: © Andrey Pozharskiy/Shutterstock.com; S. 101: © Andrey Pozharskiy/Shutterstock.com; S. 102: © Andrey Pozharskiy/Shutterstock.com; S. 103: © Sergey Bezgodov/ Shutterstock.com; S. 104/105: © StoopDown/Shutterstock. com; S. 106: © Franz Sussbauer Photography; S. 107: © Franz Sussbauer Photography; S. 108: © Max Majosch/ Shutterstock.com; S. 109: © Wagner Santos de Almeida/ Shutterstock.com; S. 110: © eva-stadler.de; S. 111: © eva-stadler.de; S. 112/113: © eva-stadler.de; S. 113: © Sabine Thiele/thielebild.de; S. 116/117: © Tanya NZ/Shutterstock. com; S. 118: © Shutterstock.com; S. 119: © Shutterstock. com; S. 120: © picture alliance/Himanshu Bhatt/NurPhoto; S. 121: © picture alliance/REUTERS/Francis Mascarenhas; S. 122/123: © Austinpaz87/Shutterstock.com; S. 124: © valeriy eydlin/Shutterstock.com; S. 125: © tetiana. photographer/Shutterstock.com; S. 127: © GetCoulson/ Shutterstock.com; S. 128: © Stéphane Gizard; S. 129: © Stéphane Gizard; S. 130/131: © Stéphane Gizard; S. 132: © Stéphane Gizard; S. 133: © Stéphane Gizard; S. 134: © Yasemin Olgunoz Berber/Shutterstock.com; S. 134/135: © Maarten Zeehandelaar/Shutterstock.com; S. 138: © MZeta/Shutterstock.com; S. 139: © MZeta/ Shutterstock.com; S. 140/141: © Nadia Shira Cohen/ NYT/Redux/laif; S. 142: © Em Campos/Shutterstock. com; S. 143: © Souheila Soula/Shutterstock.com; S. 144: © SnapASkyline/Shutterstock.com; S. 146/147: © picture alliance/AP Photo/Noah Berger; S. 148: © Flystock/ Shutterstock.com; S. 148/149: © Matej Kastelic/Shutterstock. com; S. 150: © Mark Williams Pics/Shutterstock.com; S. 151: © ms.nen/Shutterstock.com; S. 152: © Ricky kuo/ Shutterstock.com; S. 153: © Carlos Huang/Shutterstock.com; S. 154: © Adam Melnyk/Shutterstock.com; S. 155: © Adam Melnyk/Shutterstock.com; S. 156/157: © Cinematographer/ Shutterstock.com; S. 158: © 2checkingout/Shutterstock.com; S. 159: © Agatha Kadar/Shutterstock.com; S. 160: © picture alliance/REUTERS/Lisi Niesner; S. 161: © Agatha Kadar/ Shutterstock.com; S. 162/163: © picture alliance/Ralf Ibing/ firosportphoto/POOL; S. 164: © picture alliance/REUTERS/ Amir Cohen; S. 165: © picture alliance/KEYSTONE/Ennio Leanza; S. 166/167: © picture alliance/KEYSTONE/ Alexandra Wey; S. 168: © GMC Photopress/Shutterstock. com; S. 169: © Andrea Hansen Fotografie/Shutterstock. com; S. 172: © Shanti Hesse/Shutterstock.com; S. 172/173: © Fiers/Shutterstock.com; S. 174: © image_vulture/ Shutterstock.com; S. 175: © image_vulture/Shutterstock. com; S. 176: © Kotroz/Shutterstock.com; S. 177: © Kotroz/ Shutterstock.com; S. 178/179: © Bandar Aldandani/AFP via Getty Images; S. 180: © picture alliance/AA/Minasse Wondimu Hailu; S. 181: © picture alliance/Xinhua News Agency/Mohamed El Raai; S. 182/183: © Phakkapol Pasuthip/Shutterstock.com; S. 184: © Plamen Galabov/ Shutterstock.com; S. 184/185: © Robert Haandrikman/ Shutterstock.com; S. 186: © embarafootage/Shutterstock.com; S. 187: © heinstirred/Shutterstock.com; S. 188: © Nervevana/ Shutterstock.com; S. 189: © Nervevana/Shutterstock.com; S. 190/191: © STR/AFP via Getty Images

Unser besonderer Dank geht an/our special thanks go to Stéphane Gizard!

IMPRESSUM *Imprint*

© 2020 teNeues Media GmbH & Co. KG, Kempen
Cover credits: © Anita Back/laif, © Dmitri Ometsinsky/
Shutterstock.com (German cover)
© MISHELLA/Shutterstock.com (English cover)

Foreword by Pit Pauen
All other texts and captions by Axel Nowak
pp. 46/47: excerpt from *Normalität war gestern. Die Zukunft nach
der Corona-Krise verdient Besseres, Neue Zürcher Zeitung*,
May 12, 2020 © courtesy of Roman Bucheli
pp. 114/115: excerpt from *Can't Be There Today* by Billy Bragg,
© Sony/ATV Music Publishing (UK) Limited
pp. 170/171: excerpt from *In Zeiten der Ansteckung/How Contagion Works* by
Paolo Giordano, © Paolo Giordano, courtesy of Rowohlt Verlag GmbH
Translations by Amanda Ennis
Copyediting by Inga Wortmann-Grützmacher, teNeues Media
Proofreading by Esther Caspers
Image selection by Eva Stadler
Design by Eva Stadler
Editorial coordination by Pit Pauen, teNeues Media
Production by Nele Jansen, teNeues Media
Color separation by Jens Grundei, teNeues Media
ISBN 978-3-96171-319-6 (German cover)
ISBN 978-3-96171-320-2 (English cover)
Library of Congress Number: 2020942544
Printed in the Czech Republic by Tesinska Tiskarna AG

Our deepest thanks to Martin Schoeller;
without his support, we never could have
gotten this book to press so quickly.

Published by teNeues Publishing Group

teNeues Media GmbH & Co. KG
Am Selder 37, 47906 Kempen, Germany
Phone: +49-(0)2152-916-0
e-mail: books@teneues.com

Press department: Andrea Rehn
Phone: +49-(0)2152-916-202
e-mail: arehn@teneues.com

teNeues Media GmbH & Co. KG
Munich Office
Pilotystraße 4, 80538 Munich, Germany
Phone: +49-(0)89-904213-200
e-mail: bkellner@teneues.com

teNeues Media GmbH & Co. KG
Berlin Office
Mommsenstraße 43, 10629 Berlin, Germany
e-mail: ajasper@teneues.com

teNeues Publishing Company
350 7th Avenue, Suite 301, New York, NY 10001, USA
Phone: +1-212-627-9090
Fax: +1-212-627-9511

teNeues Publishing UK Ltd.
12 Ferndene Road, London SE24 0AQ, UK
Phone: +44-(0)20-3542-8997

teNeues France S.A.R.L.
39, rue des Billets, 18250 Henrichemont, France
Phone: +33-(0)2-4826-9348
Fax: +33-(0)1-7072-3482

www.teneues.com

teNeues Publishing Group
Kempen
Berlin
London
Munich
New York
Paris

teNeues